ROBERT WILLSON IMAGE-MAKER

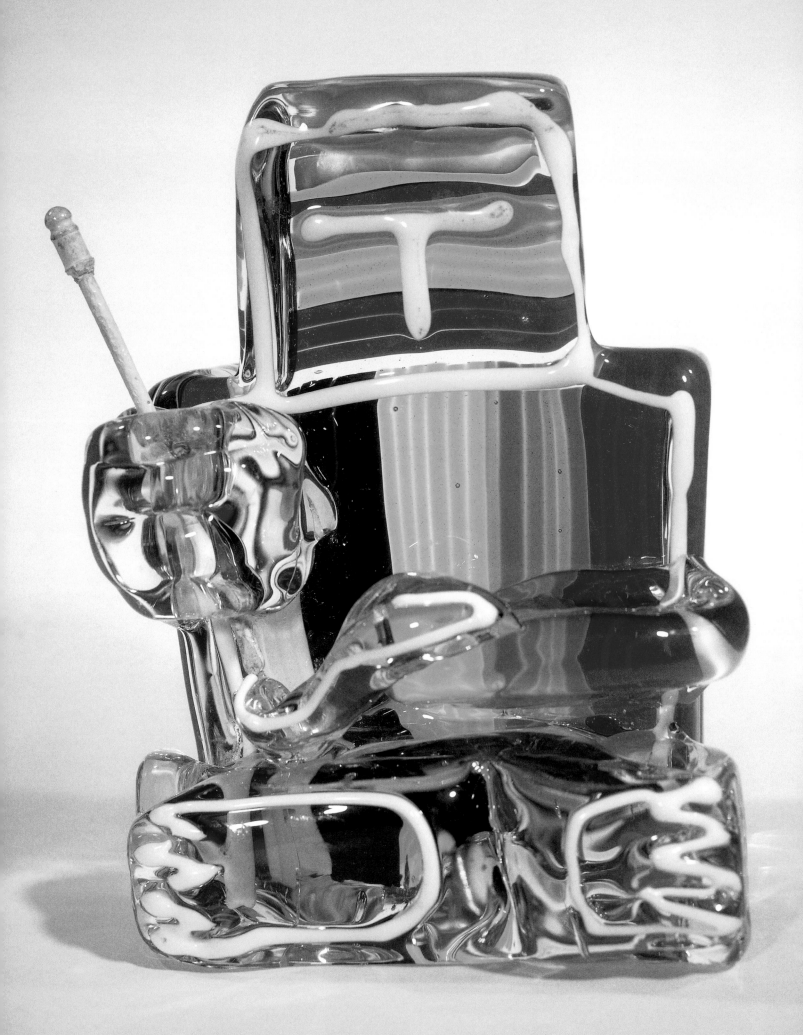

ROBERT WILLSON IMAGE-MAKER

MATTHEW KANGAS

Pace-Willson Foundation
San Antonio
in association with
University of Washington Press
Seattle and London

Unless noted otherwise, all works are by Robert Willson and are from the Pace-Willson Foundation.

"Biography" (English and Spanish), "Virgin," "Live Interval," and "Serpent Carved on the Wall" by Octavio Paz, translated by Muriel Rukeyser, from *Early Poems of Octavio Paz,* copyright © 1973 by Octavio Paz and Muriel Rukeyser. Reprinted by permission of New Directions Publishing Corp. Sales Territory: U.S./Canada rights only.

Designers: Phil Kovacevich and George Lugg
Editor: Patricia Draher Kiyono
Proofreader: Laura Iwasaki

ISBN 0-295-98218-7

All dimensions are in inches; height precedes width precedes depth.

Cover: *Desert Cactus,* 1994, glass with colored inclusions and gold foil, 17¾ x 13¼. Courtesy of the Chrysler Museum of Art, Norfolk, Virginia, gift of the Duncan Foundation, 96.17.
Back cover: *On Target,* c. 1992, solid glass, 17¾ x 11⅞ x 4, made with Pino Signoretto. Courtesy of Ravagnan Gallery, Venice.
Frontispiece: *Image-Maker* (detail of *Tribal Group*), 1979, glass and metallic leaf, 12⅛ x 9 x 6½. San Antonio Museum of Art, purchased with funds provided by Mr. and Mrs. Albert C. Droste, 85.2d.

Distributed by University of Washington Press
P.O. Box 50096
Seattle, WA 98145

Printed in Canada by Hemlock Printers, Ltd., Burnaby, B.C.

CONTENTS

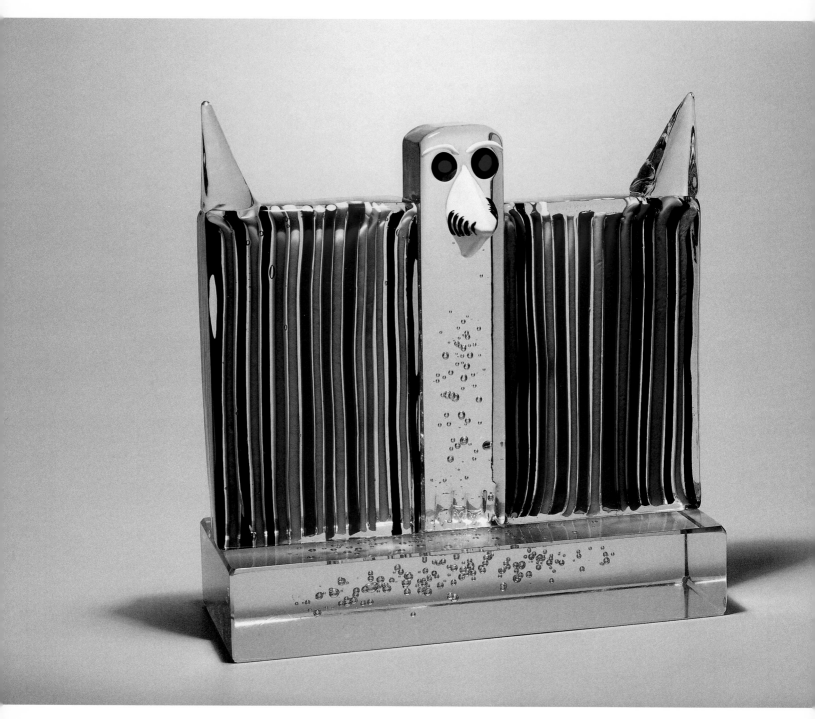

Big Bad Bird, 1995, solid glass, 18 x 17 x 8, made at Ars Murano, Venice. Renwick Gallery, Smithsonian American Art Museum, Washington, D.C.

ACKNOWLEDGMENTS

Many people have made this book possible, first and foremost among them, Margaret Pace Willson, Mary Anne Biggs, and Kathy Jonas of the Pace-Willson Foundation. Their support, enthusiasm, and dogged hard work, along with that of Laurence Miller and Linda Pace of ArtPace, were necessary before the considerable pleasures of this project could occur, as were the warm hospitality of Luis Chavez and Lucia Perez in San Antonio. Director E. John Bullard and curators John W. Keefe and Daniel Piersol of the New Orleans Museum of Art blazed the path of Willson scholarship through their two important exhibitions. They also graciously oversaw additional photography by Judy Cooper and Owen Murphy with assistance from Jennifer Ickes.

Other museum curators and individuals who responded with sincere and serious interest to inquiries are Jane Adlin, Metropolitan Museum of Art; Tina Oldknow, The Corning Museum of Glass; Dr. Nancy A. Corwin, independent curator; Tom Dimitroff, independent scholar; Catherine Futter, Chrysler Museum of Art; Holly Hotchner and Ursula Ilse-Neumann, American Craft Museum; Christine Kallenberger and Marcia Y. Manhart, Philbrook Museum of Art; Jo Lauria, Los Angeles County Museum of Art; Mark Richard Leach and Martha Mayberry, The Mint Museum of Craft + Design; Marvin Lipofsky, artist and historian; Bruce Pepich, Charles A. Wustum Museum of Fine Arts; Cindi Strauss, Museum of Fine Arts, Houston; Davira S. Taragin, Toledo Museum of Art; Kenneth R. Trapp, Renwick Gallery of the Smithsonian American Art Museum; and Howard Taylor and Karen Zimmerli, San Angelo Museum of Fine Arts.

In Italy, both expatriate Americans and resident Venetians went out of their way to help bring recognition to Robert Willson. These dedicated individuals include Alfredo Barbini; Rosa Barovier Mentasti; Louise Berndt, Galleria San Nicolò; Renato Borsato; Egidio Costantini, Galleria Fucina degli Angeli; Alessandro Diaz de Santillana; Charles Parriott, Chihuly, Inc.; Joseph Precker; Elio Raffaeli, Renzo Vianello, and Roberto Cammozzo, Ars Murano; Luciano Ravagnan, Ravagnan Gallery; Pino Signoretto; and Arnoldo Toso, Antica Vetreria Fratelli Toso.

Marguerite Shore led a team of translators that included Joyce Morinaka, Peter Nadir, and Jeff Panciera. In Venice, Oceania Barbini, Rosa Barovier Mentasti, Louise Berndt, Francesca Borsato, Egidio Comelli, Alessandro Diaz de Santillana, Amber Hauch, and Marina Raffaeli pitched in, acting as translators on the spot during interviews and inquiries. The staff at Pensione La Calcina–Ruskin's House was also unusually helpful. Don Glover of Horizon Books, Seattle, went out of his way to help find books pertinent to my research. Madeleine Wall in Florida was very helpful in tracking down reviews and articles. Gail Bardhan, Reference Librarian of the Leonard S. and Juliette Rakow Research Library of The Corning Museum of Glass, was once again a gracious and thorough resource from beginning to end of this project. Dr. Anna Lee Kahn was generous with her astute comments about Willson's debt to Maya art.

Phil Kovacevich and George Lugg of Kovacevich Design did a superlative job of book design and production, the results of which speak for themselves. Without them, the book would not look so effortless and elegant. Without Patricia Draher Kiyono's copyediting and Laura Iwasaki's proofreading, the enormous amount of details would have been overwhelming.

Alice Herbig and Pat Soden of University of Washington Press have acted as smooth and thorough liaisons to help the book reach a larger audience. Once again, I owe them a great debt of thanks. Dennis O. Palmore, Permissions Manager for New Directions Publishing, assisted with securing rights for the beautiful poems by Octavio Paz.

Tina Oldknow's foreword sets Willson's story in context and is a model of scholarship and concision. To her and all the others involved, and any I might have failed to mention, I offer deep gratitude. *Grazie mille, muchas gracias,* thank you all!

—M.K.

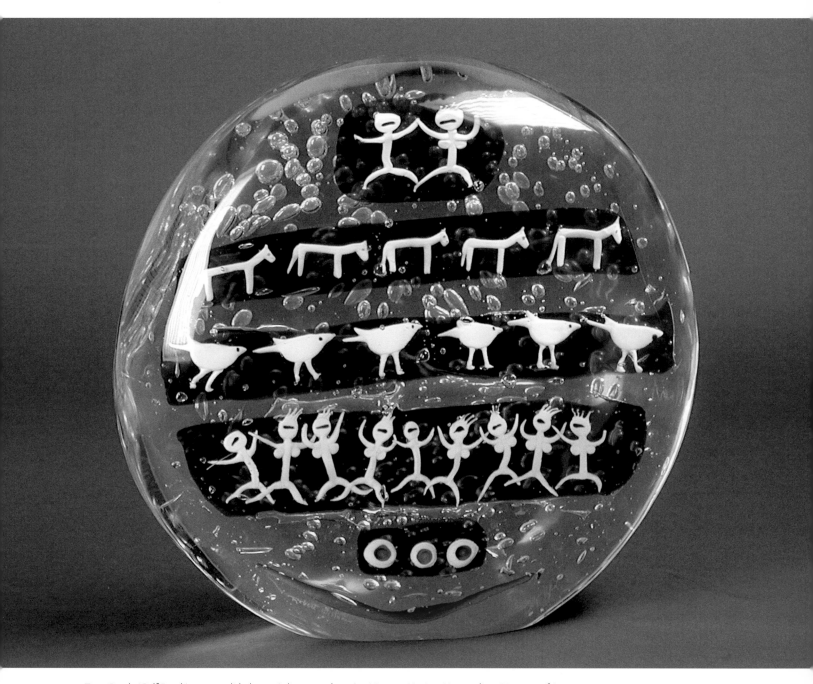

Texas Beach (Gulf Beach), 1992, solid glass, 16 diam., made at Ars Murano, Venice. Metropolitan Museum of Art, gift of Margaret Pace Willson.

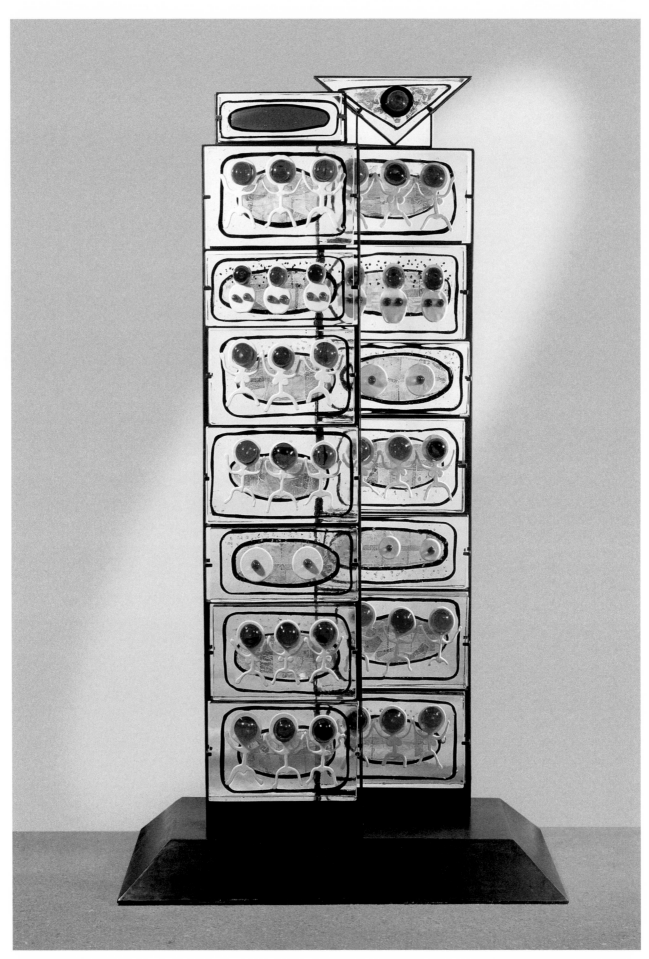

The New Doors of Life, 1996. Glass, gold leaf, and steel, 96 x 40 x 30 each. Collection of The Corning Museum of Glass, gift of Margaret Pace Willson, 2001.3.41.

FOREWORD

Robert Willson was a sculptor, "half Choctaw and half Texan" as he liked to describe himself. A maverick in art and in life, he worked outside the mainstream. His art explores themes inspired by ancient mythologies, pre-Columbian and other native American art, and the American West. A unique and visually arresting blend of European technique and Southwestern American style, his sculpture comfortably inhabits the shifting space between Old World and New, between modern times and ancient.

Willson can be considered an important figure in the American studio glass movement, even though he was never directly connected with it. He was one of the few Americans producing pieces in hot glass, outside industry, in the 1950s. The few artists who were working glass in their studios at this time—such as Michael and Frances Higgins, Edris Eckhardt, Maurice Heaton, and Robert Sowers—were using warm and cold glass techniques, such as fusing, *pâte de verre*, and stained glass.

Willson was one of the first American artists to work on Murano, the island of Venice famous for glassblowing. There he collaborated with maestros believed to be the best in the world. He was preceded by Americans Eugene Berman and Ken Scott in the early 1950s. Later, Thomas Stearns, in 1962, and the first representatives of the studio glass movement—Dale Chihuly in 1968 and Richard Marquis in 1969—went to Murano to learn about glass. Unlike Willson, these Americans designed for the Venini glassworks, and their collaboration lasted but a year or so. Richard Marquis was the only one among them to make a substantial body of his own work on Murano.

Other aspects of Willson's work, and his approach to it, strike me as meaningful in the context of glass. I say "in the context of glass" because it is clear that Willson was attracted to other materials, such as clay, bronze, and watercolors, even though glass was his favorite. I find it interesting that he moved so easily between two and three dimensions, developing a lasting relationship with glass and watercolors, as he mentions in this statement from the 1985–86 *Glass Art Society Journal.*

> As an artist seeking a material to work in with love, I happened to see glass being made in Arkansas, Ohio, and West Virginia. Immediately, I knew this was a material in which I could work—it was and is the most modern and the most exciting fabric possible. That it had the art qualities of transparency, permanent color, internal tension, and changing variety may not have been as important as the brilliance of it. In any case I have been pleased to devote my art life to work in glass and in watercolors, which are, for me, the two most interrelated media.

Surely, it is Willson's experience with watercolors that partly explains his remarkable understanding and unique use of color.

One fact about Willson that cannot fail to strike anyone interested in the history of American studio glass is how his influence in this area has been almost entirely overlooked. Willson took the initiative to come to Corning, New York, in 1956, where he met Frederick

Carder and was inspired by his role as an artist and designer. Convinced that he could work in hot glass as well, Willson applied to The Corning Museum of Glass for a scholarship, and visited Murano for the first time later that year. This story has interesting parallels to that of Harvey Littleton, who was helped to realize his dream of developing studio glassblowing in America after a visit to the glasshouses of Murano in the late 1950s. Littleton and his students set about reviving studio glassblowing and introducing glass programs into the American university system, while Willson explored a different, individual path that would have its own implications for the development of studio glass.

Although Willson's sculpture was relatively little known in the United States, early studio glass artists tended to seek him out. On Murano, Willson worked with famous glassblowers, such as the great maestro Alfredo Barbini, in addition to those who would become famous in America, such as Pino Signoretto and Loredano Rosin. In making Willson's solid glass sculptures, these masters practiced the complex technique of sculpting on the pipe, the Italian method of *a massiccio,* hot sculpting "in the mass," developed by Barbini, which did not catch on in American glass until the late 1980s.

Most people do not, but should, credit Willson for his contribution to the evolution of this technique. Willson and Barbini had to invent ways in which Willson's vision of solid glass sculpture could be realized. Theirs was a special collaboration of profound mutual respect and admiration for each other's aesthetic and technical knowledge. Matthew Kangas is right on the mark when he says that Willson's was "one of the most successful and long-lasting collaborations between Murano and any American artist," and that this extended cultural exchange has significance both for the history of glass made on Murano and for the history of art made in glass in the United States.

For me, one of the most delightful aspects of Robert Willson's story is his effect on the Venetians, who sincerely liked and admired (and promoted) him. I imagine that Willson—a long, tall Texan—must have appeared as a genuine, authentic American, the kind of true westerner that Europeans had come to expect from exported Hollywood films. Pino Signoretto thought he was "Jimmy Stewart," while Egidio Costantini considered him "an Indian!" In Willson's art, the Muranese could appreciate the landscapes, colors, textures, and myths of America. In trying to imagine looking at his art through their eyes, I can more fully appreciate the exoticism, honesty, and Americanness of his highly individualistic and idiosyncratic vision.

Finally, it is my pleasure to report that The Corning Museum of Glass is the recipient of a sizable portion of the Robert Willson Estate. The gift comprises some twenty sculptures—including the monumental glass sculpture *The New Doors of Life*—in addition to hundreds of drawings and other archival materials. Willson's connection to Corning was always a source of inspiration for him. Now his impressive legacy will be a source of inspiration for us, and for all those who visit our house of glass.

TINA OLDKNOW
Curator of Modern Glass
The Corning Museum of Glass

BIOGRAFÍA

No lo que pudo ser:
es lo que fue,
y lo fue está muerto.

BIOGRAPHY

Not what he might have been:
but what he was,
and what he was is dead.

—OCTAVIO PAZ, "Riprap,"
Early Poems 1935–1955

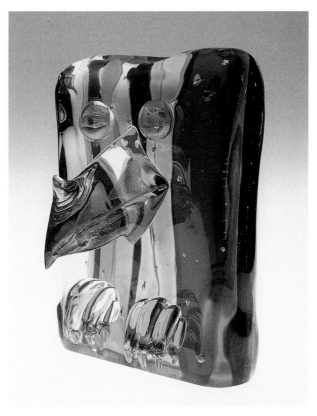

Shy Bird, 1983, solid glass, 14 x 12 x 4, made with Pino Signoretto,
Venice. New Orleans Museum of Art, 1989.138.40.

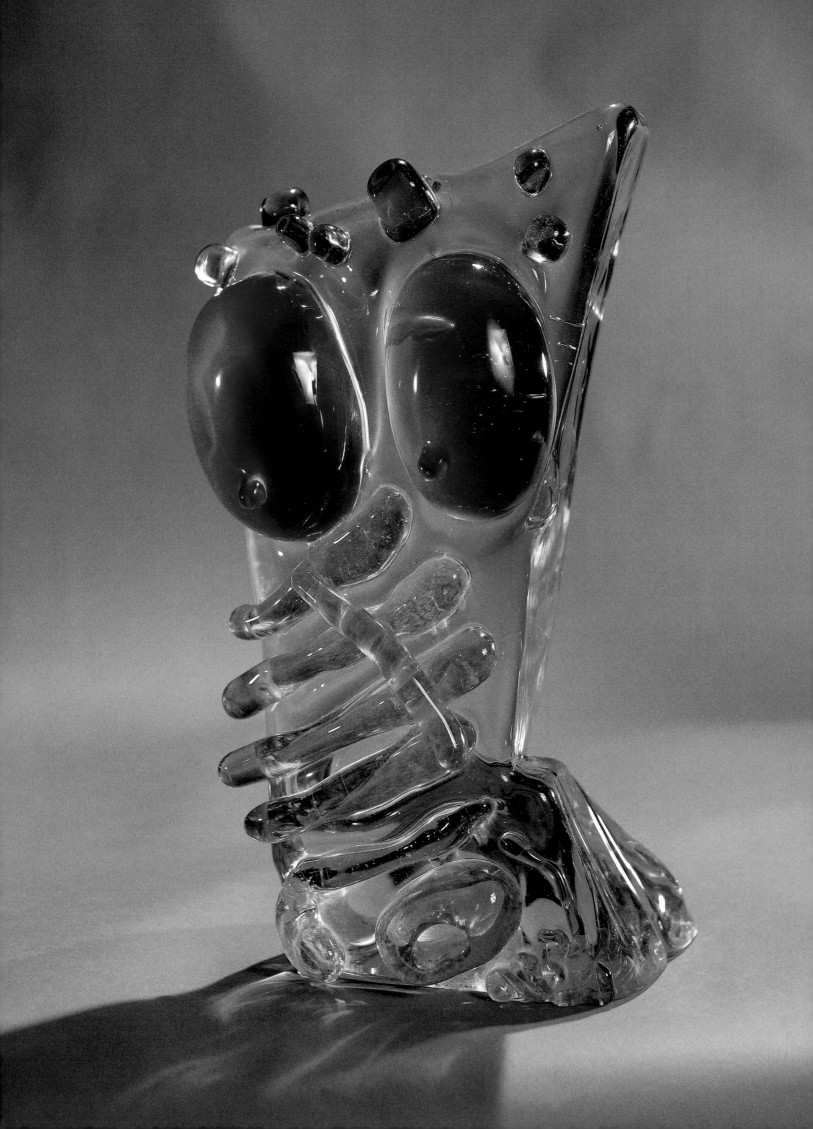

Image-Maker
Introducción: Creador de Imagenes

The art of Robert Willson (1912–2000) spanned eighty-eight years of the twentieth century and touched upon dramatic cultural, social, and political events: the Mexican Revolution, the Great Depression, World War II, the Cold War, and the computer age. Robert Willson's

Birdie Alice Blanks, January 29, 1899.

artistic vision sprang from his parents' nineteenth-century agrarian roots, was baptized in the Mexican mural movement, intensified during the post-war phase of American regional and abstract modernist art, and culminated in the fusion—the first and most sustained by an American artist—of those strains and the Venetian glass tradition. Willson's nearly five-decade-long contact with the artisans and masters of the island of Murano, by Venice, not only is unique in twentieth-century art but became strangely reciprocal. His demands for larger and larger solid (not blown) glass sculptures stretched the abilities and outlooks of three generations of makers on Murano, where today solid glass sculpture is accepted.

Like other artists of the modern movement in the past century, Willson embarked on a roving, geographically displaced career. But unlike a war refugee transplanted from Europe to America, Willson moved, ceaselessly for a time, in the other direction, away from the United States: first to Mexico from 1935 to 1941, next to the South Pacific for a distinguished military career, then to Arkansas, and on to Miami for twenty-five years as an art professor. Finally, continuously from 1956 to 1997, he worked in Venice, serene fountainhead and realizer of his dreams.

Over the years, Willson's geographically diverse formative experiences turned him into an artist and intellectual at home anywhere in the world. He benefited from his at first periodic and later sustained expatriate life. The eclectic blend of influences that define his work—Maya culture, modern art, and the Venetian glass tradition—renders his achievement singular in twentieth-century art.

Robert Willson, age 7, Fort Towson, Oklahoma.

Despite an actively exhibiting professional life, Willson is not as well known as he deserves. Perhaps a generation too early to be fully accepted by the homegrown American studio glass movement, and a generation too late to be grouped with American regional artists such as Georgia O'Keeffe, Grant Wood, and Alexander Hogue, Willson has slipped through the cracks of American art history, as artists who exhibit outside mainstream population centers often do. However, when we examine his breadth as an artist—painter, ceramist, watercolorist, photographer, and glass sculptor—combined with his parallel roles of art professor, writer, curator, amateur graphic designer, and publisher, his contributions to

(left)
Reconstruction of a Pioneer Woman, 1972, solid glass, 16³/₄ x 9 x 4. New Orleans Museum of Art, 89.136.6.

Magenta Bay Fighter Strip, Noumea, New Caledonia, May 10, 1943, watercolor and pencil on notebook paper, 4¼ x 4¾.

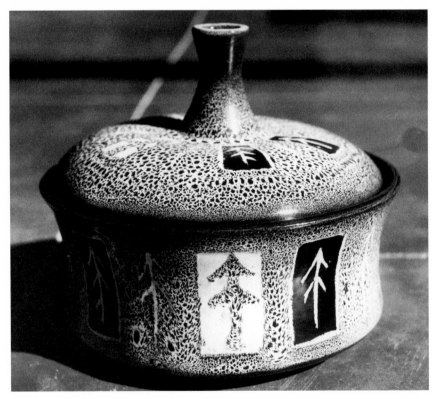

Decorated lidded casserole, c. 1948, stoneware with glazes, 6 x 9, made at Nob Hill Pottery, Mountainburg, Arkansas. Location unknown.

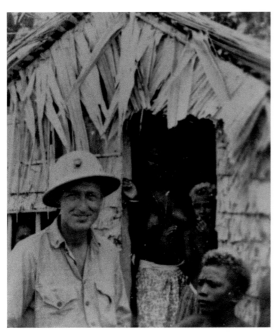

Capt. Robert Willson, U.S.M.C., Russell Islands, 1944.

American culture become undeniable. Robert Willson led many lives—cowboy, adventurer, soldier, academic, artist, lover, husband, father, grandfather—but they all impinged upon an art characterized by a driving urge to create visual images of an easily identifiable nature.

Born in 1912, a crucial year of geometric abstraction in Europe, Willson grew up to accept only certain aspects of modern art. He got to know giants of modern art—Diego Rivera, José Clemente Orozco, David Alfaro Siqueiros, Frida Kahlo, Rufino Tamayo—and his art, like theirs, would remain figurative, symbolic, and narrative. Following the example of the ancient Maya artists, whose works he encountered in Mexico in 1935, his annus mirabilis, Willson evolved a pictorial language of simplified figures, shapes, and petroglyphic signs that communicates directly with the viewer. Ancient Mexican indigenous art was a far greater influence on Willson than was Mexican mural art, but his exposure to the murals makes his own art unusually accessible. It is the refinement of that pictorial language and its embodiment in solid glass sculpture (fashioned by, in some cases, thirteenth-generation glass furnace artisans) that makes Willson's art so unexpectedly enjoyable.

Like younger American glass artists—William Morris, Harvey Littleton, Richard Marquis—Willson arrived at glass through ceramics. Suspecting that his ideas were better suited to glass than clay, in 1956 he approached legendary former Steuben Glass designer Frederick Carder; that contact led him to a Corning European study travel fellowship, and to Venice for the first time.

Unlike a Henry James hero—Christopher Newman in *The American*, for instance—who is crushed by the older civilization of Europe, oppressed by the weight of its tradition, the man from Texas embraced the European tradition, even bent and expanded it. As Willson explained in an exhibition-related video:

> I want a simple form of symbolic meaning much as primitive people do. . . . It's always an experiment. With each piece, I'm learning something. . . . Sometimes they will tell me we can't do it but usually I can overpersuade them and we do do it.[1]

Such a combination of gentle persistence and seemingly modest goals belies decades of trust and challenge between the American gentleman and the

Notebook page, study for stained glass window of bull, undated, pencil on paper, 8 x 4.

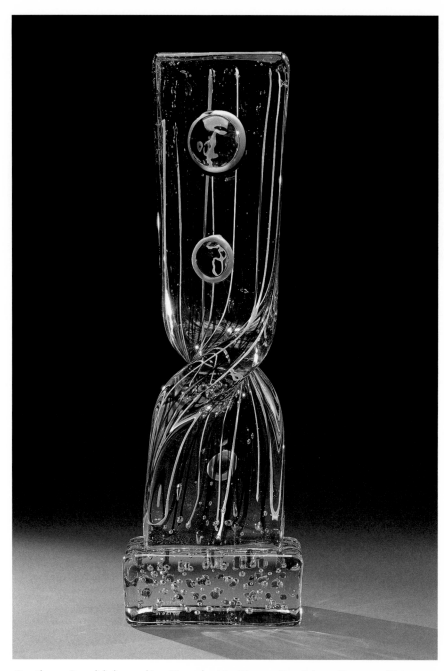

Growth, c. 1987, solid glass, 24^1/$_2$ x 7^7/$_8$, made at Ars Murano. New Orleans Museum of Art, 89.138.18.

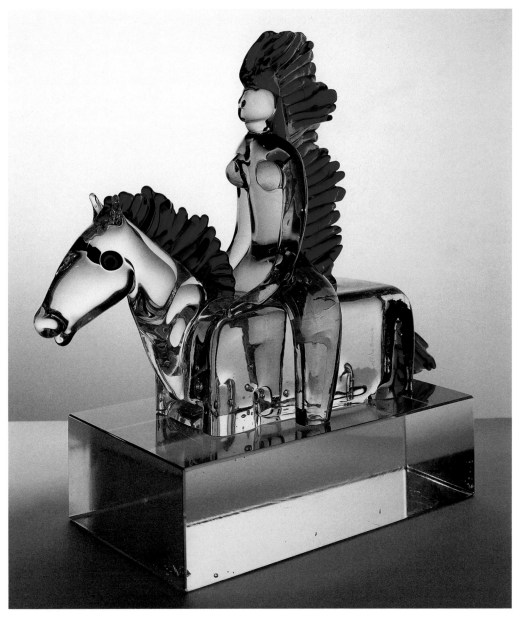

The Huntress, 1991, solid glass, 14 h., made at Ars Murano. Alberto Anfodillo collection, Venice.

Murano masters and their assistants. Small wonder they grew to adore him by the time of his final visit to Murano in 1997. Indeed, as a very young man, one of the now highly respected Murano masters begged Willson to adopt him and take him to the United States where he could become Willson's full-time assistant.[2]

Willson rambled around Venice, picking and choosing hot shops and masters to suit his needs for a given summer stay. As a result, his oeuvre is a visible biography of Murano glassmakers in the last half of the twentieth century. All the big names—Alfredo Barbini, Fratelli Toso, Pino Signoretto, Licio Zuffi, Loredano Rosin, Giordano Guarnieri, Ercole Barovier, Egidio Costantini, Roberto Moretti, Elio Raffaeli, Renzo Vianello—worked for and with Willson. The extent and duration of these collaborations varied from year to year, but the purpose of each personnel decision was to find the best and most simpatico master to execute

Reception for *Robert Willson: Sculture Vetro*, 1968, Correr Museum, Venice. Left to right: Alfio Toso, Robert Willson, Ermanno Toso, Luigi Toso.

the artist's increasingly complex demands. Willson began by sketching white spiral-footed bowls, but ended by supervising the construction of eight-foot-high steel-framed multiple-panel glass sculptures. By observing the hot shop skills available on the island, Willson matched his wishes to those he thought most likely to fulfill them. Though he commented that there was little or no decent glass sculpture being done in Venice when he arrived in 1956, glass masters and others today pay greater attention to the possibilities inherent in glass sculpture.[3]

Willson's influence is not only found in the island's workshops and galleries. He became the first American glass artist to have two solo exhibitions in Venetian museums: in 1968 at the prestigious Correr Museum on St. Mark's Square, and in 1984 at the Ca' Pesaro Museum of Modern Art, the birthplace of Italian modern art. In both instances, the substantial testimonials and tributes from Italian colleagues, curators, artists, and critics were effusive. The art of Robert Willson was acclaimed in a city, country, and culture that has not always singled out American art for approbation.

Willson's experiences in Latin America and Europe had far-reaching curatorial implications while he was teaching ceramics in Coral Gables, Florida, at the University of Miami. Two exhibitions he curated there represent the artist's apogee as a cultural world statesman and low-profile diplomat, much in the mode of André Malraux, Paul Valéry, and Octavio Paz. Sociable and personable, Willson was able to marshal U.S. oil interests in Colombia to pay for three trips there, which culminated in *3,500 Years of Colombian Art: 1534 B.C.–1960 A.D.* in 1960 at the Lowe Art Museum on the Coral Gables campus. Thirteen years later, the same museum mounted *International Glass Sculpture*,

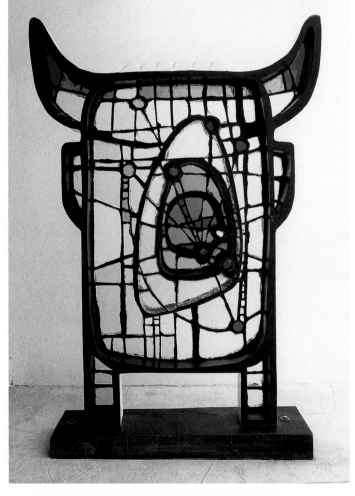

Eye of the Bull Man, 1974, stained slab glass with metal leading, 72 h., made with Karel Dupré. Location unknown.

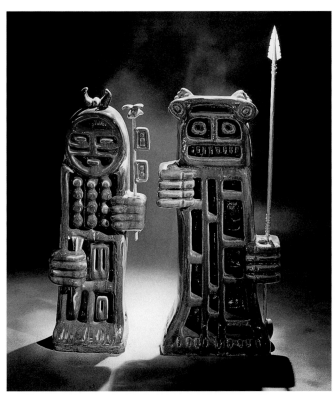

Chieftain and Hunter, 1978, celadon porcelain with iron oxides, 19 h., 24 h. Location unknown.

the first such survey in the United States. Many of the artists in the exhibition became the leading lights of the studio glass movement in America and Europe.

Willson's indefatigable correspondence—friends wrote him letters in English, French, Spanish, Italian, and German—made possible his open-handed internationalist approach. Part Southerner, part Euro-expatriate, and all Texan, Willson brought people of different nations closer together; this was especially important during the postwar period but also throughout the Cold War, when American artists were less respected in Europe. Willson's rock-solid support of the Murano masters, and his lifelong commitment to the fellowship of artists, set an international model that prophesied the glass world today.

Willson should be examined as a modern artist who lived into postmodern times. Modern art has been criticized, first, as too tied to the colonization of the Third World (Cubism and African Art)[4] and, second, as too responsive to American foreign policy (Abstract Expressionism and the U.S. Information Agency touring group shows in the 1950s).[5] But

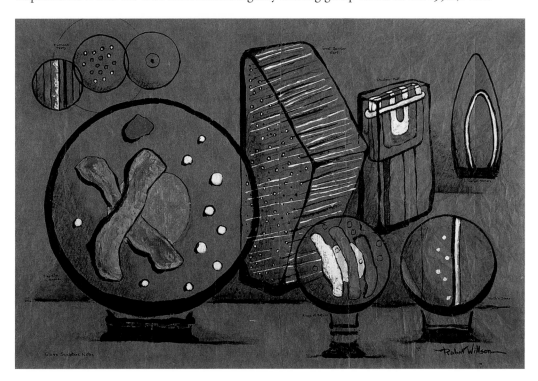

Glass sculpture notes, undated, gouache on sepia paper, 24 x 36. New Orleans Museum of Art, 89.138.52.

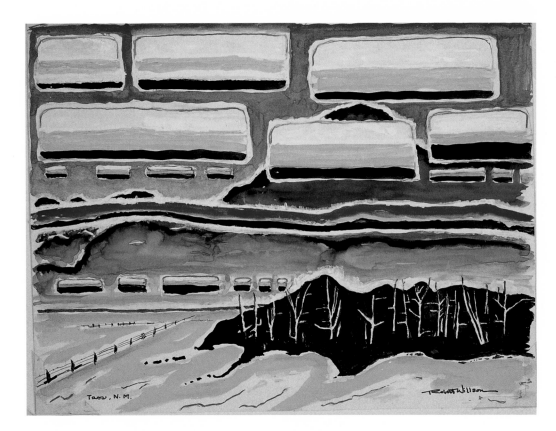

Sunset at Taos, 1990, watercolor and mixed media, 25 x 31. Mark Joseph Willson Collection, Newtown Square, Pennsylvania.

Willson's sensitivities to indigenous art and his championing of American regional subject matter were deeply rooted in his own background. By growing up on a Choctaw reservation, being the son of a Christian missionary and itinerant minister, and spending extended periods in Mexico at archaeological sites and folk-art villages, Willson absorbed native American imagery as a natural and wholly defensible outgrowth of his environment. This gift of multi-cultural influences was particularly appreciated by the Italians.[6]

Transformed into glass via his detailed workshop drawings, the petroglyphic, hiero-glyphic, and diagrammatic imagery existed on immediate as well as symbolic levels. Mustang, serpent, coyote, armadillo, Earth, dog—all had both autobiographical and indigenous mean-ings for the artist. As the imagery gradually became more peopled and schematic and spread across the glass surface, Willson approached a form of ideographic writing that could be tailored to the hot shop workers' three-dimensional fulfillment. The closer the rapport and the longer the working relationship (as with Barbini and Raffaeli), the more clearly realized the artist's complicated ideography became.

The humor in Willson's art, its simplicity, and the sense of a child's dream world of ani-mals drew on popular culture as seen in comic books and cartoons. Seemingly at odds with higher cultural aspirations during the modern period, such direct influences came easily to the proto-postmodernist Willson, who believed that, even in a largely illiterate society such as that of the ancient Maya, carved picture stories on the temples communicated with the population. The bracing interface of modernism and populism in Willson's art relies on a visual language he created from firsthand experience with the ruins and relics of pre-Columbian societies. Add

(right)
Spirale: The Lost Trail, 1992, solid glass, 23⅝ x 7⅞ x 4¾, made at Ars Murano. Courtesy of Ravagnan Gallery, Venice.

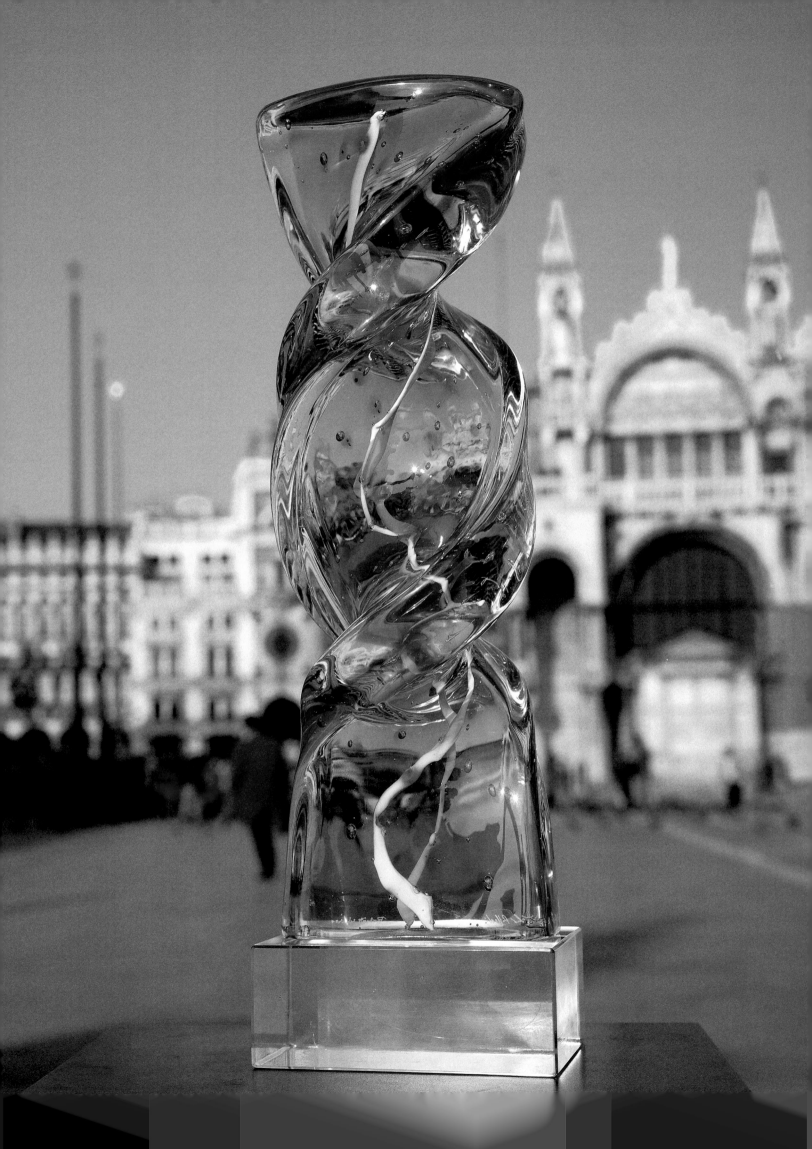

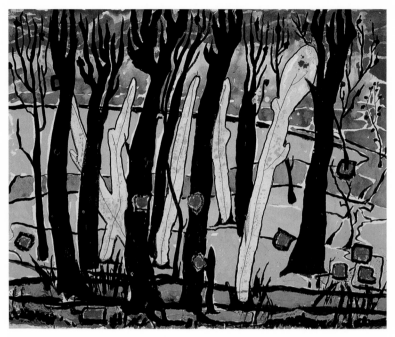

Ghost Trees, 1994, watercolor and mixed media, 28 x 34.

to that his responses to art by the Mexican muralists, and one begins to see how Willson adapted the symbolic character of ancient Mesoamerican languages to a variant of the visual images used by Rivera, Orozco, and Siqueiros.

Willson's resolve in 1956 (twenty years too early?) to use molten glass as an art material now appears prescient. After mainstream media such as oil paint and bronze were discredited by postmodern theorists as too traditional, ironically, craft materials (clay, wood, metal, cloth, and glass) came to be seen as radically unconventional and marginalized, and hence, as desirable aesthetic tools. If many of the younger glass artists included in *International Glass Sculpture* went on to gain considerable status (Richard Marquis, Marvin Lipofsky, Joel Philip Myers, Stanislav Libenský), it may be because of the older artist's earlier efforts to break down prejudices against glass and claim for it a high seriousness of purpose.

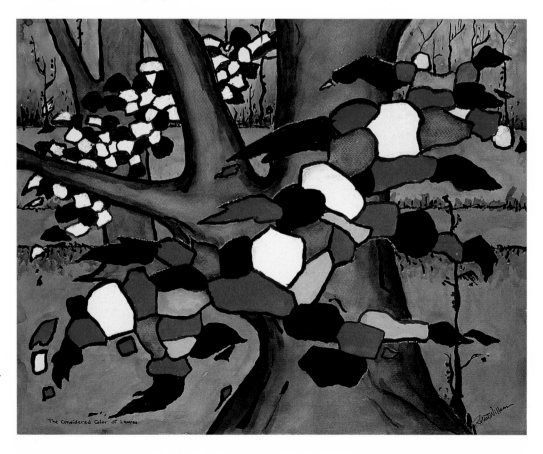

The Considered Color of Leaves, 1998, watercolor and mixed media, 29 x 35.

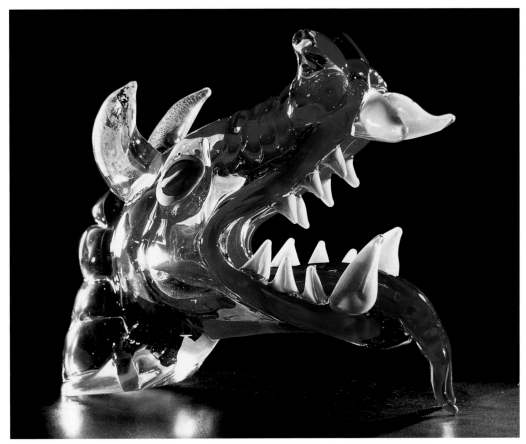

Serpent Head, 1996, solid glass, 12 x 8 x 6, made at Ars Murano.

Although this book is not a biography, I have drawn upon the artist's journals, letters, and published writings to give a voice to this American tale. The man whom the young Italian glassblower wanted for an adoptive father, comparing him to the actor James Stewart, had a magnetic personality. In lieu of a full biographical study, we fortunately have the written and videotaped legacy of this charismatic artist. He was also an English major as an undergraduate and a contributor to literary journals. Perhaps more than the utterances of other twentieth-century masters, his voice rings with a true authorial tone.

Robert Willson traveled from Oklahoma and Texas to Mexico and Florida, and then throughout Europe and the Mediterranean, all the while jotting notes and observations. Reading his words adjacent to the images of his remarkable art, the reader may begin to understand this outstanding artist and cultural figure.

1. *Robert Willson: Sculpture in Glass,* prod. Multi-Media Associates for the New Orleans Museum of Art, 1990, videocassette.
2. Pino Signoretto, interview with the author, Venice, March 9, 2001.
3. Robert Willson, *Texas, Venice and the Glass Sculpture Era—Notes* (San Antonio: Tejas Art Press, 1981), "Venice and Solid Glass Sculpture," unpaginated section.
4. Thomas McEvilley, "Doctor, Lawyer, Indian Chief: 'Primitivism in 20th-Century Art,'" *Artforum,* November 1984, pp. 54–61.
5. Serge Guilbaut, *How New York Stole the Idea of Modern Art: Abstract Expressionism, Freedom, and the Cold War* (Chicago: University of Chicago Press, 1983).
6. Paolo Rizzi, "The Color of Venice," in *A Story in Glass: Robert Willson* (Venice: Edizioni in Castello, 1984), p. 26.

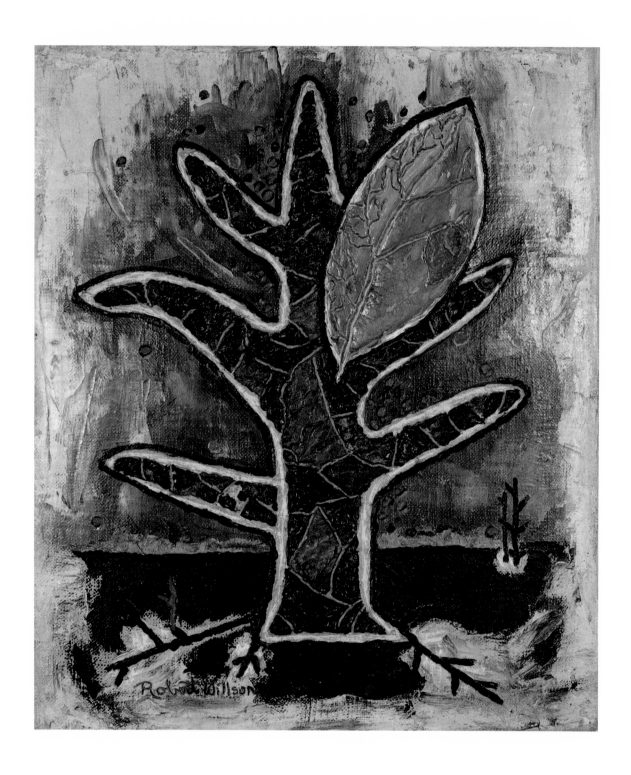

Sun and Shade: Formation of an Artist
Sol y sombro: Formación de un artista
1912–1952

I write this journal partly to keep clearly in mind some of the past times lest I forget
and to record the very fine and most interesting people I have known: these I will
not willingly lose. Also there is a vague hope that some descendant down the line,
perhaps an artist, or writer, may read this and feel some closer kinship. Somehow
I would like that.

—R.W., preface to *Texas, Venice and
the Glass Sculpture Era—Notes*, 1981

The words above, written when Robert Willson was sixty-nine, leapt from the page as I began
research in San Antonio for this book. They are the preface to a 300-page double-spaced type-
written document covering the years 1912 to 1981, recalled after the artist returned to San
Antonio upon retiring from a twenty-five-year teaching career at the University of Miami.
Throughout writing this study, I have felt I could be the person Willson meant, "a writer"
who, though not a genealogical descendant, still feels "some closer kinship." Willson's com-
ments on the places of his past—Mexico, Texas, Arkansas, Italy, and Florida—appear here as
subjective memories, observations clarified rather than blurred by the passage of time.

In addition to the manuscript, three leather-bound books of photographs, drawings,
sketches, and watercolors done between 1935 and 1948 reveal how the artist was formed. His
youthful creative odyssey can be traced through those artworks, incipient ideas that germi-
nated many years later as paintings and sculptures executed in glass. Willson's long appren-
ticeship as an artist eventually led to glass but also involved photography, painting, drawing,
and ceramics. He was seeking qualities he later found so attractive in glass: lucidity, trans-
parency, plasticity, bright color, and patterning.

When he arrived in Venice in 1956, Willson was still searching for his niche in American
art. He found it among the master glassblowers on Murano island in the Venice lagoon, 8,000
miles from the Texas and Mexico of his youth and early manhood. He arrived fully equipped
with memories and ideas from the great art he had viewed: Maya and Aztec art and murals
by people he had met, including Diego Maria Rivera (1886–1957), José Clemente Orozco
(1883– 1949), David Alfaro Siqueiros (1896–1974), and Pablo O'Higgins (1904–1983). Willson
absorbed an extraordinary mixture of regional American art of the 1930s and 1940s and the
humble yet brilliant productions of Mexican folk artists and artisans.

Willson was among the first non-native, non-Mexican Americans to assimilate and trans-
form examples of Native American and Mesoamerican art into his own hybrid. He responded

(left)
*The Rational
Tree*, 1948,
oil on board,
14 x 12. Location
unknown.

to the landscapes of pioneer Texas and Oklahoma in his watercolors and drawings, but he simplified and abstracted the imagery of rolling hills and dry deserts, partly influenced by his

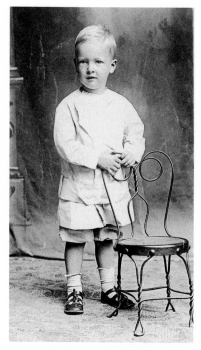

Robert Willson, c. 1915.

graduate study with Rufino Tamayo (1899–1991) at the University of Fine Arts in the town of San Miguel de Allende, Mexico. While searching for his way, he briefly corresponded with major figures a generation older, Alexander Archipenko, Grant Wood, Alexander Hogue, and John Steuart Curry. Thus, Willson is the perfect midcentury artist: at once representational *and* abstract, regional *and* international. His exposure to these influences offered him alternatives rather than forced choices. With the confidence of youth, he selected aspects from each figure he encountered, often recording exactly why he did so.

Robert Willson was born in Mertzon, Texas, on May 28, 1912, to James Thomas Wilson (1879–1953) and Birdie Alice Blanks (1883–1972). The Willsons (Robert's father dropped the second "l"; the son later restored it) can be traced to Scotland and Ireland as far back as 1608. The first recorded Robert Willson came to North Carolina with an Irish bride in about 1800. Several generations later, the family lived on their plantations in Alabama, sided with the Confederacy during the Civil War, and migrated to Texas in 1867.

Willson's father, James, began as a farmer and practiced as a certified public accountant before becoming, in midlife, a Methodist minister on a Choctaw reservation in Oklahoma. By the time of his retirement from the cloth in 1935, the family, which included another brother, John Human, and a sister, Thelma, who died in childhood, had settled at Spring Canyon Ranch in Handley, Texas.

Willson's childhood on the Choctaw reservation generated happy memories but also, perhaps, a clouded or romanticized identification with Native Americans. Over the years, in published and televised interviews, Willson claimed various percentages of Indian ancestry.[1] Indeed, his closest boyhood friend, Robert Dukes, was Choctaw. And yet, Willson's 1981 journal suggests this connection was wishful thinking. The link would have been on his mother's side: his maternal grandfather, Robert Alexander Blanks, according to the journal "always said he had Scotch, English and Indian blood." But in a 1903 lawsuit against the United States, the Blankses failed to establish Native American heritage, which would have granted them oil-drilling rights. Willson did claim that several Alabama ancestors married Choctaw women, but no documentation has been found.

Why then did Robert Willson continue to claim Native American heritage for the remainder of his life? His strong identification with American Indians perhaps came from a sense of indebtedness to his friend Bob Dukes (they shared horseback riding, survival skills, and camaraderie). But he also felt an affinity to Native American culture in general. The unencumbered simplicity and symbolically loaded character of Indian imagery appealed to the artist more than any other art he came in contact with. By adopting an Indian quasi-persona, Willson the artist began to "think" like an Indian: directly, pragmatically, and symbolically.

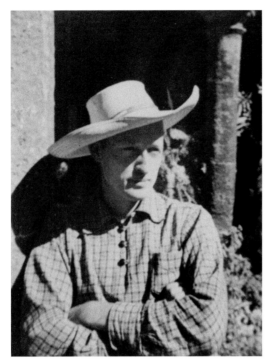
Robert Willson, San Miguel de Allende, Mexico, 1941.

Willson went so far in this unusual identification as to assume an Indian alter ego, "Oklo Yakni," complete with falsified biography.

Willson's interests in school and college were at first literary. After a year's study supported by a scholarship for ministers' sons at Southern Methodist University in Dallas (where he wrote and produced a one-act play and interviewed American novelist Theodore Dreiser), the nineteen-year-old transferred to the less expensive University of Texas at Austin. There he came into contact with a Southwest folklore historian and storyteller, English literature professor J. Frank Dobie, who instilled in Willson the love of a good yarn. After switching his major from geology to English, Willson graduated in 1934.

His first known artworks are a series of woodcut illustrations in the off-campus, student-generated literary magazine *The Calithump* ("a somewhat riotous parade accompanied by the blowing of tin horns and other discordant noises"). The editor's statement in the inaugural April 1934 issue encapsulated a political distrust of left and right that Willson would carry throughout his life:

> [*The Calithump*] does not believe in capitalism because its editors are broke. Running down the fingers on the left hand, it sees the socialists as too capitalistic and the communists as too bourgeois, the anarchists as too smelly, the fascisti as too noisy and the nudists as too strenuous.

Illustration for *The Calithump*, March 1934, block print on paper, 9¼ x 5¾.

Among the young authors published in *The Calithump* who later earned acclaim were novelists Peter DeVries, Nelson Algren, and Catherine Whitmar (Willson published her collected poems in his Tejas Art Press series fifty years later).

It was the following year, 1935, spent in Mexico on a Farmer International Foreign Exchange scholarship, that proved a turning point for the young illustrator. His proposed academic year in Mexico City at the National Autonomous University of Mexico was quickly supplanted by sojourns and adventures throughout the country as student strikes intermittently shut down classes.

Willson could not have arrived in Mexico City at a more exciting and dangerous time. His travels to the Maya ruins, the northeastern hill towns, the Pacific Coast, and market towns made him into an

Annalee Wentworth, Utopia, Texas, 1933, pencil on paper, 11 x 8.

The second trip to Tepoztlán, Mexico, October 27, 1934.

artist, and an observant and tolerant man. The black-and-white photographs taken that year, which he entitled *Sun and Shade,* document his presence in the midst of a turbulent revolution. The Institutional Revolutionary Party (P.R.I.) came to power when Lázaro Cardénas was elected president in 1934. His administration faced lingering conflicts between allies and opponents over the reforms of the 1920s and 1930s. In a fundamental change for Mexican society, a reformist government was being instituted for the benefit of peasants and workers. During 1935 alone, while Willson was there as a fresh-faced twenty-two-year-old, the government quadrupled land grants to peasants, attempted to close all private (religious) schools, created the Department of Indian Affairs to promote a policy of *indigenismo* focusing on the needs of natives, organized Chiapas coffee workers into a state-sponsored union, attained full control over the army, and handled 600 labor strikes. The Cardénas government's economic policy of "experimental developmentalism" sought to attract foreign investment. Unfortunately, the only regimes interested in participating were those of authoritarian and fascist countries, Germany and Italy.[2]

Willson never could have imagined that *The Calithump*'s editorial references to left- and right-wing extremists would materialize before his eyes in Mexico that year. His life in the capital was a study in contrasts. On the one hand, he enjoyed a leisured time, attending bullfights, playing tennis with wealthy American girls at a country club for foreigners, and dating

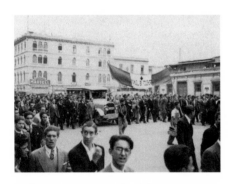

Student protest, Mexico City, July 12, 1935.

attractive young daughters of American businessmen. On the other hand, he was plunged into the political chaos of the day through his new friendships with American journalists, expatriates, and left-wing activists.

Willson attended and photographed a student protest on July 12, 1935. He also wrote of a riot on March 2 in which Mexican Gold Shirt fascists fought with Communists who were defending their newly legalized headquarters. The Nazi Party of Mexico, the Gold Shirts, and other fascists were in an uproar over President Cardénas's radical reforms and frequently took to the streets. Willson commented in his photo album:

> When the Communists tried to open their headquarters after a new law said they
> had the right . . . the Communists and Gold Shirts (fascists) fought in Santo
> Domingo Square. The police did not stop the Gold Shirts from beating up the
> Communists. Both sides were rank cowards.[3]

Forty-six years later, he recalled in his memoir:

> Because I came from a country based on a "law-abiding society," I was very inter-
> ested in the contrast in Mexico. . . . There was constant chaos, confusion and rebel-
> lion. Corruption, bribery and intimidation were the rule of the day.[4]

About the siege of the Communist headquarters he said:

> After the plaza was cleared, the Gold Shirts gathered in a group and marched down
> the street to . . . the new Communist headquarters. . . . The new red banners were

still hanging in front of the old stone building. . . . Then the Gold Shirts rushed the building and took it quite easily. They knocked out every window, threw all the furniture into the street and burned it; burned all the papers and records; tore down the signs and knocked the frames from around the windows. Finally, at what seemed a pre-arranged signal . . . policemen in groups marched up armed with rifles. The Gold Shirts had disappeared, leaving the bonfire burning.[5]

Because of the student strikes, university officials gave Willson an assignment to travel around Mexico, visiting historic archaeological sites and interviewing prominent artists and poets of the day. His insights and photographs form a fascinating record of Mexican intellectual and cultural life at the time.

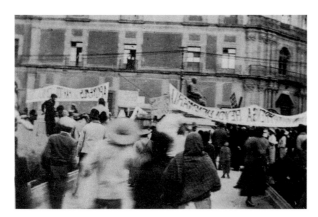

Mexican Communists and Gold Shirts rioting, Mexico City, March 2, 1935.

Another young man who would become an important figure in his nation's cultural life, Octavio Paz (1914–1998), was in Mexico City the same year. The memories of the Nobel Prize–winning poet and critic echo Willson's recollections. In the prose collection *Essays on Mexican Art*, Paz recalled that in 1934, "when General Lázaro Cardénas took over the presidency, the Communists regained their government posts and won others." He also noted that the decade from 1929 to 1939 was the strongest period of Mexican influence on American art. Both Paz and Willson observed the giants of the day, Rivera, Orozco, Siqueiros, and Frida Kahlo (1910–1954). Paz remembered in 1987:

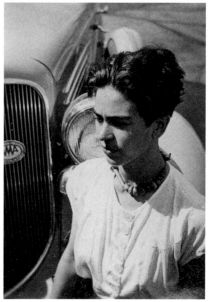

> In those years Rivera was painting the walls of the Palacio Nacional and I would see him high up on a scaffolding, dressed in a pair of ragged, paint-splattered overalls, armed with thick brushes and surrounded by pots of paint, helpers and amazed onlookers.[6]

Willson recalled in 1981:

> The first time I saw Diego Rivera was while he was on a scaffolding painting his important fresco, a history of Mexico, in the National Palace. It was a quiet day, nobody was coming along to look, and we talked slowly about the mural and the United States. Diego was bored, and said, "Look, you paint this last space. It's all right, you can come up here." So I painted a square foot of the mural on the stairway wall. Diego shrugged and did not destroy it. "Good enough," he said.[7]

Frida Kahlo, Mexico City, January 1935.

Kahlo was there that day. Willson had befriended Ruth Ageloff, an American Communist whose sister, Sylvia, was secretary to Leon Trotsky (1879–1940), the exiled Bolshevik leader taken in by the Riveras. Willson visited the artists in their home in Coyoacán and commented on Kahlo's work:

[Kahlo] painted an odyssey of woman's pain. Despite her cultural sophistication, the style of her work was purposefully primitive, often mimicking the peasant retablos seen in churches. And the subject matter was rarely pretty. Yet certainly she was one of the strongest artistic talents in Mexico. I wish I had known her better but somehow I rarely saw her and the presence of Leon Trotsky in the Rivera home made visiting delicate.[8]

Later, when Trotsky moved to another house for a prolonged stay, it was Sylvia's Cuban boyfriend, Ramon Mercader, who assassinated Trotsky on behalf of Stalin in 1940.[9]

Discussing the Mexican mural movement in his memoir, Willson recalled how Siqueiros claimed to have inspired the entire Mexican mural project with a call to artists. In a 1919 journal published in Spain, *Vida Americana*, Siqueiros urged them to return to their home countries and "paint their own people."[10] Whether at his behest or not, the union of painters, sculptors, and technical workers was founded, and its project was begun in 1923, a full decade before Roosevelt's Works Progress Administration and Federal Artists Project.

By 1935 Orozco's and Siqueiros's most important paintings in the National Preparatory Academy (where Paz had attended high school) were completed. Siqueiros's affiliation with the Mexican Communist Party was known to Willson, although his key role in an unsuccessful attempt to assassinate Trotsky in 1939 was not common knowledge. Willson was more interested in the seeming contradictions in the former member of the Mexican party's central committee:

Ruth Ageloff, Mexico City, 1935.

> David worked rapidly whenever he took time to work but his art was not of the "revolutionary" character, whatever that was, that he talked about. His canvases were dark, the subjects quiet, and the techniques such as lacquer and spray painting too self-conscious to mean anything. Yet there was a strength and power evident in the way he drew and colored. If only he had been more an artist and less an actor.[11]

In contrast, Willson enthusiastically praised Orozco. He believed Orozco was "the real rebel in the group, refusing to swallow either European Communism or dead art cycles of the ancient Indians." According to Willson, Orozco criticized Siqueiros's and Rivera's Communism, recalling, "And they called me an anarchist! But what there was then was a chance to paint." Both Orozco's theories and art "represented honesty, fairness and respect for the

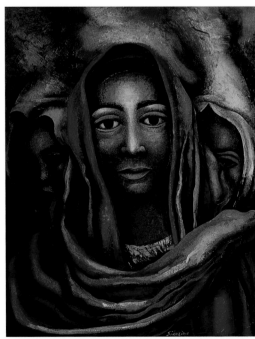
David Alfaro Siqueiros, *The Landlady (La Patrona)*, 1939, oil on board, 30 x 24½. Courtesy of Marshall and Helen Hatch collection, Seattle. ©2001/Licensed by VAGA, New York.

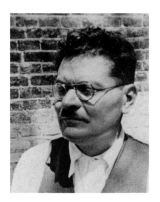

José Clemente Orozco, Mexico
City, 1935.

quality of man." In a compelling, if cynical, critique of both the Mexican mural movement and the American National Recovery Act (N.R.A.), Orozco told Willson: "Social art and commercial art, where is the difference? . . . We are told to paint Communism and you are told to paint nice things about the N.R.A. but who thinks any of it is art?"[12]

Observing all these leftist artists ("I knew every artist working in the city"), Willson had a startling revelation, recalled in hindsight:

One thing about Mexican art became clear to me. The ancient Mexican Indians had one of the world's greatest arts, full of force and meaning. Revolutionary Mexico looked back to the Indian for inspiration but never quite reached the same brilliance.[13]

In addition to following the careers of the muralists, Willson became an avid fan of bullfighting. He befriended several celebrated toreadors whom he photographed in public and private moments. For an artist who later concentrated almost exclusively on the female figure, the photographs and drawings of the matadors and peasant men in 1935 remained his most sustained study of the macho male figure.

As historians have pointed out:

Bullfighting was banned in the national capital at various times. . . . Nevertheless, many people rejected claims that bullfighting was a barbaric act of cruelty to animals, claiming it represented an artistic spectacle of life, danger and ultimate death.[14]

Willson was one of those who viewed bullfighting as artistic spectacle. Although the detailed description of his first bullfight reads a bit like a college newspaper, it communicates an on-the-spot enthusiasm, boosted by his friend Lou Stephens, who had "tried amateur work with young bulls and knew some of the bullfighters."[15] Willson attended this first bullfight on February 10, 1935. His excitement at the time, and the later account, were strongly influenced by Ernest Hemingway, whose *Death in the Afternoon* had appeared in 1932. Willson's reminiscence of his visit to the matador Armillita (Fermin Espinosa) is simple and direct in tone:

On that Sunday he slept until eleven, then took only a milk-and-egg drink and rested until time to dress, when we were there. It was March 3, the day of the great fight—so we were not bad luck. We were cautioned not to touch any of his clothes laid out on a chair because he had a superstition about that. White flannel underwear, much lacing of the tight trouser legs, pink string tie to match the pink stockings, stiff white shirt front, elaborate vest, slippers, traditional knot or pigtail pinned to the hair. The rich coat came last. And all to be worn only once. . . . It was time for him to rest a while. We wished him everything good and made a mad rush to get to the bullfight.[16]

Willson traveled an extraordinary amount that year. It was one thing to meet, interview, and even paint with so many of the nation's artists, but his extensive exposure to ancient Olmec, Toltec, and Maya ruins affected him for life. Monterrey, Veracruz, Tepoztlán, Oaxaca, Taxco, Teotihuacán, Yucatán, Patzcuaro, and Guadalajara: he visited, photographed, sketched, and painted aspects of all these cities and towns.

Willson regretted the "Spanish contribution" to Mexican indigenous art and yearned to visit the remaining original sites of past civilizations. He witnessed re-creations of Indian

(left) Bullfighter Lorenzo Garza, Mexico, February 1935.

(below) Bullfight, Mexico City, March 3, 1935.

(right) Armillita dressing before bullfight, Mexico City, Sunday morning, March 3, 1935.

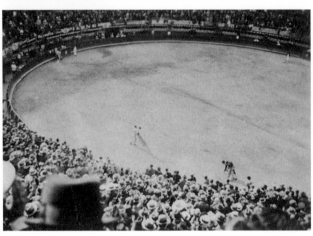

dances: the Plume Dance in Oaxaca, the Dance of the Old Men on Janitzio Island, and those of the Shell Men in Chalma, the Jarana in Yucatán, and Los Tlacololeros in Guerrero were all performed during his visits. From the artist's accounts and striking black-and-white photographs, it appears the village dance festivals were far different from those reenacted today for tourists. Some were even performed on the ruins, as at Teotihuacán, a Maya pyramid site.

The image of dance groups became an important part of Willson's later art, underscored by his interest in becoming a dancer himself. Willson contacted pioneer choreographer Ted Shawn in 1934 to inquire about joining his Ensemble of Men Dancers. Willson's letter is lost, but Shawn's reply suggests that the University of Texas graduate may also have been planning a magazine article or book on dance illustrated by his own woodcuts. In words that would ring true to Willson for many years, the choreographer wrote from Lee, Massachusetts:

> Movement, only, is expressive. Pose is expressive only as it suggests the preceding movement which produced it. . . . I hope by next summer to be able to have . . . a printing press at the farm all summer. Perhaps then, we could . . . do the book together.[17]

What was it about ancient Maya art that so moved Willson? In later published interviews and television spots, he alluded to "simplified symbolic language," or visual imagery that contained cultural and philosophical references beyond its immediate status as communicating sign. Paz put it this way:

> Mayan art astonishes me in two ways. In the first place is its realism . . . the images it presents us can be read. They are not illustrations for a text: they are the text. . . . Contrary to those of modern art, they are not merely images; they are image-signs. . . . The other way that Mayan art amazes me lies in its transformation of a literal realism into an object that is metaphor, a palpable symbol. Image-signs . . . become

altogether one with the forms that express them and even with the material itself.[18]

Something like this equation—image equals sign equals object equals material—is exactly what describes Willson's mature art, the glass sculptures.

Other aspects of Maya art find equivalents in Willson's art. For example, the hieroglyphic writing has a parallel in Willson's

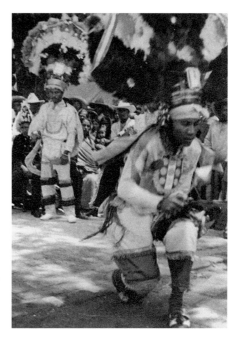

Ceremonial dance, San Juan Teotihuacán, 1935. Robert Willson noted in his journal: "Plume dance: Manuel Urias again. He would be good on a professional stage because of his endurance and agility."

Pyramids of San Juan Teotihuacán, October 20, 1935.

figurative surface decoration; the Maya pantheon of more than 166 animals and human deities suggests Willson's Texas-style menagerie (horses, coyotes, mustangs, snakes, birds, armadillos, buffalo); the multi-tiered heaven and underworld eschatology of the Maya found its way into Willson's landscape watercolors and striated glass spheres. Even Maya colors had symbolic properties; red, white, black, and yellow, for example, represented, respectively, east, north, west, and south.[19] Color in Willson's work is always separate, never blended, all the better perhaps to commandeer it for symbolic purposes.

In his 1980 introduction to an Aztec poem translated by the prominent linguist John H. Cornyn, Willson expressed an unusually pessimistic assessment of the fate of the Aztecs:

> All that the cultured world can do now is mourn the destroyed beauty, the lost chance for another view of life (surely no worse than modern man's). . . . One of the greatest of all human catastrophes was the rediscovery of America by Europe.[20]

The Ancient Song of Quetzalcoatl, translated by Cornyn in 1930, must have had a tremendous impact on Willson as a young man; at the age of seventy-eight, he reprinted it with his own illustrations in a plain offset edition. A sequence of poems from the Aztec (Nahuatl) language is joined by fourteen other ancient poems drawn from various anthologies. All capture the wistful, fatalistic resignation that may have appealed to Willson. Some are dark mixtures of sadness and celebration:

> Somewhere else is the place of life.
> There I want to go,
> there surely will I sing
> with the most beautiful birds.
> There I will have genuine flowers . . .
> the only ones that give peace to man,
> that intoxicate him with joy.[21]

Performer at reconstruction of Toltec ceremonies, San Juan Teotihuacán, October 20, 1935.

On top of a partially uncovered mound, Chichén Itzá, Mexico, August 25, 1935.

Palace of Nuns, Chichén Itzá, Mexico, August 25, 1935.

Palace of Nuns, Chichén Itzá, Mexico, August 25, 1935.

Temple of Warriors, Chichén Itzá, Mexico, August 25, 1935.

Others suggest a form of immortality that comes close to the enduring nature of art—and the constructed object:

> My flowers will not come to an end.
> My songs will not come to an end.
> I, the singer, raise them up;
> They are scattered; they are bestowed.[22]

Long after the bullfights and the "intoxicating joy" of Mexican culture past and present, the artist recalled:

The year was my first direct contact with working artists on a professional level. Perhaps it set clearly for me the tendency toward art I already had. And the year evoked my love of archaeology by feeding it with the actual ruins, artifacts and remains of pre-conquest peoples of America, reinforced by meeting so many of the direct descendants of those ancient Americans. It was important guidance for me.[23]

Back in Texas in late 1935, Willson briefly taught art in Harlingen, where he met Virginia Lambert, the school nurse. After a brief courtship, they married (the marriage ended in 1977), and Willson joined the New Deal make-work project, the Civilian Conservation Corps (C.C.C.). Together they traveled with the C.C.C., Willson acting as "civilian educational adviser." The experience spurred him on to seek a higher degree, which would enable him to teach at a university level. Common today, master of fine arts degrees were not widespread in American universities in 1935.

Robert and Virginia Willson, 1942.

Before he decided to enroll in a program at the University of Fine Arts in San Miguel de Allende, Willson contacted several prominent regional artists of the day, inquiring about a possible future career. Writing from the University of Wisconsin in 1940, John Steuart Curry (1897–1946) was "not certain what the university can do for you. If they can help you out here, you may be sure I shall be glad to give you what advice I can."[24] A few weeks later, Grant Wood (1892–1942) of *American Gothic* fame, was more encouraging: "I believe we have what you want here at the University of Iowa. You can obtain the degree of Master of Arts with less academic requirements than in any other institution I know of."[25]

Before Willson could apply to the University of Iowa for the following academic year, Wood died. Willson returned that year to San Miguel de Allende where, after another period of study, this time with Tamayo, he received the M.F.A. in September from the state-accredited University of Fine Arts.[26]

Rufino Tamayo was a far more cosmopolitan figure than Rivera or Orozco. Although Willson later complained frequently about the plight of a college art instructor, Tamayo's example proved telling. When Tamayo's art did not sell during the 1930s, he took up teaching because "with it, I did not have to sell. . . . I could just keep on painting and put the paintings in a corner."[27] Commenting on the audience for modern art, Tamayo made a prophetic remark to the young American: "There is a point at which the producer and the spectator meet. The meeting point must be related to nature, and the figure is part of that."[28]

Willson admired and learned from Tamayo, who was educated at the San Carlos Academy of Art, where Willson had briefly enrolled in life drawing classes when the University of Mexico was on strike. As a Zapotec Indian, Tamayo offered Willson an intellectual and artistic riposte to his former muralist mentors, preferring instead folk art traditions of the Mexican Indians. He told Willson, "The first time I saw pre-Columbian art, I knew it would be my source."[29] And on his first trip to Europe in 1949, Tamayo encountered the work of Pablo Picasso.

The Ranch Needs Sun, 1987, watercolor and mixed media, 32 x 43.

World War II changed Willson's life. Between July 6, 1942, and August 16, 1944, he trained as an officer and served in the U.S. Marine Corps. He remained in the Reserve Corps until August 27, 1948. His tour of duty took him to the Pacific theater, including Guadalcanal Island, New Zealand, the Russell Islands, Bougainville Island, and Green Island. Attaining the rank of captain, he served with distinction. Because of his training as a visual artist, Willson became an expert in military reconnaissance photographic analysis and interpretation.

Even during this difficult period, Willson's sensitivity to indigenous art came into play in the Russell Islands:

One day I saw a native carrying a small carved bird, a simple work in wood, seemingly symbolical, representing a bird in flight. The conception was as direct and original as any sculpture I have ever seen. I could not buy it at any price, so I supposed it had some mystical value.[30]

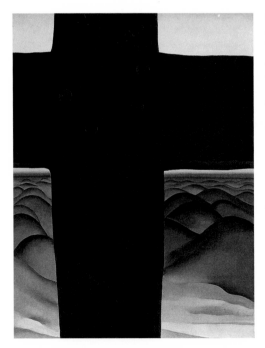

Georgia O'Keeffe, *Black Cross, New Mexico*, 1929, oil on canvas, 39 x 30. The Art Institute of Chicago, 1943.95. ©2001, Artists Rights Society.

With the conclusion of the war, Willson returned to teaching (this time at Trinity University in San Antonio); he now had a wife and family to support. His son, Mark Joseph, was born on November 27, 1945. It was a time of uncertainty and exploration. Perhaps seeking to take advantage of the G.I.

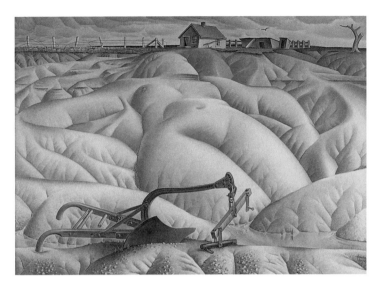

Alexander Hogue, *Erosion No. 2: Mother Earth Laid Bare*, 1936, oil on canvas,
40 x 56. Philbrook Museum of Art, Tulsa, Oklahoma, museum purchase, 1946.4.
©2001 Estate of Alexander Hogue.

Desert Song, Yuma, Arizona, 1940, oil and pasted lacquer, 18 x 24. Location unknown.

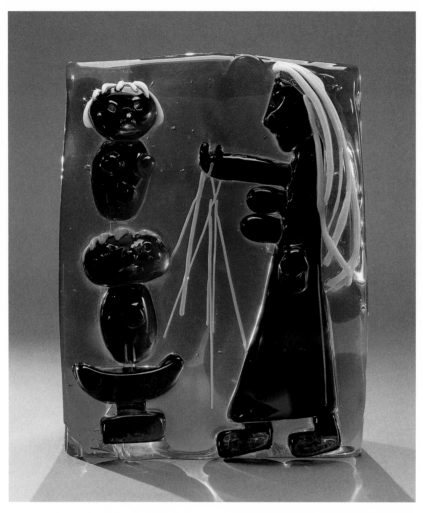

Etruscan Altar, c. 1972, solid glass, 15¹⁄₈ x 11¹⁄₄ x 3. New Orleans Museum of Art, 89.138.9.

Rufino Tamayo, *Tormented (Atormentado)*, 1948, oil on canvas, 39¹⁄₂ x 29. Courtesy of Marshall and Helen Hatch collection, Seattle.

Alexander Hogue, *Cap Rock Ranch*, 1945, lithograph, 11 ½ x 16 in. Philbrook Museum of Art, Tulsa, Oklahoma, bequest of Mrs. James H. Gardner, 1976.5.17.

Bill, he wrote to regionalist painter and University of Tulsa professor of art Alexander Hogue (1898–1994), who, after referring Willson to a recent Ph.D. graduate in art of the University of Iowa, told him:

> Frankly, I don't see why you want such a degree. Paint like hell and send everywhere but don't be discouraged by rejections. Finally, acceptances will overbalance rejections and . . . your place in education will be secured by your reputation as an artist.[31]

Mark Joseph Willson with stoneware bottles made at Nob Hill Pottery, Mountainburg, Arkansas, c. 1949.

Disenchanted with teaching unmotivated students after the life-and-death excitement of battle, Willson conceived of an alternative: cut the overhead, move to the country, and become a potter. He had met ceramics artist Harding Black while teaching at Trinity. Working with Black, he evolved both pots and figurative sculptures, one of which (*Savage Attitude*, 1947) was included in the prestigious exhibition *Twelfth Ceramic National,* at the Everson Museum of Art in Syracuse, New York. Still in thrall to pre-Columbian ceramics, the war veteran settled down to creating pots and sculptures. It did not hurt that Willson qualified for a small business loan

available to veterans. The Willsons decided to start the Nob Hill Pottery studio and sales gallery in Mountainburg, Arkansas, where they had moved in 1948.

At this time, the Appalachians and Ozarks were rich in ceramic and weaving traditions. The Penland School of Handicrafts in western North Carolina had been founded in 1929 by Lucy Morgan (1923–1962). The school taught ceramics and weaving skills as a means of supplementing family incomes when mining and farming proved inadequate.[32] (Willson spent part of the summer of 1953 there making pots.)

Willson became enthusiastic about handcrafts made by people of his ancestry: American descendants of Anglo-Saxon and European stock who, like his father's family, had moved to the South beginning in the eighteenth century. He loved their tales, folk remedies, genuine friendliness, and creative resourcefulness. Together with pioneer modernist jeweler Elsie Freund (1912–2001), who summered with her husband, Louis, in nearby Eureka Springs, the Willsons established the Ozark Council of Artists and Craftsmen.

During the same period, Willson published his most important statement as an artist, "The Experimental Attitude in Art," a personal and political manifesto that articulates his aesthetic beliefs far more clearly than had earlier statements. Subtitled "A Declaration of Ideas," the essay appeared in the November 1948 issue of *Motive* and begins with an evocative "Definition":

> The bird sings on a top limb; the wolf howls at the moon; the mustang runs and kicks into the air; the leopard plays with a leaf. Man watches a setting sun, touches a beloved face, is receptive to a painting, picks up a stone carving, sings, dances, worships. These are happenings which enrich life. They build up soul and character in a man so that he is able to enjoy life and meet death unafraid.[33]

This is as close as Willson ever came to writing an artistic credo. Divided into four short sections—"Definition," "Levels," "Personal Philosophy," and "Art and the Future"—"The Experimental Attitude in Art" is a midcentury testament and a challenge to others. The artist, an older and wiser thirty-six, outlined three "levels" of art production—illustrative, emotional, instinctive—stressing again the need to go back to "primitive urges" for inspiration. He is also at his most idealistic, hopeful, and freedom loving as he discusses art: "Creative art is anti to authority, control, organization or repetition of the work. It thrives only in a democratic or free society."[34]

On the surface, with the move to the Ozarks, Willson appeared to retreat from the politics and grueling, unsatisfying work of college teaching in a move toward entrepreneurial craft production, but he could not stay away from academia for long. Within a few months, he was helping art department chair David Durst set up the first ceramics program at the University of Arkansas in Fayetteville. It was probably this experience, coupled with worsening economic fortunes in rural Arkansas, that led Willson in 1952 to seek a stable teaching job. His position at the University of Miami would last until his retirement in 1977.

Like many young families in the 1950s, the Willsons had to balance youthful desires for freedom and independence with pressures to conform to the current version of the American Dream: work, spend, build a family, and don't rock the boat. If, in taking the position in Coral Gables (derisively called "Suntan U."), Willson felt temporarily defeated, delayed again

The Baleful Bunny, 1949, oil on canvas. Location unknown.

from working full-time as an artist, within a year or two he would discover that a university affiliation provided the perfect base for expanding his creative life, in spite of the teaching load. In fact, it was the University of Miami that brought out the true artist in Robert Willson. His position there stimulated his growing enthusiasm for glass and allowed him summers and sabbaticals to travel to Europe for the first of many times. It prodded him into becoming an art museum curator, leading to two historically important survey exhibitions. And finally, it gave him needed financial stability to raise a family and devise additional ways to underwrite his glass sculptures.

In the fall of 1952, when Willson began teaching in Miami, Venice was but an idea, a postcard, an illustrated chapter in an art history book. Within four years, it would be a dream come true.

1. Carol Barnes, "Willson Edits Poetry, with a Touch of 'Glass'," *North San Antonio Times*, July 1, 1982, p. 3; *Glass Sculpture by Robert Willson,* prod. Audio and Video Productions of Venice, 26 min., 1984, videocassette.
2. Friedrich E. Schuler, "Mexico and the Outside World," in Michael C. Meyer and William H. Beezley, eds., *The Oxford History of Mexico* (New York: Oxford University Press, 2000), p. 521.
3. Robert Willson, *Sun and Shade: Photos in Mexico, 1935* (Mexico City: Willson Press, 1935), p. 21.
4. Robert Willson, *Texas, Venice and the Glass Sculpture Era—Notes* (San Antonio: Tejas Art Press, 1981), p. 45.
5. Ibid., p. 49.
6. Octavio Paz, *Essays on Mexican Art* (New York: Harcourt Brace, 1987), p. 17.
7. Willson, *Texas, Venice*, p. 122.
8. Ibid., p. 124.
9. Pavel Sudoplatov and Anatoli Sudoplatov, *Special Tasks: The Memoirs of an Unwanted Witness— A Soviet Spymaster* (Boston: Little, Brown, 1994), p. 73.
10. Willson, *Texas, Venice*, p. 120.
11. Ibid.
12. Ibid., p. 110.
13. Ibid., p. 107. In 1934–35, Willson interviewed many other artists and writers, including Mardonio Magana, Francisco Goitia, Roberto Montenegro, Maria Izquierdo, Carlos Mérida, Luis Hidalgo, Roberto de la Selva, Valentin Vidaurreta, Carlos Orozco Romero, Raul Anguiano, Antonio Pujol, Miguel Machado, Carlos Bracho, Luis Monasterio, Guillermo Castano, Romulo Rozo, and the Americans Pablo O'Higgins, Marion Greenwood, Grace Greenwood, and Douglas Brown.
14. Robert M. Buffington and William E. French, "The Culture of Modernity," in Meyer and Beezley, *Oxford History,* p. 430.
15. Willson, *Texas, Venice*, p. 151.
16. Ibid.
17. Ted Shawn, letter to Robert Willson, June 9, 1934.
18. Paz, *Essays*, pp. 76–77.
19. Michael D. Coe, *The Maya* (New York: Praeger, 1966), p. 148.
20. Robert Willson, "Introduction," in John H. Cornyn, trans., *The Ancient Song of Quetzalcoatl* (San Antonio: Tejas Art Press, 1980), pp. 12–13.
21. Excerpt from the poem "Here on Earth Is Not the Answer," in Miguel Leon-Portilla, trans., *Pre-Columbian Literature of Mexico* (Norman: University of Oklahoma Press, 1969). Reprinted in Cornyn, *The Ancient Song*, p. 91.
22. Ibid., p. 93.
23. Willson, *Texas, Venice*, p. 164.
24. John Steuart Curry, letter to Robert Willson, January 4, 1940.
25. Grant Wood, letter to Robert Willson, January 27, 1940.

26. Course credits from Willson's prior study year, 1934–35, must have been transferred toward the degree.

27. Willson, *Texas, Venice*, p. 117.

28. Ibid., p. 118.

29. Ibid., p. 117.

30. Ibid, unpaginated.

31. Alexander Hogue, letter to Robert Willson, June 8, 1946.

32. Lucy Morgan and LeGette Blythe, *Gift from the Hills* (1958; reprint, Chapel Hill, N.C.: University of North Carolina Press, 1971).

33. Robert Willson, "The Experimental Attitude in Art," *Motive*, November 1948, pp. 17–19.

34. Ibid., p. 19.

Years of Discovery
Años de descubrimiento
1953–1968

Despite the real importance of glass in every phase of our life today, the surface
has not been scratched. . . . Today is not the age of glass, but tomorrow is.

—R.W., *Glass for the Artist*, 1958

Robert Willson later professed to dislike university teaching ("I tended to give all my support
to the bright students who wanted to work and learn and to neglect the rest"), and he eventu-
ally claimed to dislike living in Florida ("Somehow I never liked Miami. . . . It became boring
in looks, climate and people"). But in fact becoming a professor of art
offered more than economic stability to a forty-year-old man with a
family. We tend to forget what an indispensable position American
institutions of higher learning attained in the development of contem-

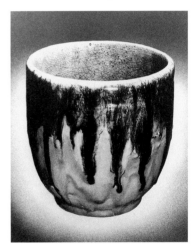

Ceramic bowl, c. 1948, glazed stone-
ware, 5 h., made at Nob Hill Pottery,
Mountainburg, Arkansas. Location
unknown.

porary artists in the postwar
period. Willson was typically
understated when he remem-
bered that "to me the biggest
reward for teaching at the uni-
versity was the library."[1]

As we examine Willson's
first decade and a half of teach-
ing at Coral Gables, we see
him maturing as an intellectual
and a pedagogue, sometimes at
a faster rate than as an artist.
As one example, his friendship
with C. Clay Aldridge, director

Havilena Hog, c. 1955, unglazed ceramic, 7¹/₂ x 14¹/₂ x 4. New
Orleans Museum of Art, gift of Harding Black, 91.178.

of the university museum, the Lowe Art Museum, led to a highly
important piece of Cold War cultural programming, *3500 Years of
Colombian Art: 1534 B.C.–1960 A.D.,* which opened March 12, 1960. At
the time, it was the most extensive such survey seen in an American
university museum. Willson conceived the idea, found funding, and
selected each object personally over the course of three extended visits
to Colombia in 1959 and 1960.

In addition, these years saw Willson's successful application to the
U.S. Department of Health, Education, and Welfare (H.E.W.) for a
grant outlining a higher education curriculum plan for the teaching of

(left)
Footed bowl
with *latticino*
decoration,
c. 1959, solid
glass, 12 diam.,
made at Fratelli
Toso, Venice.

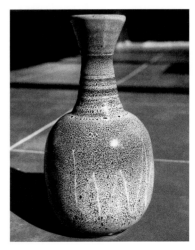

Vase, c. 1951, glazed stoneware, 8 h.
Location unknown.

Corning Glass Works, Corning, New York, April 1956.

glass as an art form.[2] While teaching ceramics, design, and art history, and comanaging all the ceramics technical facilities, Willson also received from the Corning Glass Corporation of Corning, New York, a generous travel study grant that allowed him in 1956 to go to Venice for the first time. The grant permitted him to tour Europe, visit historic glassmaking sites, and see significant art collections both private and public. The H.E.W. grant led, in turn, to a limited-edition offset-printed textbook compiled with his students, *Glass for the Artist, Suggestions for the Use of Glass as a Material for Fine Arts.*[3]

The young witness of the Mexican Revolution had become a serious teacher, an international cultural diplomat, a grant writer, and an artist interested in furthering friendly relations between the United States, Latin America, and, soon, Italy. The president of Colombia, Alberto Lleras, wrote Willson a month after attending the opening of the Colombian art exhibition in Coral Gables, "I want you to know I am also well aware that the success attained was to a large extent due to your own initiative and personal efforts."[4]

Before examining Willson's quiet debut as an artist on the international scene, it is important to note how, upon his arrival in Miami, he remained committed to pottery and ceramic sculpture. At the time, this inclination made sense. In keeping with his love for pre-Columbian art, he viewed clay as a talismanic material, out of which some of the greatest masterpieces of medieval American art had been fashioned. His throwing, glaze explorations, and surface decorations are all of a piece with other American pottery of the period—well made, better designed than usual, but part of a movement still struggling for acceptance: modern American studio pottery.

With the rise of magazines like *Ceramics Monthly* and *Craft Horizons,* more advanced ideas became accessible, modernism was disseminated, and artists became more aware of one another. In 1955, for example, we find Willson corresponding with leading postwar ceramist Peter Voulkos, teaching at what was then the Los Angeles County Art Institute (later Otis Art Institute), who remembered Willson's prior visit to the pathbreaking artists' colony Black Mountain College, near Asheville, North Carolina. Voulkos's response is typical of the camaraderie among ceramics teachers of the day, even those who met only briefly:

> If I remember correctly, I was supposed to send you some slides. I'm sorry I won't be
> in the east this coming summer. So far I have been planning on going back to the
> Archie Bray Foundation, Helena, Montana, for the summer to get some production
> done. . . . I certainly wish that I could be of help to you and if there is anything we
> could do through the mail, just let me know.[5]

Building on his memories of ritual effigies in Maya art, Willson made *God and Goddess of War* (1957), which was awarded a merit prize at the San Francisco Museum of Modern Art's competitive annual show of painting and sculpture that year. Dark and brooding, with

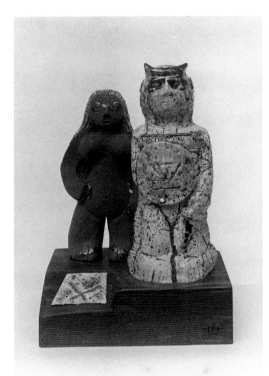

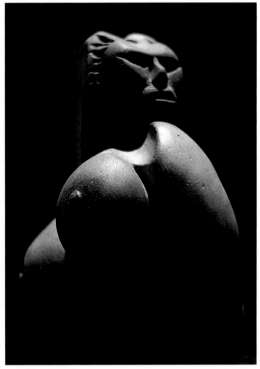

God and Goddess of War, 1957, ceramic with wooden base, 17 h. Location unknown.

Ceramic Sculpture, 1958, unglazed ceramic, 9 h. Location unknown.

gleaming eyes, the pair of figures resembles charred remains, as if found in the rubble of a nuclear-bomb blast site. *Ceramic Sculpture* (1958), a large-breasted, somewhat more realistic, unglazed brown female bust, seems more prophetic of the many later buxom female nudes in glass. It was also the subject of an unusual series of black-and-white and color photographs.

Throughout the late 1950s, Willson experimented in other media including cast cement, cast aluminum, and a mixture of metal, clay, and colored or stained glass (it was his earliest use of this material). In 1962 he published "Creating Sculpture for Buildings" in *Florida Architect,* arguing that architects should let artists produce sculpture when money becomes available for new buildings. In the article, he calls for art in new "public and private buildings" that are "largely barren of art, substituting instead textural walls, raw materials themselves and structural features."[6] Willson's solution for art in public places is startling: "Major sculpture will not return to our buildings except through some method of sand-cast cement creations."[7]

A few years later, after his own efforts at sand-cast cement sculpture had resulted in only one large commission, *Palmetto Panther* (1966), for his son's school, Willson wrote again for *Florida Architect,* this time much more cynically and acerbically: "It seems to be the consensus of critical opinion that there is little significant relationship between art and architecture at present." He attacks International Style architect Ludwig Mies van der Rohe (1886–1969), who, in Willson's words, "said that modern architectural design is too complicated to permit the architect even to try to take care of the other arts. . . . How precisely wrong he was!" After dashing off a history of successful architect-artist collaborations, he offers a defense of "quality," along with three other "solutions: authentic purpose, presentation architecture," and the "museum." In a stern warning, Willson wrote (ten to twenty years before the 1 percent for art

Palmetto Panther, 1966, cast cement, 24 x 48 x 12, made with Mark Joseph Willson. Palmetto High School, Miami.

movement): "Make no mistake about it, no building of cultural value will be built without art, however you plan it. You cannot make distinction out of nothing and still give us reason to return again and again to the temple."[8]

Willson's restless imagination—which led him to the glass-art elite of Venice during these years—was accompanied by the recognition that with his experience in Latin American culture, he had much to offer the university besides teaching. He also might have required successively larger challenges in order to stay happy and intellectually satisfied. The Colombian exhibit of 1960 is a good example. Once Willson obtained Aldridge's permission to proceed, along with that of university president Jay F. W. Pearson, he was free to approach International Petroleum Co., Ltd., the Colombian arm of Esso. While U.S. government officials assisted and endorsed Willson's subsequent scouting and object-selection trips to Bogotá, Barranquilla, Cartagena, Cali, and Medellín, the bulk of the work was his own doing. As he recorded in 1981, "I donated every spare minute of my time for one year to the project."[9] Comprising 391 objects, including 49 pieces of gold, more than 100 ceramics, 56 twentieth-century paintings and sculptures, as well as textiles and silver, *3500 Years of Colombian Art: 1534 B.C–1960 A.D.* also contained masterpieces of Spanish Colonial art, most of which was being seen in the United States for the first time.

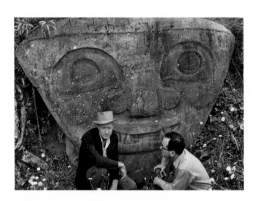

Robert Willson and Enrique Grau, San Agustín, Colombia, March 1, 1960.

The impact of visiting the ruins at San Agustín in Popoyán reinforced the sense of mystery and monumental figuration Willson sought in his own art. He recalled, "Not much if anything is known of by who[m] or when these works were done. Are they the first artworks

in the Americas?"[10] One can palpably sense the artist's excitement, so close to the origins of the art he revered most, as he was at Popoyán. The formative experience of meeting with leading archaeologists, museum directors, and artists of Colombia trained him to negotiate with foreigners for a mutually desired goal, in this case, the priceless loans. Perhaps equally important were his opportunities to observe "all the local colonial and Indian dances" performed expressly for him at a weekend party in his and painter Enrique Grau's honor at the house of Senator Horacio Rodriguez Plata. Willson's love of dance would never desert him, nor his conviction that it was a sacred and sensual behavior.

Among the twenty living artists whom Willson and Grau visited and selected work from, members of the prewar "Pioneer" generation included Pedro Nel Gomez (1899–1984), the most eminent Colombian muralist, and Ignacio Gomez Jaramillo. Willson's response to the work of one artist who would later become famous was insightful: "Typical works [of Fernando Botero] have monumental figures, balloon-like in shape, folklore in derivation. . . . Not impressive to me, but [I] think he will become popular with the art circles." Because Willson's further goals of a 1,000-slide library, an annual exchange scholarship, and a full-color catalogue to accompany the exhibit were scotched by Esso, he noted, "It was some pleasure, later, to see that Esso had its troubles in Colombia. Greed will be repaid with greed, someone has said, I am sure."[11]

His 1956 meeting with Steuben Glass designer Frederick Carder (1863–1963) at Corning was a pivotal event.[12] Willson remembered Carder handing him a piece of ancient glass to touch: "It must have been contaminated because I have been obsessed with glass ever since."[13] Carder at ninety-three was a living relic, having invented Steuben's goldish Aurene ware, popular throughout the 1910s and 1920s, and subsequently surviving dismissal by Arthur A. Houghton, Jr. The Corning heir and new owner of Steuben not only switched the company to clear crystal glass in 1933 but, according to legend, smashed with his cane much of Carder's remaining colored inventory.

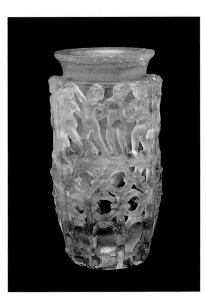

Frederick Carder, *Green, Blue, and White Diatreta Vase*, 1952, lost-wax-cast lead glass, 8³/₄ h. Rockwell Museum of Western Art, Corning, New York.

Willson's meeting with Carder is not recorded, and few contemporary records or letters remain. Nonetheless, it is clear that Carder symbolized for Willson a successful factory-based glass artist, one who could design and execute art glass in the only way possible at that time, in an industrial setting. It would not be until 1962 at the Toledo Museum of Art in Ohio that glass with a lower melting temperature would be invented by Libbey Glass Company chemist Dominick Labino (1910–1987). Along with Harvey Littleton, the participants in the Toledo workshops were present at the dawn of the studio glass movement, the shifting of art glass away from the factory floor to the American artist's private home studio.

That year, Willson was already cementing his client-worker relations with the top master artisans of Venice. Influenced by Carder's example, he was determined to make glass sculpture. Willson did not wait for Labino's and Littleton's breakthroughs.

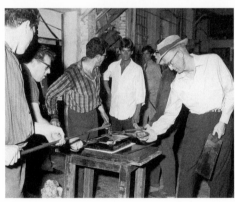

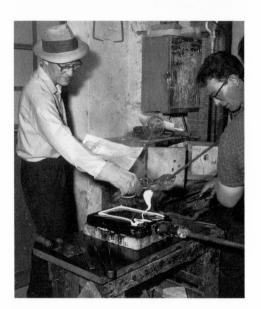

Robert Willson and Licio Zuffi at Fratelli Toso, Venice, making an early version of *Trail of the Wolf*, 1968.

For him, the studio glass movement came too late; he was already seeking ways to execute his increasingly heavy solid glass sculptures before it got under way.

Although he traveled to the Mediterranean area in 1956, it is more likely that 1959 was the first summer he hired and worked with artisans on Murano, such as Fratelli Toso, still located at Fondamente Colleoni 7 (founded in 1854). The Cold War period was a fascinating time to arrive in Italy. The country's position within the American sphere of influence was secure. Although a Communist government was nearly elected on several occasions, the Christian Democratic Party rose to power in 1943 and continued its influence, in and out of coalitions, for the next fifty years. The loss of Italy's colonies was offset by a rapid postwar modernization of industry, fueled in large part by cheap labor in the south and the discovery in 1945 of natural gas in the Po River valley in the north, crucially, near Venice. The need to generate export income and taxes was great because Italy was saddled with massive war reparations.

The Communists were shut out of Italy's coalition governments thanks to pressure from the Vatican and the U.S. emissary, Clare Booth Luce. In return for this compromise of national sovereignty, the Italians received, in addition to Marshall Plan aid (which ended in 1952), a $1 billion loan in 1964, following a package of other loans, grants, and gifts to take care of the enormous war debt.[14]

Arriving as he did at the beginning of the Italian economic miracle (1958–63), Willson benefited from Italian goodwill toward Americans and the desperate need on the part of Murano glasshouses to reestablish prewar markets and attract custom clients like Willson and architects in search of design glass. Big houses such as Venini became profitable and gained international recognition thanks to the efforts of Ludovico Diaz de Santillana (1931–1989), son-in-law of founder Paolo Venini (1895 –1959). At the same time, there was already a long tradition of welcoming foreigners to the island, so long as they shared ideas and technology rather than stole them. Greeks had arrived in the twelfth century to help execute the mosaic tile floors of the Basilica of St. Mark's. Germans brought the art of mirror making to Venice in 1317 and were encouraged to stay. And clear Bohemian crystal had become so coveted that cullet (clear shards to be remelted) had to be smuggled past the Republic's stringent yet ultimately futile efforts to control the transfer of technology out of Venice.

Arnoldo Toso, current owner of Antica Vetreria Fratelli Toso, recalled Willson's appearance in 1959.[15] A single drawing for a murrine-based bowl exists to confirm this.[16] Toso's uncle Ermanno (1903–1973), then director, was quick to realize how serious Willson was about his artistic progress. As the American wrote in his journal *Murano Diary 1964*, "My friend Ermanno Toso seems to take a real interest in my attempts to get a creative result from the glass. He knows the difference. Now he is a little bent with age."

That year, 1964, appears to be the first time Willson worked with his most important early collaborator at Toso, Licio Zuffi (1921–1973). Their learning curves were parallel: Willson learned on the spot ("I need to draw more detailed, exactly as I want it and be on hand to decide shifts in design as they appear"), while Zuffi responded enthusiastically to the new challenge and the welcome break from tourist production work. A sequence of black-and-

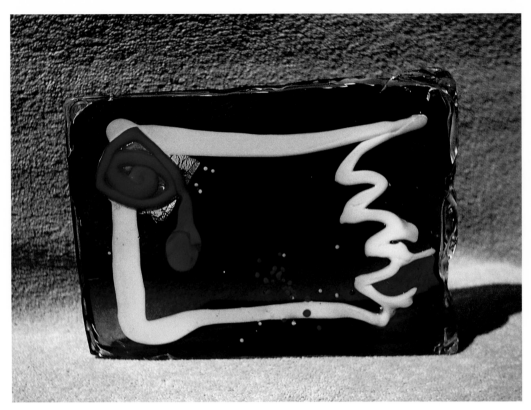

Trail of the Wolf, 1968, solid glass with trailing add-ons, 10 x 14 x 3, made with Licio Zuffi. Location unknown.

white photographs taken during the making of *Trail of the Wolf* illuminates their close working relationship. The diary records Willson's frustrations as well:

> There is a tendency on the part of all the masters to overdo decoration. If a certain texture is indicated, they cover the area, making it into monotony. They also want to make everything smooth and perfect—this comes from commercial work. An artist would need to work with one maestro until they understood each other.[17]

Giovanni Moro, owner of Moro G. Murano Antico Forno, Venice, 1964.

Giordano Guarnieri of Moro G. Murano Antico Forno, Venice, August 1964.

Willson's relationship with Alfredo Barbini, whom he met that summer, would become the kind of collaboration Willson desired. In fact, it was probably the most important of his career. Before that fateful union, however, Willson underwent an initial apprenticeship of his own with other glassworkers.

Giovanni Moro (1931–1997), owner of Moro G. Murano Antico Forno, introduced Willson to one of his blowers, Giordano Guarnieri, who worked with Willson on several pieces. The American's diary chronicles the ups and downs of such a procedure:

> I designed a simple bowl, with trailed lines and gold horses for handles—in the fashion of Venice—and Guarnieri tried it. Although he did not follow the design too clearly and fell back on all the extra curves of the tourist pieces, at one stage he had an interesting

effect . . . then the trailed lines fell off—glass too cold when they were applied. . . . When he tried to renew the blue trailed lines, he botched up the piece. It looked pretty bad and he was not happy with it.

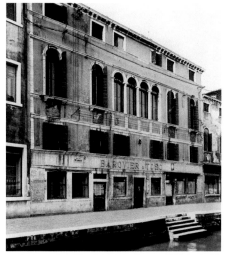

Willson observed Guarnieri's limits and strict delineation of decision making:

> At all stages the worker showed me and asked whether it was the way I wanted. This is a true team action. Obviously, these men cannot decide design questions out of their production approach. Art values escape them often. They could not make this without me—I could not do it without them. . . . This small shop, with only one glass worker,

Barovier and Toso, Murano, Venice, c. 1959.

is similar to the plant suggested by Harvey Littleton except that this man [Guarnieri] is an expert and Harvey is an amateur.

By contrast, his meetings and hot shop sessions with Barbini, beginning June 30, 1964, went very well, good omens for their long future collaboration:

> Through the courtesy of the National Experiment Station, the translator, Miss Naibo, walked with me across town to the glass house of Dr. Alfredo Barbini. It is a neat new brick plant with a large single central furnace . . . Barbini . . . serves as a master craftsman and actually makes the glass at the bench. (He has three other master craftsmen). . . . Barbini is a sculptor with some very fine pieces. . . . His work is in several museums. . . . His manager, Luigi Fuga, said that Barbini will execute the work of other sculptors but "in his own manner." . . . Barbini is the only example I know of here of a major glass producer who is owner, master craftsman, designer and artist, *all in one.*[18]

Later, after a July 9 meeting, Barbini agreed to work with Willson. Together, they devised a stacked, multiple-wall, metal-mold system to build up the solid glass as it was poured. On July 28, they worked together on *Golden Woman*. Writing in his *pensione* room, Willson marveled at Barbini's "perfection of plans and preparation, his careful rehearsal, his detailed instructions to his staff—this is very impressive and important to the success of unusual ventures."[19]

Similar approaches and inquiries that summer to Venini's director, Diaz de Santillana, did not pan out, due to the collapse of the house's main furnace around July 14. Equally unsuccessful was an attempt to work at Barovier and Toso, although Willson came to know and admire Angelo Barovier, son of the owner Ercole Barovier (1889–1974). Willson commented about father and son, whose family was "older than the discovery of America":

Angelo Barovier of Barovier and Toso, Venice, August 1964.

> Angelo's father still loves glass and is delighted to spend his years experimenting with new glass designs. He is especially interested in textures, materials, and new techniques . . . [Angelo] has

developed a style of *painting* with glass on large 3 x 4 ft. panels, working with crushed glass to form a matte texture through which he scratches vague solid forms—almost purely abstract.[20]

Apparently Willson's efforts that summer were so successful and attracted so much attention that he was allowed to apply for an exhibition at the Opera Bevilacqua la Masa, affiliated with the Ca' Pesaro Museum of Modern Art. Both institutions had been founded with the legacy of Felicità, Duchess of Bevilacqua la Masa, and both places would display the art of Robert Willson, the former in 1964 and the latter in 1984. The Bevilacqua la Masa Gallery show was an important turning point for the American: his first gallery show of glass art anywhere, and his first in Venice. No known reviews survive, but painter Renato Borsato, president of the Bevilacqua la Masa Foundation at the time, later described how the functions of the gallery and museum were divided:

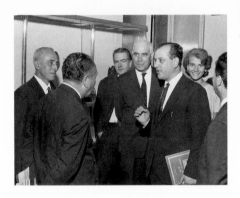

Visitors to the exhibition *Robert Willson: Sculpture in Glass,* Bevilacqua la Masa Gallery, Venice, September 8, 1964. Left to right: Aldo Toso, Ermanno Toso, Dr. Trentin, Guido Perocco, Mario de Biasi, Daria Perocco.

On the first floor was the gallery; this was devoted to young artists. On the second floor was the museum, part of which was under the control of the city's director of fine arts, Guido Romanelli. It was Willson's friend, Dr. Astone Gasparetto, one of the Foundation trustees, who proposed Willson's show for the gallery. Our program committee approved it because, one, Venetians have always offered support for foreign artists and, two, because he was well respected because of his earlier shows in America.[21]

Installation of *Robert Willson: Sculpture in Glass* at Bevilacqua la Masa Gallery, Venice, September 8–28, 1964. Exhibition design by Renato Toso.

On exhibit were ten pieces made by Zuffi, four by Barbini, and one, *Old Slab* (1964), by Guarnieri at Moro G. Murano.

After the summer's excitement, Willson demonstrated the fruits of his travels, labors, and experiments in his curriculum guide, *Glass for the Artist*. A combination of history, aesthetics, and technical know-how, the text detailed "11 eras of glass," from "natural glass," through Egyptian, Roman, Gothic, and Venetian, onward to European, Asiatic, American, and contemporary. Noting that all glassworkers in Venice set up shop on Murano Island in 1291 after being expelled from Venice for safety reasons, the author wryly added: "It is interesting that in the Murano of today, one sees this same technical proficiency but there is little original creativeness evident."[22] Summing up, Willson again plays the innocent yet informed prophet:

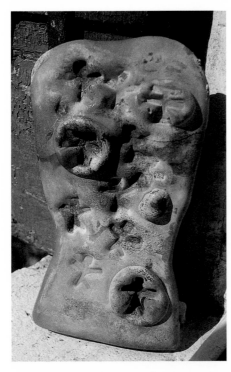

Old Slab, c. 1964, solid glass with antique corrosive technique, 14 h., made with Giordano Guarnieri at Moro G. Murano, Venice. Location unknown.

> It seems reasonable to expect that artists will learn to use glass for absolutely permanent and unbelievably beautiful masterpieces. . . . Glass is in the future. Perhaps art can go along, too. Today is the time [1958] for great freedom by the artist. We need to make a warm invitation to all exciting and dedicated talents who love glass. Now is the time to open new vistas and be creative.[23]

In Venice, Willson avidly followed his own advice. Although the greatest years of fully realized pieces were still to come, the late 1960s saw initial explorations with a variety of owners and makers—Moro and Guarnieri, Toso and Zuffi, Egidio Costantini, Aldo Bon Polo, and most important, Barbini and Barbini (designer and maker).

The most radical and, to the Muranese, questionably innovative artistic undertaking in those years was La Fucina degli Angeli (Forge of the Angels). An enterprise of the curator and art dealer Egidio Costantini, it was meant to raise the level of quality and international visibility of Venetian glass. Costantini had, to everyone's surprise (except that of Peggy Guggenheim, his major patron), convinced European artists to give him drawings to be executed in glass in the Murano hot shops. Drawings by such major artists as Picasso, Jean Arp (1887–1966), Marc Chagall (1887–1985), and Jean Cocteau (1889–1963) were rendered, usually in three versions: one for Costantini, one for the hot shop, and one for the artist. As Costantini recalled:

Egidio Costantini, director, La Fucina degli Angeli, Venice, 1966.

> My rule is that the artist prepares the drawings. That is how it happened with Robert Willson. But then I oversaw . . . how the glass would turn out. This is how I worked with Picasso, Miró and the others.[24]

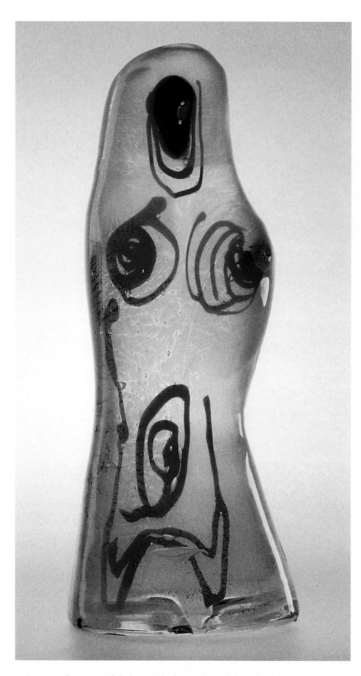

Mirage Myth, 1970, solid glass, 15 ¹/₄ h., made with Loredano Rosin at La Fucina degli Angeli, Venice. Arnold Saltzman collection, New York.

Willson jumped at the chance to participate, and on September 28, 1966, he sent "four drawings, unfinished as you requested. I will cooperate in every way possible because I believe in what you are doing."[25]

Willson was a complete unknown compared to the rest of Costantini's "stable" (Max Ernst, Mark Tobey, Lucio Fontana, Le Corbusier, Gino Severini). Why then did Costantini agree to work with him? Costantini recalled:

> He was a calm and simple man. I loved him for his kindness. . . . His behavior was so simple, so understated, yet he could enter into every milieu. I liked this very much.[26]

Repeating a view widely held in Venice about Willson, Costantini explained the power and appeal of the American's art to him: "His art was heavily influenced by Indian art; he *was* an Indian! He had come very highly recommended by a mutual friend, Attilio Sinagra."[27] As things transpired, it appears Willson completed several works with La Fucina degli Angeli,

THE MYTH CRW, ROBERT WILLSC

Study for *Myth,* 1968, ink on paper, 11 x 8. Courtesy of Egidio Costantini, Venice.

Stone Age Love Letter (1970) and *Female Nude* (1968) among others. It is likely that both were included in the twenty-second glass sculpture show at the Ca' Pesaro featuring La Fucina degli Angeli artists (July 22–September 30, 1967; Willson's name is on the poster). Mark Tobey (1890–1976) and Dorothea Tanning were the only other Americans invited that year. The event went far to boost the morale of the unknown American; little did he know that seventeen years later he would be honored with his own retrospective.

The exhibition that opened in August 1968 at the prestigious Correr Museum in St. Mark's Square was a major honor of the moment. It came about, again, as a result of the artist's hard work and assiduous, thoroughly low-profile networking. Giovanni Mariacher, director of the municipal art museums for the City of Venice, introduced the American to his new Venetian audience in a brochure essay, the first real critical study of Willson's glass art. He informs the reader about Willson's background, his years in Mexico, Texas, and Florida, his studies at the Corning Museum, and his advances as a glass sculptor while on Murano.

Mariacher lauds Willson for drawing upon an Italian background "that for centuries has been identified with . . . exuberant potentials."[28] Comparing the Correr group with the 1964

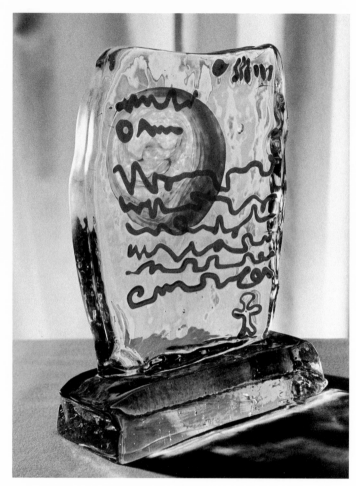

Letter of Stone, 1970, solid glass with trailing, 15¼ h., made at La Fucina degli Angeli, Venice. Courtesy of Egidio Costantini, Venice.

Study for *Letter of Stone,* 1970, ink on paper, 11 x 8. Courtesy of Egidio Costantini, Venice.

show at Bevilacqua la Masa, he describes the new work as "a collection both larger and more structured" than the 1964 set. Barbini and Toso were the makers of all the Correr pieces, including *Silver Virgin* (1968), which is Willson's first work to enter an Italian museum collection, another coup for the American glass artist.

As to the "varied" subject matter, Mariacher mentions Egypt (where Willson traveled in 1966), the Middle East, and the "Indians from Oklahoma." Abstract art is also referred to, along with Greek mythology and the "strong folk-like tone reminiscent of the Texas origins of the artist." Reinforcing the exercise of "freedom of expression," the arts administrator claims, "is the artist's great gift," and he concludes:

> His most recent works in particular reveal a more mature and refined language, perhaps . . . less eclectic than in the past and more aware of the road that seems today to be the most efficient when we engage in blending pliability into the precious yet difficult richness of glass.[29]

Two other recorded responses to the show accentuate the beginning of Willson's acceptance as an international artist. In remarks made at the opening, the city councilman for the arts, Mario de Biasi, expressed respect for Willson as an American artist and gratitude for his willingness to stretch out a hand to Italians in search of his artistic expression:

> As with the glass pieces that are next to me here, the drawings convey the artist's personality, his fundamental tendency to abstract, often communicating on a schematized level, classical cultural memories, or figurative references that remind us of the generous and strong land from which he hails. Moreover, the chromatic character of the work seems to free itself with force, sometimes even violently, seeking a union with the liquid transparency of the supporting material. These are Willson's new experiences, which he has wanted to exhibit and which we gladly present here, where the modern exists alongside . . . the ancient. We are delighted that Murano has once again lured the soul of an artist who is so vital and impassioned. We have no doubt that these experiences will continue in the future, with a reciprocal and certainly profitable exchange of sensibilities and ideas.[30]

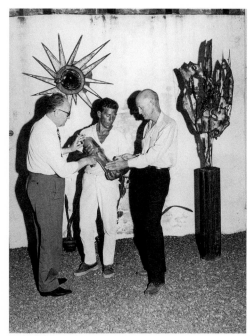

Egidio Costantini, Loredano Rosin holding *Mirage Myth*, and Robert Willson, at La Fucina degli Angeli, Venice, 1968.

Undoubtedly equally gratifying to Willson (and revealing to us today) was an unsigned review on page one of the local monthly *La Voce di Murano*, in August 1969. Written by the paper's owner, Silvano Tagliapietra, it went so far as to propose:

> This is an exhibition which would be desirable to be offered again to the Muranese, [because] the same show [seen] in Murano would enable Professor Willson to share in the comments of the masters and technicians of the island, and, for them, in turn, the opportunity to engage in a dialogue on what could be and should be done in Murano instead of the output that we call "agricultural," produced and sold as if it were potatoes.

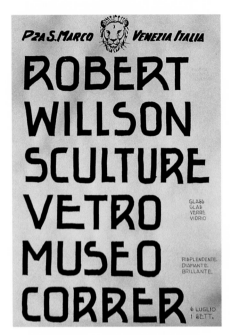

Poster for Correr Museum exhibition of Robert Willson's work, Venice, 1968.

As to the art itself, Tagliapietra detects the hands of Zuffi and Barbini, praising them both for "final work" that is "clean and learned":

> One must surmise that the discourse between artist and master has been smooth and direct. The artist was aware of his goal and was able to convey it. . . . We detect the presence of a search, an effort.[31]

Complimentary in the extreme, this review demonstrated that Willson had finally arrived. Although he was to produce one final body of ceramic sculpture in 1979, he was now set on the path of the apotheosis of solid glass sculpture.

Eight months before the glittering opening at the Correr, Willson had stood in St. Mark's Square alone on New Year's Eve and recounted in a diary-poem entry entitled "Midnight, January 1, 1967":

> A bitter cold night, a half moon, stars, mists . . . the amber light on top of the clock tower stood out.
> The front of San Marco . . . was lit, and a few street

lights around the piazza. . . . The small crowd cheered briefly. There was some hugging and kissing, not much . . . A few fireworks were heard and seen in the sky toward the old bridge. The belltower bells started ringing. Boats in the harbor whistled. Soon it was quiet enough to hear the motors of the boats on the canal. Not many people were out. Pigeons wheeling in and out of the lights—unusual lights for them.

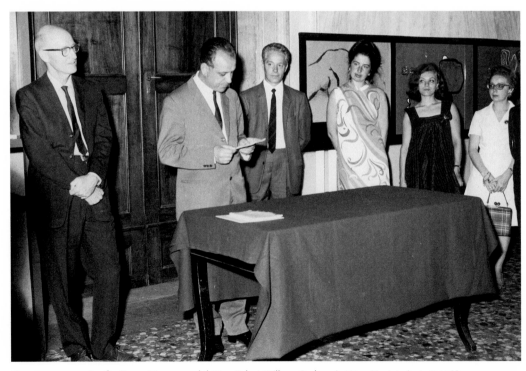

Opening ceremonies for Correr Museum exhibition *Robert Willson: Sculture in Vetro*, Venice, August 1968. Left to right: Robert Willson, Giovanni Mariacher, Mario de Biasi.

With the stunning accomplishments of the preceding years to warm him, followed by the honors at Bevilacqua la Masa and the Correr, Willson had discovered his own "New World," Italy. True expatriate at last, Willson's coming years would be more geographically divided than ever, but they would never again be as lonely as that New Year's Eve. Willson was about to begin his most important years as an artist.

1. Robert Willson, *Texas, Venice and the Glass Sculpture Era—Notes* (San Antonio: Tejas Art Press, 1981), unpaginated section.
2. Robert Willson, Final Report Project No. 5-5516-65, Contract No. HEW. OEC.2-6-058304-1146, "A College-Level Art Curriculum in Glass and Proposal," February 1968, U.S. Dept. of Health, Education and Welfare, Office of Education, Bureau of Research.
3. Robert Willson et al., *Glass for the Artist, Suggestions for the Use of Glass as a Material for Fine Arts,* (Coral Gables, Fla.: University of Miami, 1958).
4. Alberto Lleras, letter to Robert Willson, May 23, 1960.
5. Peter Voulkos, letter to Robert Willson, January 29, 1955.
6. Robert Willson, "Creating Sculpture for Buildings," *Florida Architect*, February 1962, p. 6.
7. Ibid., p. 26.
8. Robert Willson, "Distinction Out of Nothing," *Florida Architect*, April 1966, p. 7.
9. Willson, *Texas, Venice*, unpaginated section.
10. Ibid.
11. Ibid.
12. Paul Perrot, "Frederick Carder's Legacy to Glass," *Craft Horizons*, May–June 1961, pp. 32–35.
13. Willson, *Texas, Venice*, unpaginated.
14. Norman Kogan, *A Political History of Postwar Italy* (New York: Praeger, 1966), p. 24.
15. The successor firm is Antica Vetreria Fratelli Toso; the family glass firm ceased operating in 1982.
16. Arnoldo Toso, interview with the author, Venice, March 8, 2001.
17. Robert Willson, *Murano Diary 1964* (loose-leaf journal), unpaginated.
18. Ibid.
19. Ibid.
20. Ibid.
21. Renato Borsato, interview with the author, Venice, March 9, 2001.
22. Willson et al., *Glass for the Artist*.
23. Ibid.
24. Egidio Costantini, interview with the author, Venice, March 13, 2001.
25. Robert Willson, letter to Egidio Costantini, September 28, 1966.
26. Costantini, interview.
27. Ibid.
28. Giovanni Mariacher, *The Glass Sculpture of Robert Willson* (Venice: Correr Museum, 1968), unpaginated.
29. Ibid.
30. Mario de Biasi, unpublished remarks, 1968; trans. Marguerite Shore.
31. [Silvano Tagliapietra], "Le sculture in vetro di Robert Willson," *La Voce di Murano* 4, no. 26 (August 1968), p. 1.

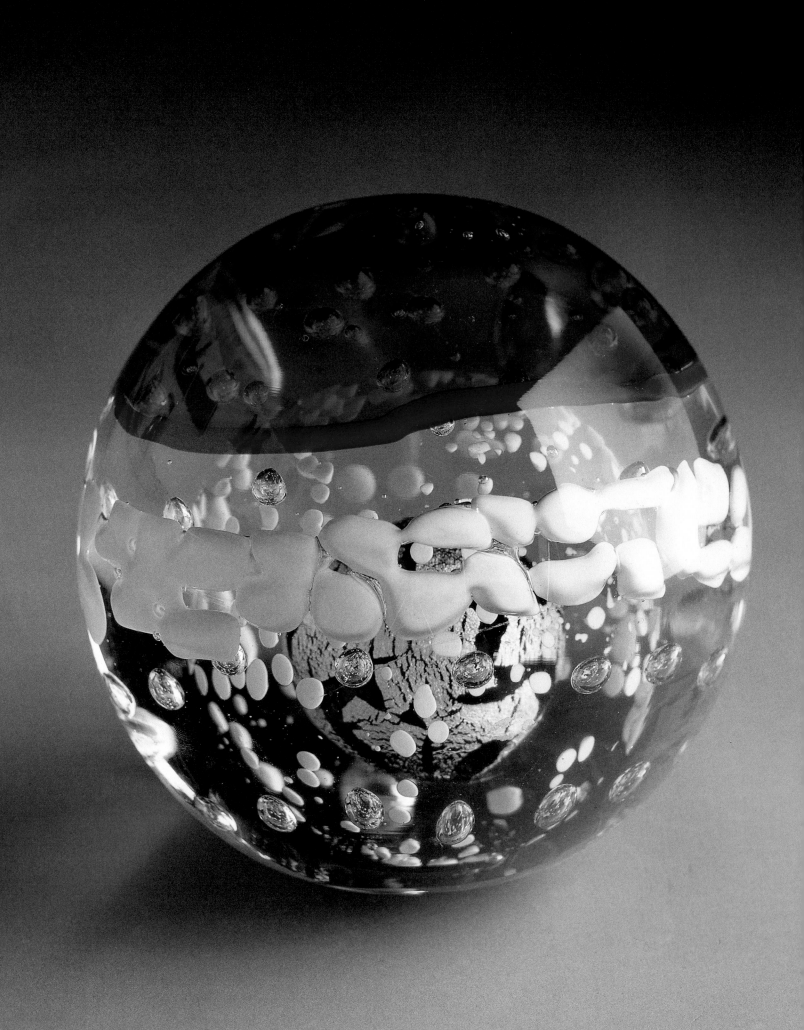

Encounters in Venice
Incontri a Venezia
1969–1984

VENEZIA

Da una barca

Venezia è là dove

Le case crescono dall'acqua

La gente camminano sulle onde

Tutte le fanciulle,

Chi sono talmente arrotondate.

Non può essere vero.

VENICE

From a boat

Venice is where

Houses grow out of the water

People walk on the waves

All the young girls,

Who are so rounded.

It can not be real.

—Robert Willson, c. 1969

After the triumph of the Correr Museum exhibition, Willson's entrée into the comparatively closed world of the Murano glasshouses was secure. For the next twenty-seven years, things would go smoothly. His love of the glass island and of Venice and its people was profound; it included the masters and artisans whom he always went out of his way to credit and acknowledge. In the 1970s and early 1980s, the artist–master artisan relationships burgeoned into one of the most successful and, without question, longest-lasting collaborations between Murano and any American artist. It is true that other Americans, Thomas Stearns and Dale Chihuly among them, came and went between 1960 and 1968, concentrating their efforts at Venini with varying results.[1] Stearns exhibited in local gallery and museum shows, including the 1962 Venice Biennale, before Willson did, but neither Stearns nor Chihuly stayed as long in Italy as did Willson. For Chihuly to fully make use of the Venetian artisans' skills, he had to bring people Willson had broken in (Loredano Rosin and Pino Signoretto, for example) to the Pilchuck Glass School in Stanwood, Washington. They changed American glass with their virtuoso technical skills, setting the bar higher for Americans.

High water in Piazza San Marco, Venice, April 1961.

(left)
Sky and Clouds, 1983, solid glass, 9 h. Peter J. Hennessey collection.

Like Willson, Chihuly had begun his career as an academic, heading the sculpture department at Rhode Island School of Design for a decade. In 1971, at a tree farm north of Seattle, he cofounded an "academy" (and personal hot shop), which became the Pilchuck Glass School.[2] Such organizational tasks were unnecessary for Willson (other than importing glass after each session on Murano); he simply returned faithfully to Italy each year, armed with more and more detailed preparatory drawings and closely oversaw their execution.

Such an extended cultural exchange places Willson in parallel histories: first, that of glass made in Murano (he is mentioned in two major histories), and second, that of glass art in the United States.[3] In advance of Dominick Labino's and Harvey Littleton's breakthroughs (quickly followed up by Chihuly, Richard Marquis, Marvin Lipofsky, Henry Halem, and Joel Philip Myers), Willson forged ahead in 1956, working within the existing Italian glass factory system. He remained convinced throughout his life that this was the best route to follow— for him and for all glass artists. Unlike the work of Chihuly and the others, his pieces were not blown or inflated but gathered on the end of the blowpipe in increasing masses; Willson required more complicated techniques than blowing vessels. Not only was solid glass sculpture not well established in the United States, but more pertinent, it did not have a long history in Venice either. As one Italian scholar wrote:

> Heavy solid glass that Murano had always regarded with some suspicion because it did not figure in any of the more traditional styles of workmanship . . . found an ardent supporter in Ercole Barovier who in 1935 parted company with Vetreria Artistica Barovier and joined other glassmakers to start the firm of Barovier & Toso.

Nearly three decades later, Barbini pushed the possibilities even further:

> [He] created [abstract blocks] around 1960 after he set up his own workshop. His sculptural experiments also extended to objects in heavy sommerso, or overlaid, glass, molded in dynamic and asymmetrical but always well balanced forms.[4]

Alfredo Barbini's factory and garden, Murano, Venice, July 1976.

Willson availed himself of these 1962 "experiments" when he began to work with Barbini, a collaboration that would continue on and off until 1988. For once, Willson benefited from good timing. If he had been too early and then too old to become a full-fledged member of the American studio glass movement, he was in exactly the right place at the right time when it came to taking advantage of Barbini's breakthroughs. As for the American studio glass artists aligning with the Murano system, historian Attilia Dorigato compared them and the men of Murano to Barbini:

> These [studio glass movement] artists whose activities are conducted independently of workshops and furnaces—often in their own studios—aim to create original pieces that do not have functional properties. On Murano, they tend towards developments of sculptural significance in plasticity and form, following the example set by Alfredo Barbini in the 1930s.[5]

Barbini's own apprenticeship was with Vittorio Zecchin (1878–1947) and the famed Napoleone Martinuzzi (1892–1977), two designers responsible for elevating the level of design for Venetian glass during the Mussolini years. Working for Luigi Scarpa Croce (1901–1966), Barbini produced his first "hot" (*a caldo*) solid glass pieces around 1938. His human and animal figures were shown at the Venice Biennale in 1942.[6]

The same age as Willson, Barbini seemed fated to meet the American, who also wanted to make human and animal figures in solid glass. As Barbini reminisced:

> Willson was an exquisite person. We had a good collaboration but we came out of completely different backgrounds. I had more respect for the Murano tradition but I always felt the challenge to arrive at an aesthetic point in solving a technical problem. With Willson, it was a goal of symbolic mythology and content conveyed through glass.[7]

Because Willson had cut his teeth with Licio Zuffi at Fratelli Toso, and worked briefly with Vittorio Ferro and Giordano Guarnieri at Moro G. Murano, when he resumed his association with Barbini in 1966, he already knew what was needed to achieve the effects he desired. Barbini was grateful:

> Every time I explained technical difficulties to him, it was easy for him to understand so that, later, it was easy for him to work with others and do similar or even more challenging work. . . . We spoke for a long time together about how to make bodies and other shapes.[8]

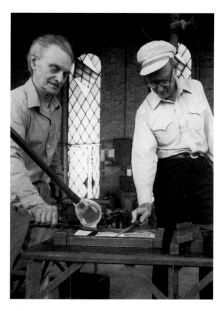

Alfredo Barbini and Robert Willson at Barbini's factory, Murano, Venice, c. 1970.

Returning to the United States after the Correr Museum show, Willson settled back into teaching full-time. He remained in touch with the people at Corning, and out of these ties came the first important English-language study of his work, "Robert Willson: Sculptor in Glass," by Paul N. Perrot, Corning Museum of Glass curator. Perrot accepted the hybrid nature of the American's glass art, noting in a 1969 issue of the College Art Association's *Art Journal*:

> As we look at Robert Willson's sculptures, we cannot say they are Venetian, for no one in Venice had thought of handling form and color in this manner before, nor do we recognize them as the products of American culture, for the quality of the colors, the choice of the palette and the techniques are purely Venetian.[9]

Venetian *lattimo* figures. Left to right: *St. Matthew the Apostle, St. Mark the Evangelist* or *St. John the Evangelist, The Goddess Diana*, c. 1750, nonlead opaque white glass with lampwork on figures, 4³/₄ h. each. New Orleans Museum of Art, purchases, William McDonald Boles and Eva C. Boles Fund, 2000.19, 2000.17, 2000.18.

After seventeen years of teaching, Willson decided to make a change. C. Clay Aldridge, former Lowe Art Museum director at the University of Miami, had taken a job in 1968 at the Lakeview Center for the Arts and Sciences in Peoria, Illinois, and invited

Willson to join him there as curator for a year. This curious interlude in Willson's life (he organized nine exhibitions) is not without humor. From the beginning, the stereotyped image of Peoria as a conservative, narrow-minded community proved sadly true.

Willson's account is relatively fair-minded and gives credit to Aldridge and the board of trustees for being wholly supportive of his undertakings. Affiliated with the municipal park department, Lakeview Center wanted to be all things to all people, an institutional goal that proved to be Willson's undoing. All he wanted to do was curate interesting visual arts exhibitions. As he remembered:

> The real trouble was in the community among artists and art teachers at the local Bradley University. Just before I went to Peoria [the artists] withdrew from the Center. . . . They were very jealous of each other . . . and had no desire to help or cooperate. So I went my own way without them, cancelled their annual show and secured a better group of shows than was usual for the Center.[10]

Balancing the petty local artists' community against the more progressive board and director, Willson's efforts were well received with one exception. Peoria became the site of what can only be called Willson's Oklo Yakni hoax. Seeing a huge empty exterior wall of the new building upon his arrival, he contrived to have an abstract mural, *Snow Flowers in the Sunset* (1969), painted for only $500 (he used local housepainters), claiming it was the design of a mysterious Choctaw Indian artist, Oklo Yakni (purportedly meaning "red earth"), who never once appeared in Peoria. Willson outlined the artist's biography for a local newspaper reporter:

> Trained in art in Perugia, Italy, and Paris. [He] wants no part of the modern American art movement. He lives a nomadic existence in the western part of the United States and Mexico. The mural is a copy of one of his paintings.[11]

Oklo Yakni [Robert Willson], *Snow Flowers in the Sunset*, 1969, latex on concrete wall, 40 x 40 ft. Lakeview Center for the Arts and Sciences, Peoria, Illinois.

Why did Willson go to this length to conceal his identity as the artist of the mural, or, seeing him in a postmodern light, why did he create a persona or artistic alter ego (à la Marcel Duchamp's Rrose Selavy)? Was it the stupefying boredom of Peoria or, as he claimed in his memoir, an attempt to attract more young people to the art museum? This was 1969, the height of the Swinging Sixties youth revolution. But Willson's son, Joe, challenged his father's claims of youth-oriented goals when he came home for Christmas from Princeton University. His appearance shocked his fifty-seven-year-old father: "Long and stringy hair, looking somewhat disreputable. He was so ugly that Virginia cried and, before we introduced him to anybody, we took him to a barbershop to have him trimmed."

The 33-by-35-square-foot mural was "visible from all roads around the park." With peculiar logic, Willson wrote:

> Because it was Peoria, I listed the name of the artist as an Indian named Oklo Yakni and no one seemed to guess. Most of the older people did not like it; but young people driving by would take the trouble to come in and tell me how much they enjoyed it.[12]

The artist's somewhat contradictory motives and actions are hard to understand. Suspecting that Peoria was stodgy, he paired his largely conservative programming with a gesture bound to incite outrage. In the newspaper interview, Willson freely admitted (perhaps exaggerated?) that "early reaction was ninety per cent negative." Was it all another episode of wish fulfillment for Willson to become a Native American? It could represent his most extreme yet tangible attempt at achieving such a desire. Even the pseudobiography of Oklo Yakni sounds like Willson's dream existence, educated "in Perugia . . . and Paris . . . lives a nomadic existence in the western part of the United States and Mexico." However viewed, the charade was a parting shot from the Texan who soon thereafter repaired to Florida.

With a new museum director in place at the Lowe Art Museum, John Baratte, Willson concocted his greatest and final achievement as a curator, *International Glass Sculpture*. The 1973 survey was among the earliest such events in North America. Other annual invitational exhibitions of glass artists were held at the Corning Museum of Glass (from 1959) and, later (from 1978), at the Leigh Yawkey Woodson Museum in Wausau, Wisconsin, organized by another artist-curator, David Huchthausen.

Willson's conception of the exhibition embodied his broader enthusiasm for glass sculpture; it encompassed European artists he met during his H.E.W. study-grant travels and placed his own work in perspective with that of his international peers. His *Myth* (1970), one of 160 works selected, was made with Loredano Rosin (1942–1991). This extremely simple, elegant work is a softly formed transparent female torso with inner red-line drawings to connote head, breasts, legs, and pubic area. Although at 15 inches high, it was one of the smaller works, it was among the most monumental.

Published alongside historical background essays by Corning Museum of Glass curator Kenneth M. Wilson and Italian arts administrator Astone Gasparetto, Willson's essay, "The Perfection of Glass . . . An Artist's View," held that the Lowe Art Museum survey was "the first American exhibition of esthetic glass sculpture in depth and its proper international context."

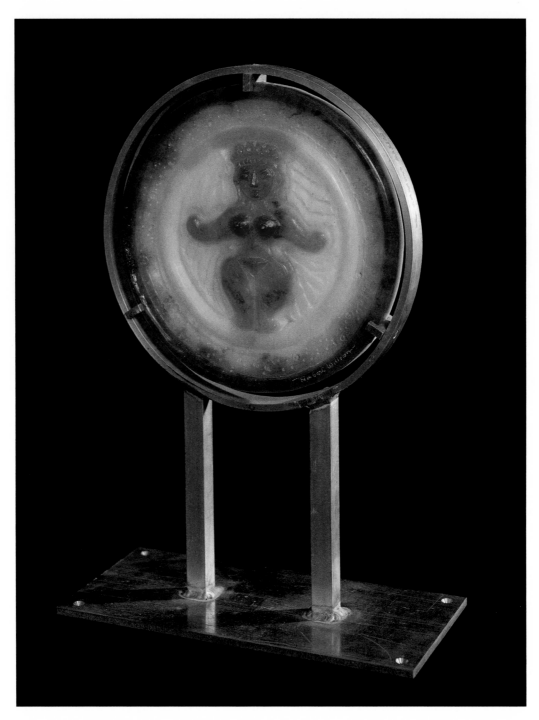

Archaic Horizon Stele, 1973, *pâte-de-verre* glass with metal mounts, 8 diam., made at Daum Frères, Nancy, France. New Orleans Museum of Art, gift of the artist, 89.138.8.

The five major characteristics of glass are "transparency . . . tension . . . true color . . . permanency . . . [and] brilliance." He draws the distinction between the widely prevalent "type of blown glass one person can finish without helpers" and "the opposite extreme . . . in the factory with its complexity of specialists, chemists, heavy equipment, varied glasses, and teams of helpers."[13]

Egidio Costantini's works based on artists' drawings were singled out for praise (fifteen by Jean Arp, Jean Cocteau, James Coignard, Raimond Dauphin, Max Ernst, and Attilio Sinagra,

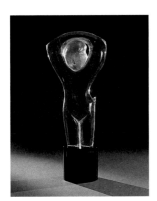

Loredano Rosin, *Abstract Standing Figure*, c. 1970, solid glass, 15 h. New Orleans Museum of Art, gift of Robert Willson, 89.139.16.

and two Americans—Dorothea Tanning and Willson), as was the factory of Daum Frères in Nancy, France, where Willson had two pieces made. In his favored role of occasional prophet, Willson faltered when predicting that factory-based settings were the wave of the future for American glass. He mentions "a hundred or more individual studio glass workers in the United States" but failed to see how that number would mushroom to thousands. Understandably mistaken, Willson stated with confidence:

> Glass sculpture in American will become more important only when the artists move into the glass factories (as they have in Europe) of West Virginia and elsewhere. . . . This exhibition will be influential for a decade.[14]

Willson periodically visited Pilgrim Glass Company in West Virginia in 1973, 1976, and 1979 to have paperweights made and to work with Italian expatriate Roberto Moretti on several sculptural pieces. But few other American artists followed his lead.

International Glass Sculpture was a major breakthrough for the Europeans. Among those selected for this important American show were colleagues Willson had met during his travels or with whom he had corresponded. Besides the stable of La Fucina degli Angeli, Willson also borrowed twenty *pâte-de-verre*

Richard Marquis, *Scattering of Pills* (detail), 1971, glass, pulled and lampworked cane, 1³/₄ each. Courtesy of the artist and Elliott Brown Gallery, Seattle.

works from Daum Frères (including his new *Escort Stele*) along with an unusual *Möbius Strip* (1970) by Salvador Dalí. Barbini sent nine works done between 1960 and 1970, and Renato Toso lent six works (including *Sea Form*, 1972). Other Europeans involved were Raoul Goldoni of Yugoslavia; Pavel Hlava, Stanislav Libenský, and René Roubicek of Czechoslovakia; Willem Heesen of the Royal Leerdam Glass Form Centre in the Netherlands; and Timo Sarpaneva, Tapio Wirkalla, and Oiva Toikka of Finland.

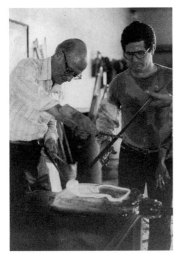

Robert Willson with Pino Signoretto, Venice, 1983.

The curator distinguished between "Americans working in Europe" ("they have fewer limitations") and "Americans in the Studio Tradition" ("the artist is involved with all phases of design and production"). In the former category, four artists, Paul Jenkins, Lipofsky, Moretti (who worked in both Venice and the United States), and Willson were featured,

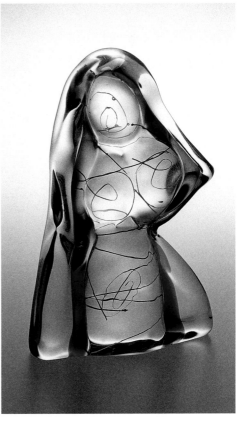

Silver Virgin, 1970, solid glass with silver wire, 12 h., made with Alfredo Barbini, Venice. Museo del Vetro di Murano, Venice.

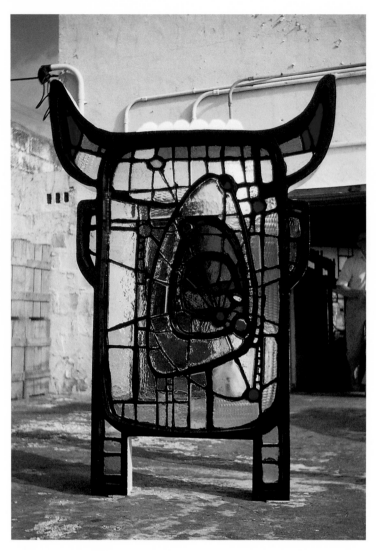

Eye of the Bull Man, 1974, leaded colored and clear glass and metal, 48 x 36 x 12, made with Karel Dupré. Location unknown.

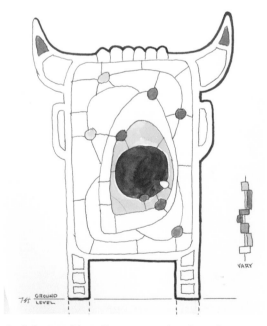

"THE EYE OF THE BULL" · Glass Sculpture · Outdoors

Study for *Eye of the Bull Man*, 1974, ink and pencil on paper, 11 x 8½. Collection of the Leonard S. and Juliette Rakow Research Library, The Corning Museum of Glass, gift of Margaret Pace Willson.

with seven more works by Willson. In the latter category, seventeen artists were chosen, several of whom were and remained well known, like Littleton and Labino, Halem, Marquis, and Myers. Counted among the rest, who seemed to have largely disappeared since 1973, were Audrey Handler, Robert E. Naess, Eriks Rudans, Kent F. Ipsen, and Boris Dudchenko. The color catalogue, with its three essays, full bibliography, and glossary of terms, remains an important document of a significant show.

At sixty-one, Willson was approaching retirement age. After twenty-one years in Miami and approximately fourteen summers in Italy, he had done an extraordinary job of balancing teaching commitments, curatorial undertakings, and seemingly unceasing creative work. And yet, even at such an "advanced" age, Willson in some ways was just coming into his own as an artist. Always seeking a challenge, he decided to explore stained glass. It was a way to expand glass art's sculptural scale and, perhaps, take a stab at the increasing number of public art proj-

Livio Seguso, Venice, July 1973.

ects for civic and corporate settings. *Eye of the Bull Man* (1974), a freestanding panel, is the most successful of these projects, done with Karel Dupré. Miróesque in its flattened, red-yellow-blue simplified form and Spanish subject matter, it represents a path not taken further. As a representation of a human wearing a bull mask, the piece also alludes to Willson's beloved ritualistic societies. But after these stylistic detours, the artist was back in Italy the next year, pursuing three-dimensional objects again.

Releasing the creative energies pent up during eleven months of the academic year, Willson also took up watercolors, resuming the love of his early youth. Here the link is crucial between painting and glass, what Willson called the "back and forth influence on my ideas and experiments in depth and transparency."[15] The bright colors Willson favored were softened by both the watercolor and the glass. The subjects of many were landscapes, Southwest scenes that grew increasingly abstract yet always remained recognizable. The striated horizontal or vertical sections of sky reveal the influence of Maya art, both in the idea of powerful natural elements and in the notion of separated planes of existence. The unblended solid colors (red, yellow, blue, green), common to both the watercolors and the glass, recall the application of color in Maya art.

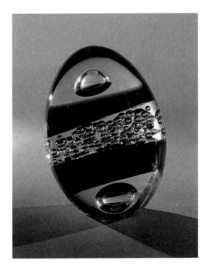

Livio Seguso, *Vertical Oviform*, c. 1970–72, solid glass, 14 h. New Orleans Museum of Art, gift of Robert Willson, 89.132.12.

Another small lined notebook, *Venice 1976*, provides unusual insights into the American's growing rapport with the maestros of Murano. The entries offer frank appraisals along with self-criticism and more mundane financial notations. It was the year Willson worked briefly with Livio Seguso, who "often wears dressy shirts while working but is not afraid to wipe tools on it . . . and trains helpers to do all possible steps, leaving Livio's time to keep things going."[16] Activities with Seguso, Barbini, Rosin, and others were often interrupted, to Willson's frustration, by strikes, feast days, and other work stoppages or slowdowns when "the men waste time in bars."

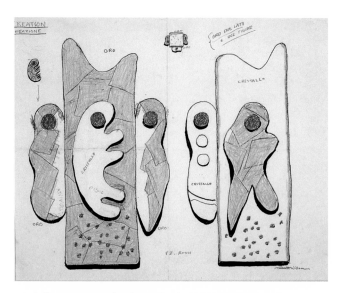

Study for *Creation*, undated, pencil, ink, and crayon, 18½ x 24.
New Orleans Museum of Art, gift of the artist, 90.58.

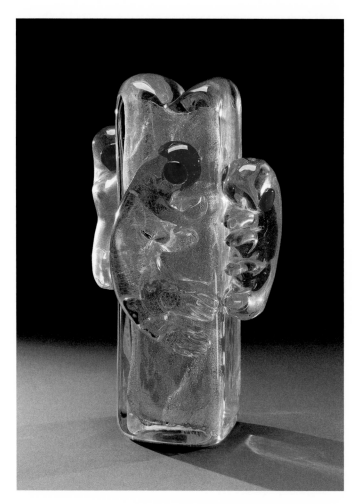

Creation (theme from *Amoeba* series), 1976, solid glass, 16 x 9¼, made with
Loredano Rosin. New Orleans Museum of Art, gift of the artist, 89.138.28.

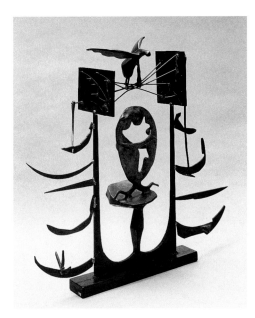

David Smith, *Royal Incubator*, 1949, steel, bronze, and silver, 38⅜ x 37 x 9⅞. Virginia and Bagley Wright collection, Seattle. ©Estate of David Smith/Licensed by VAGA, New York.

Having been included in the 1972 Venice Biennale (probably as part of Barbini's display), Willson could afford to feel confident and accepted. Loredano Rosin (1936–1991), formerly with Salviati and Costantini (who hired individual blowers rather than setting up his own shop), made Willson's *Myth* (1970) along with at least two others: *Creation* (1976) and *Venus on the Half Shell* (1976). These sculptures represent the essence of Willson's vision, his taste for imagery of generative origins, and readily identifiable subjects: fetus and breast.

Creation was worked on at Rosin's shop on May 31, 1976. Annotated in the notebook with a sketch and the remark "gold and silver decoration and crystal," the work springs from a pair of traditions: American modernist sculpture and European decorative arts using botanical and animal images. One forerunner of *Creation* is *Royal Incubator* (1949), by David Smith (1906–1965), with its inner bronze fetuslike shape sheltered by a nest of steel spikes.

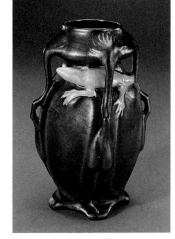

Clément Massier, *Vase with Lizard*, c. 1900, stoneware, 7 x 4 x 3½. New Orleans Museum of Art, gift of Robert and Margaret Pace Willson, 89.23.

Willson's *Creation* sets three faintly figurative shapes (each with a red spot for an eye) on a central nourishing post, a highly abstracted womb-wall surrogate. Instead of the beautiful green patina on the central bronze shape in *Royal Incubator*, the gold- and silver-leaf additions lend *Creation* a gleaming tone, rendering it "royal" through the privileged use of precious metals. Tenuously clinging to the womb wall, the organisms seem even more vulnerable than in *Royal Incubator*.

Creation also bears comparison with a nonfunctional work, *Vase with Lizard* (c. 1900) by French art potter Clément Massier (1845–1917). As in *Creation*, the lizard perches on the side of the central shape. Illusionistic and decorative yet also unsettling, the startling addition of a reptile adds a note of ecological fragility and danger, the same kind of naked vulnerability both the Smith and Willson works express. Alluding to origins of life and mimicking the translucency of a growing liquid membrane, *Creation* is one of Willson's most serious and beautiful sculptures.

Another work done with Rosin, *Venus on the Half Shell* (1976), epitomizes a different central image of Willson's—the breast—yet also comes out of an amusing old Murano tradition of rendering sexual organs. According to the prominent expatriate art dealer Louise Berndt (Rosin's companion and mother of his daughter), "Breasts, penises and vaginas are all made on the side by the blowers, after hours by the men as gifts to one another."[17] In Willson's case, the breast can be traced further back, perhaps to Maya art (as seen in Tlatilco ceramic tribal figures) but also to his life drawing classes. The artist's imagery of the isolated breast with erect nipple goes back as far as 1934, but it found more refined expression in drawings

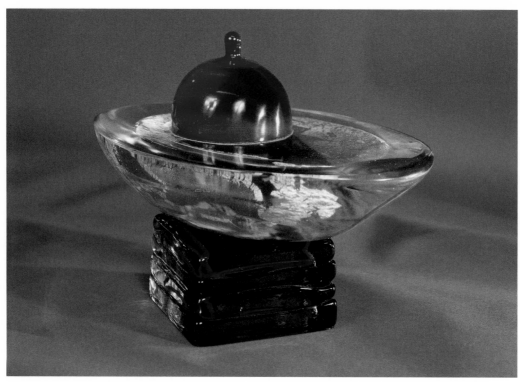

Venus on the Half Shell, 1976, solid glass, 7½ x 14½ x 6, made with Loredano Rosin, Venice. New Orleans Museum of Art, gift of the artist, 89.138.3.

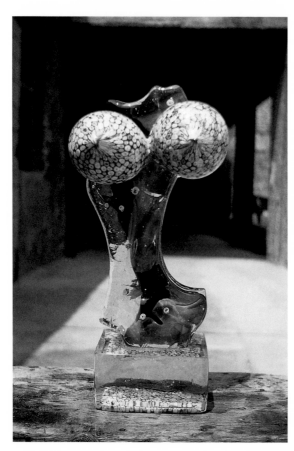

Nude Torso, 1973, solid glass with *millefiori* additions, 15 h. Ray Grover collection.

and sculptures like *Blue Seated Nude* (1971), *Nude* (1973), *Nude Torso* (1973), and the engraving done at S.A.L.I.R. on Murano, *Insouciant Nude* (1976).

In Rosin's hands, all the nonessentials are removed. The entire body is replaced by a pulsing red breast positioned upright on a clear, flat rectangular plinth, with aroused nipple pointing upward, as in *Insouciant Nude*. While elsewhere in other works, like *Ruins of Early Venus* (date unknown), ovaries and a pelvis are prominent, *Venus on the Half Shell* alludes to fully formed femininity but also to the mythical birth of the Greek goddess Aphrodite, emerging from the waves of the sea (also alluded to in *Wave and Foam*, 1974). Part image, part Surrealist object, part erotic testament, this work becomes one with an even longer tradition, that of the breast in Western art.

Art historian Mervyn Levy points out that Greek and Roman art tended to play down the breast, that breasts were further diminished in the antisensualist Middle Ages, and that, by the seventeenth and eighteenth centuries, a renewed interest and enthusiasm for it appeared. Willson's overtly

bulging versions should be allied more with the attitude toward the breast shown in Hindu art, which celebrated the large breast as a desirable attribute in a woman or a goddess. Levy asks:

> [Why are] painters and sculptors less willing to depict the breast in small, rather than large, forms? The answer . . . must be sought in psychology rather than aesthetics. . . . From the moment of birth . . . the breast dominates the whole field of experience during the first few months of existence.[18]

Indeed, considering that Willson's chief artistic outlet was the creation of a three-dimensional object, it is also worth noting how, to one group of psychoanalytical thinkers in Great Britain—the so-called object relations school—the breast is called the "first object" or "transitional object," that is, the first thing the infant relates to during breastfeeding and, later, during cuddling. The path to understanding the baby's world is through the physical and emotional apprehension of the breast. As Donald Winnicott puts it with respect to the infant's bond to the breast: "If the infant could speak, the claim could be 'This object is part of external reality and I created it.'"[19] The breast is the "transitional object," the way station between the physical union of the mother and child and the real world.

Other British psychologists see the toy or doll as the next "transitional object," but Willson's *Venus on the Half Shell* represents an extraordinarily literal example of what happens

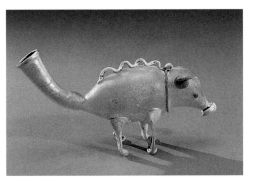

Flask in shape of pig, c. 100 A.D., blown glass, 2¹/₂ x 6⁷/₈. New Orleans Museum of Art, gift of Melvin P. Billups, 60.50.

when babies grow up to be artists. With the power of object-making in their grasp, they act out, according to Melanie Klein, a "reparative drive"; that is, an ameliorative process of producing an object, in this case, an artwork that is an unconscious gift back to the mother, source of all love and well-being.[20] Not only is Willson's (and Rosin's by indirection) a "reparative drive" toward a "return to the mother," it is a representation of the weaned infant's thwarted return to the breast. This is Willson as powerful artist and simultaneous image-maker and object-maker. The title is a genteel gloss for a deep drive that is not to be repressed. As Willson told critic Harry Reed in 1982: "My work is in the real world of objects and recognizable ideas. Ideally I seek to make each glass sculpture into a true universal symbol."[21]

The interlude of figurative porcelain ceramics in 1979 coincided with the publication of Willson's curriculum guide, *Art in Clay*, one of the first products of Willson's amateur small press, Tejas Art Press. He began the venture shortly after returning to San Antonio following his retirement in 1977 and divorce from Virginia Lambert, his wife of thirty-six years. This self-published guide is chiefly useful as a repository of the artist's thoughts about art. Subtitled "A World Survey of 27,000 Years of Ceramic Sculpture," it contains Wilson's own pantheon, including, not surprisingly, Hindu terra-cotta goddess figures with big breasts, second-millennium B.C. Greek matriarch figures with enormous breasts, and a predynastic Egyptian woman and child. Further ancient examples from Iran, India, and Crete, all with large breasts, are joined by an eighteenth-century image of a mother breast-feeding her child.

Always having worked as an artist, even with the full-time obligation of teaching, Willson at sixty-five felt utterly liberated upon retirement; he made a completely successful transition. He was about to begin two decades that would see his greatest glass sculptures created in Italy, along with another major museum show in Venice, followed by several American museum retrospectives, the most important two of which were held at the New Orleans Museum of Art in 1990 and 1999.[22]

In his stock-taking memoir, Willson was the first to admit the difference between college art teachers and what he called "full-time artists." The summer of 1983 was surely a watershed year in terms of numbers of works created and their consistently compelling quality. If there is a fusion of image and object in the best of Willson's art, 1983 was the year when such a fusion occurred over and over again. Freed by retirement to create more works and, at the same time, reconnected to the Texas wellsprings of his earliest imagination, the artist poured forth Southwest landscapes and menageries in the form of glass birds, coyotes, buffalo, mustangs, and longhorn bulls, with an Indian princess or two thrown in.

Another source of inspiration might have been Willson's marriage in 1981 to a former

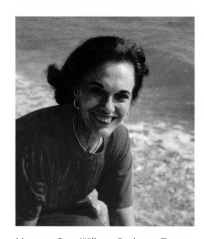

Margaret Pace Willson, Rockport, Texas.

student from his postwar teaching days at Trinity University in San Antonio. His marriage to Margaret Bosshardt Pace lasted for nineteen years, until Willson's death in 2000. An accomplished professional watercolor artist, Pace became an immediate and enthusiastic supporter of Willson's talent, his art, and, most important, his unending desire to return to Venice to live and work. Accompanying him there on visits of increasing length beginning in 1978 until their final stay in 1997, Pace encouraged Willson's genius and provided a loving and articulate response to his art.

Having embarked upon a new series of works (and a new marriage), Willson returned to Venice in 1983 for what became one of his most successful and prolonged creative sojourns, the preparation and execution of the sculptures that would comprise the apex of his recognition in Italy, *Sculture in Vetro: Robert Willson*, the 1984 survey at Ca' Pesaro on the Grand Canal.[23] (The former Palazzo Ca' Pesaro of Felicità, Duchess of Bevilacqua la Masa, had been converted to Venice's Museum of Modern Art.) Forty-two sculptures and six watercolors and drawings were displayed. The museum survey featured the work of Alfredo Barbini done for Robert Willson, an Italian connection that the Venetian organizers especially wanted to stress. A few weeks later, Willson's first exhibit at Ravagnan Gallery on St. Mark's Square opened as a complement to the Ca' Pesaro event; it concentrated exclusively on sculptures done with Pino Signoretto.

Luciano Tedesco, an official of the sponsoring organization, the Bevilacqua la Masa Foundation, had approached Willson about the possibility of an exhibition:

> At the suggestion of Professor Astone Gasparetto, we are inviting you to submit a
> request to this foundation to obtain an exhibit slot at our space in the Ca' Pesaro. . . .
> We assume you will accept . . . without assurances on our part as to the specific
> time period.[24]

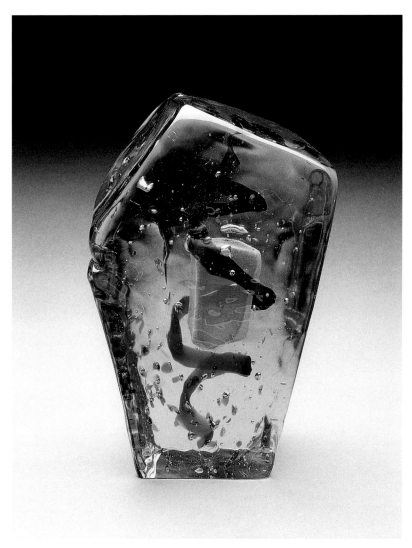

Crystal Flow, 1983, solid glass, 14 h., made with Alfredo Barbini, Venice.

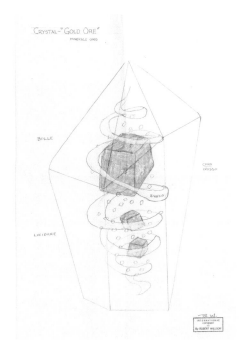

Study for *Crystal Gold Ore*, c. 1983, pencil and crayon on paper, 11¹/₂ x 8.

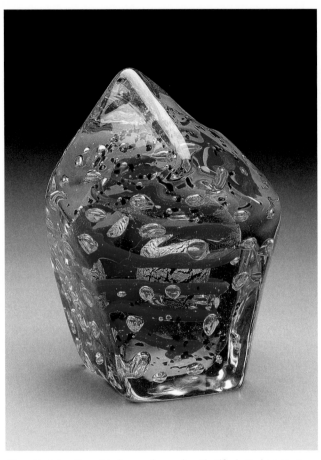

Silver Crystal, 1983, solid glass, 12 h., made with Alfredo Barbini, Venice.

As negotiations progressed, Willson arrived in Venice and immediately began work with Barbini and Signoretto, whom Barbini had recommended for the larger pieces Willson now required. As Signoretto remembered:

> I had left Barbini and gone elsewhere and, then, a few years later, had opened my own studio when Willson came here. The work was too heavy for Alfredo Barbini so Willson asked around about who can make these? Barbini said, "Go to see Pino. He's just opened his own studio and he can do them for you." That was fantastic! To have my old maestro send someone to me! I had seen my maestro make them and then later I got to make them![25]

There is perhaps more softness and delicacy as well as attention to detail in Barbini's examples compared to Signoretto's, but the younger maestro brought greater scale, weight, and his own elegant but sparing details. *Silver Crystal* (1983) and *Crystal Flow* (1983) are among Willson's most mesmerizing works, titled with identifiable imagery while taking the visual form of abstract slabs. A series of spheres Barbini had begun earlier was continued with *Sky and Clouds* (1983). A vertical shaft with a red center and trailing blue shafts below, *Lightning* was close to Willson's 1980 watercolor *Rainbow Skies over Texas*. When Barbini mentioned Willson's taste for bright color, he understood the reason: "It was the country he came from! He needed such bright colors. Coming from the Southwest as he did, he naturally had a taste for really bright colors. Normally here on Murano, my colors are softer."[26]

Golden Gates: From Yesterday to Today (1983) was more structurally ambitious than the spheres or chisels. A tripartite, altar-screen shape is surmounted by an eagle with outstretched wings. A concentric white target is the central panel's image, flanked by a stylized male and female couple. Red, white, and blue subtly direct the American subject, perhaps an allusion to archaeological excavations in the Southwest. The gold leaf behind the trailed white drawings adds a sacred note. *Texas Bull* (1984) and *Buffalo Blanket* (1983) reinforce the artist's rediscovered sources of inspiration back home in Texas. *Ancient Goddess (Indian Goddess)* (1983) builds on another Indian theme, the

Rainbow Skies over Texas, 1980, mixed media on paper, 28 x 22. New Orleans Museum of Art, gift of the artist, 89.138.51.

Lightning, 1983, solid glass, 15 h., made with Alfredo Barbini, Venice.
Trinity University, San Antonio.

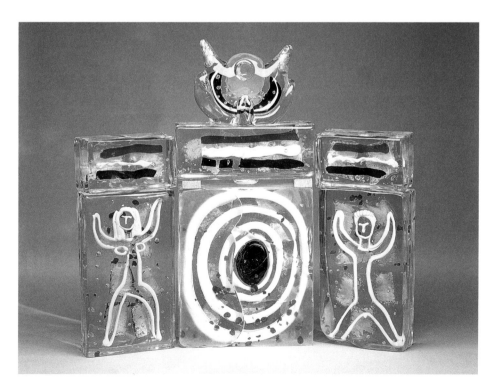

Golden Gates: From Yesterday to Today, 1983, solid glass, 24 h., made with Alfredo Barbini, Venice.
New Orleans Museum of Art, gift of the artist, 89.138.19a–f.

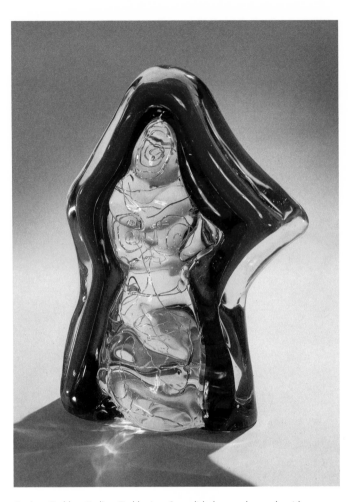

Ancient Goddess (Indian Goddess), 1983, solid glass, 15 h., made with Alfredo Barbini, Venice.

Zuni Symbol (Zuni Maiden), 1978, celadon porcelain, 17 h.

Study for *Real Goddess*, c. 1983, colored pencil on paper, 16¹/₂ x 22. Collection of the Leonard S. and Juliette Rakow Research Library, The Corning Museum of Glass, gift of Margaret Pace Willson.

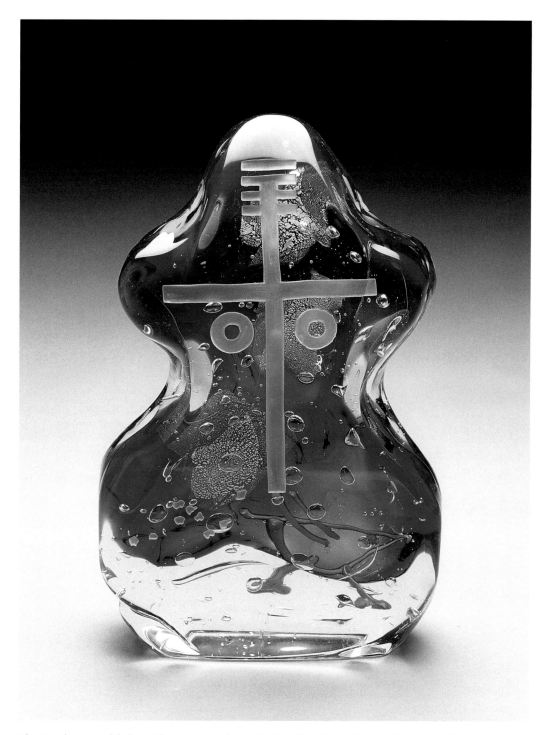

The Nymph, 1983, solid glass with engraving, 15 h., made with Alfredo Barbini, Venice. Victoria and Albert Museum, London.

corn goddess, and shares its shape with the ceramic work *Zuni Symbol (Zuni Maiden)* (1978). The glass version, however, turns the leaden opacity of the glazed porcelain into the glistening transparency of crystal, complete with immersed silver filament "drawings." Also related among the Barbini works is *The Nymph* (1983), with bulging breasts, broad hips, and schematized face sandblasted into the front surface. To connote the watery subject, clear and blue glass with bubbles are joined by Willson's sandpiper bird in red at its base.

Sculptor (1983), a companion piece to *Image-Maker*, which shares that work's red, white, and blue vertical striping, may be another Willson self-portrait. Instead of holding a wand or sculpting tool, *Sculptor* grasps a quivering mass of golden material about to be formed. In this sense, Willson is commenting on the glassmaking—or art-making—process. *Tree Symbol* (1983) and *Coral Reef* (1989) were produced by Signoretto, although the young maestro notes that it was Willson who added the white viscous trailing in *Coral Reef*. *Tree Symbol* recalls Maya art with its strong use of the tree as a symbol of life, reminiscent of Willson's Mexican-period paintings of the mid-1940s.

Robert Willson and Alfredo Barbini at Barbini's factory, Murano, Venice, May 1989.

Although they would work together periodically again over the next few years, Willson and Barbini had in a way outgrown each other. The Italian's influence on Willson had been profound, and not only by making it possible to conceive more ambitious designs; both men were obsessed with the female nude and worked together sympathetically to attain desired ends. As Barbini recalled:

> My credo is "you don't force glass, you follow glass." Many times glass is so soft that it takes on the shape of a body. But the problem is to stop the work once one sees the basic body shape. Willson was always there during the work.[27]

Signoretto was more adept at the myriad animal shapes Willson began to devise that year. The subject matter made sense for an American, Signoretto remembered:

> One hundred percent American! Like Jimmy Stewart! You could see it in the style, the landscapes, the Indian motifs, all definitely American. I feel he was expressing his nature and that was his way of being a sincere and honest artist.[28]

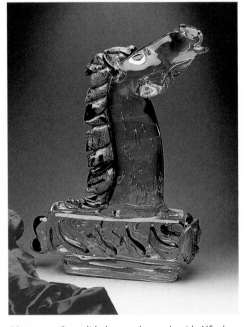

Mustang, 1984, solid glass, 21 h., made with Alfredo Barbini, Venice.

The opening of *Sculture in Vetro: Robert Willson* at the Ca' Pesaro Museum of Modern Art was attended by more than 200 people. Besides Willson's Italian friends, including a few Murano associates he had invited, Venetian political and cultural dignitaries appeared, eager to be a part of an occasion with an American artist devoted to Venice, which lent an international air to the bureaucrats and their city. In addition, a large group of American friends and Willson's relatives flew over for the event. After the *vernissage*, the entire group took private water taxis to the Palazzo Dario, where a dinner had been planned to celebrate Willson's achievement. Toasts and testimonials in English and Italian followed. What might have appeared valedictory to some (Willson was seventy-two) was far from being a farewell. In the coming years, Willson would build on the achievements of the Barbini and Signoretto collaborations, find a

Murano factory even more inspiring and cooperative, and create a late-period body of work that was a towering culmination of his life's art-making.

"Venezia" translated by Marguerite Shore.

1. Thomas Stearns, "The Façades of Venice: Recollections of My Residency in Venice, 1960–62," in William Warmus, *The Venetians: Modern Glass 1919–1990* (New York: Muriel Karasik Gallery, 1989), p. 63; Linda Norden, *Chihuly Glass* (Providence, R.I., 1982), p. 10.
2. Tina Oldknow, *Pilchuck: A Glass School* (Seattle: Pilchuck Glass School; University of Washington Press, 1996), p. 55.
3. Rosa Barovier Mentasti, *Venetian Glass 1890–1990* (Venice: Arsenale, 1992), p. 172; Susanne K. Frantz, *Contemporary Glass: A World Survey from the Corning Museum of Glass* (New York: Harry N. Abrams, 1989), pp. 23, 134.
4. Attilia Dorigato, *Murano Glass Museum* (Milan: Electa Editions, 1986), pp. 78, 88.
5. Ibid., p. 92.
6. Gianfranco Toso, *Murano: A Glass History* (Venice: Arsenale, 2000), pp. 159, 162.
7. Alfredo Barbini, interview with the author, Venice, March 13, 2001.
8. Ibid.
9. Paul N. Perrot, "Robert Willson: Sculptor in Glass: An Appreciation," *Art Journal*, fall 1969, p. 46.
10. Robert Willson, *Texas, Venice and the Glass Sculpture Era—Notes* (San Antonio: Tejas Art Press, 1981). The Peoria exhibitions included *Fragments of Egypt, The Eight, The Character of Collecting Modern, Cloth Fiesta*, and *The Grand Tour.*
11. Jerry Klein, "Let Drivers Beware: Gripes, Yipes, Oohs, Ahs Greet Lakeview Mural," *Peoria Journal Star*, December 21, 1969.
12. Willson, *Texas, Venice.*
13. Robert Willson, "The Perfection of Glass . . . An Artist's View," in John J. Baratte et al., *International Glass Sculpture* (Coral Gables, Fla.: University of Miami, 1973), p. 9.
14. Ibid.
15. Willson, *Texas, Venice.*
16. Robert Willson, *Venice 1976* (unpublished notebook).
17. Louise Berndt, interview with the author, Venice, March 8, 2001.
18. Mervyn Levy, *The Moons of Paradise: Reflections on the Breast in Art* (New York: Citadel, 1964), p. 67.
19. D. W. Winnicott, "The Fate of the Transitional Object," in *Psychoanalytical Explorations/D. W. Winnicott*, ed. Clare Winnicott, Ray Shepherd, and Madeleine Davis (Cambridge: Harvard University Press, 1989), p. 54.
20. Klein, quoted in Adrian Stokes, *The Image in Form* (Harmondsworth, UK: Penguin Books, 1972), p. 120; Hanna Segal, "Art and the Inner World," [London] *Times Literary Supplement*, July 18, 1975, p. 800.
21. Harry Reed, "Solid Glass: Robert Willson's Sculpture," *Glass Studio*, no. 41 (1982), pp. 28–30, 43–45.
22. John W. Keefe, *Sculpture in Glass: Works by Robert Willson* (New Orleans: New Orleans Museum of Art, 1990); Daniel Piersol, *Trail of the Maverick: Watercolors and Drawings by Robert Willson, 1975–1998* (New Orleans: New Orleans Museum of Art, 1999).
23. Renato Borsato, et al. *A Story in Glass: Robert Willson* (Venice: Edizioni in Castello, 1984). The exhibition opened in the Bevilacqua la Masa Room on September 25, 1984, and closed October 18. It was accompanied by a hardbound, 202-page full-color book with bilingual texts by Barbini, Borsato, Domenico Crivellari, Guido Perocco, Giovanni Mariacher, Paolo Rizzi, Carlo Della Corte, Astone Gasparetto, Giandomenico Romanelli, Enzo di Martino, Attilia Dorigato, and Willson. Included in the catalogue are excerpts from "testimonials" from previously published essays and reviews by Roland E. Fischer, Paul N. Perrot, Bob Parvin, and Harry Reed.
24. Luciano Tedesco, letter to Robert Willson, April 6, 1983.
25. Pino Signoretto, interview with the author, Venice, March 9, 2001.
26. Barbini, interview.
27. Ibid.
28. Signoretto, interview.

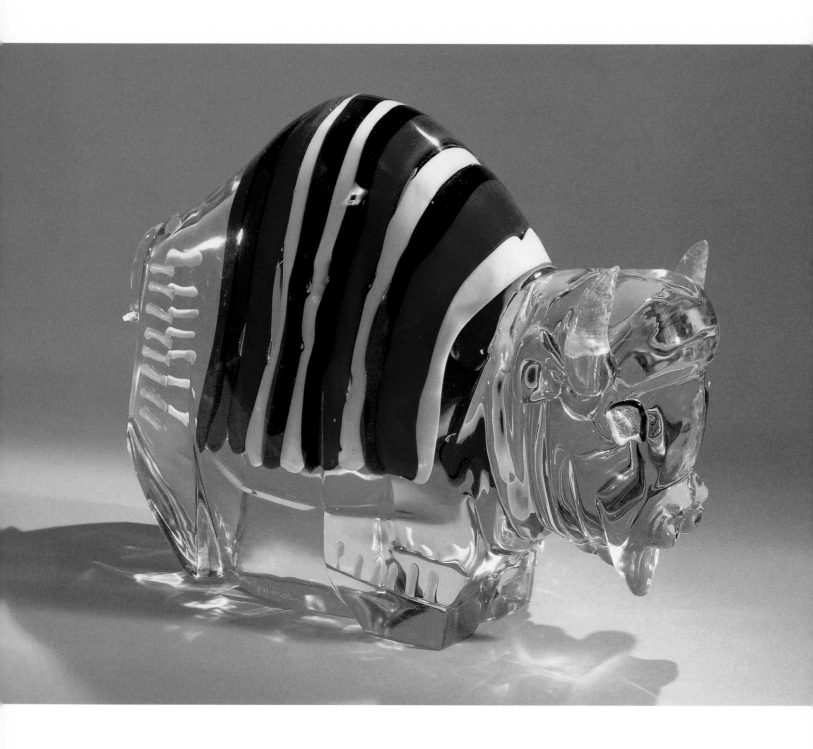

How Many Buffalo This Year?
Quanti buffali quest'anno?
1985–2000

> The daily early morning walk across deserted San Marco piazza to take the vapo-
> retto, the ride with the other workers, through the canals, past the naval yards and
> the cimitero island, to Murano, the work before the blazing hot furnaces in the hot
> weather, the ride home at night well tired and hot, and the drawing of ideas for the
> next days—it has become the most remembered and loved routine of my life.
>
> > —R.W., *Texas, Venice and the*
> > *Glass Sculpture Era—Notes,* 1981

By 1985, when Willson was seventy-three, he easily could have slowed down and relaxed. Had he remained in Florida after retiring, he probably would have. But because his normally prolific studio output had diminished somewhat during the twenty-five years of teaching at the University of Miami, and because, during those years, he usually had more ideas for artworks than time or money to execute them, Willson's postretirement years yielded his best and most sustained serial achievements.

His collaborations with Alfredo Barbini and Pino Signoretto behind him, Willson began to look elsewhere for simpatico workers who could be easily persuaded to fulfill his needs. He found them in Elio Raffaeli, Roberto Cammozzo, and Renzo Vianello, who together set up Ars Murano in 1980. The fact that they repeated many of the same themes Willson had first designed for Barbini and Signoretto makes it difficult to determine the exact sequence, artisan identity, and date for each piece. Even with the hand-drawn charts Willson kept each year from roughly 1973 on, it is not always easy to assign maestro credit to every work. When interviewed in 2001, Barbini, Signoretto, and the others could not themselves confidently identify particular works as coming from their furnaces. Some pieces were claimed by

Study for *Buffalo (Il Buffalo),* undated, graphite, ink, watercolor and Crayola, 18 1/2 x 31. New Orleans Museum of Art, gift of the artist, 90.55.

all three houses, others denied. Even when informed that their signatures appeared on a given sculpture, the maestros were diffident or noncommittal.

The latter-day Willson connoisseur is left to associate particular qualities with particular maestros: softness and rounded forms with Barbini; clearer glass and brighter colors with Ars Murano; substantial weight, size, and superior figurative modeling with Signoretto. Definite

(left)
Buffalo Blanket,
1983, solid glass,
14 x 16 x 6, made
with Alfredo
Barbini, Venice.
James Curphy
collection, San
Antonio.

attribution is only an issue if the art historian seeks to preserve the contextual links between designer and maker. That attempt is made here because Willson himself always insisted that the Italian makers of his work be credited. American glass designers, such as Dale Chihuly, rarely observe such a courtesy, apart from listing maestros and gaffers in publications. The American studio glass movement in general has lauded the designer and maker as one and the same. (In the early years, 1962–82, this practice was the chief distinguishing factor of American studio glass; after 1982 many makers could afford to employ teams of workers.)

Works of great technical ambition such as Willson's might require assistance from as many as ten employees. The history of Murano is the history of designers and makers working together. A few, like Barbini, became both artist and maker and, in the process, changed the face of Venetian glass. To the extent that solid glass sculpture is now available, if not widespread, in the shops of Venice and Murano, Barbini and Willson deserve to share credit.

After the Ca' Pesaro Museum exhibition with Barbini and the Ravagnan Gallery grouping of works done with Signoretto, Willson settled into more than a decade of work that combined earlier themes and brought out a few new ones. The repetition of images reveals the increasing adventurousness of subsequent treatments by each maestro: Barbini favored rounded delicacy, Signoretto leaned toward heft and exuberant scale. After 1990 Raffaeli (who had once worked for Livio Seguso before setting up his own shop) became the maestro with whom Willson completed his days. Along with his two partners and colleagues, Cammozzo and Vianello, he executed some of Willson's most beautiful sculptures.

The rapport and genuine affection among the four men showed that Willson had at long last found technicians who wanted to help him fulfill his wishes without imposing their own egos. They gladly complied with his persistent desire to make glass sculpture a little bigger, a bit more colorful, and more likely to draw attention on its own terms.

Such an arrangement meant Willson could plan greater and greater challenges for each summer, thoroughly understanding technical limits but all the same determined to "overpersuade" the men at Ars Murano when necessary to achieve his aims. Cammozzo remembered how Ars Murano's relationship with Willson developed gradually over the years:

> In the process of working together, he let us know his point of view, about his land
> and the happiness he expressed through his colors. What he had there [in Texas] was
> a free way to live: the horses, the colors, the sun. It was like a new thing each time
> we began a piece with him, even if we were repeating a design, because he was
> always willing to face a challenge.[1]

By the time Willson arrived at Fondamenta Vetrai 138, the first Ars Murano site (in 1995 it moved to Ramo San Giuseppe 7), he had been working in Italy for thirty-four years. His drawing had become more and more detailed, with extensive notations in Italian and English. He understood the hot-shop floor dynamic between designer and makers, having acquired a rudimentary knowledge of Italian. He also understood the importance of creative latitude. Raffaeli recalled:

> He knew a lot about glass and how to get what he wanted. Yes, the drawings were
> very important. . . . Through them, we understood immediately what he wanted.
> At first, we didn't know if we could do it, but we tried. He was so kind to us, like
> a father. We grew up with him![2]

Louise Berndt was not alone in her assessment of Willson's final team: "The collaboration with Raffaeli was better than with the others because he kept the sense of Robert Willson's watercolors better, bright color, but softer, too."[3] Willson's Ars Murano sculptures do capture the soft, unblended colors of his watercolors, but he might have actively searched for that quality when selecting Raffaeli, Cammozzo, and Vianello, the heirs to Barbini and Signoretto.

Another new friend was Luciano Ravagnan, whose Ravagnan Gallery on St. Mark's Square became the American's primary sales outlet in Europe and the site of three well-received solo exhibitions in 1984, 1989, and 1996. Ravagnan Gallery had never shown glass art before Willson's, so this, too, was a breakthrough. The two men became close friends, as the distinguished gallerist recalled:

> I met him as a client first. He bought a Ludovico de Luigi painting from me, and then, much later, he showed me his portfolio. I told him I've never shown glass before, but I'd like to try to show it *as art*.[4]

The positive response to the Ca' Pesaro Museum show benefited both parties. Each summer they met:

> He and Margaret would always stop by the gallery. Oh, we'd have a *caffè* at the Florian. At first, when I knew them, they stayed in an apartment or dependency flat owned by the Gritti Palace Hotel, and then, later, they moved into the dependency of the Palazzo Querini on the Campo dell'Accadèmia. It was a simple but beautiful place, next to the British Consulate, on the Grand Canal.[5]

Thus comfortably ensconced, while Margaret pursued her own watercolors during the day, Willson took the *vaporetto* across the lagoon each morning to Ars Murano. From his early days at Toso with two, three, or four pieces completed per year, Willson progressed after 1981 to as many as one or two dozen works each summer. Again, Ravagnan remembers the warmth of affection toward Willson once he stepped off the boat: "On Murano, he was such an open man. One day I took the boat with him and it was amazing, everyone greeted him, but everyone!"[6]

The Willsons' "dependency flat" (second from right), Dorsoduro 1051, apartment 8, Campo dell'Accadèmia, adjacent to the Palazzo Querini on the Grand Canal, Venice.

"We called him *sempreverde*," Raffaeli smiled, "because he'd return each year with all new 'leaves' or ideas for us. He was like a tree, the *sempreverde*, or evergreen."[7] As their stays in Italy grew longer, the Willsons' days turned into a mixture of hard work and leisurely relaxation, not exactly *la dolce vita*, but hardly a tourist's life in Venice. Margaret Willson recalled how the upper echelons of Venetian society were not open to them because they were classed as artists; nevertheless, there was a long list of Italian friends to join for dinner or a concert at the famed La Fenice Theatre.[8] Emma and Astone Gasparetto became good friends, along with Giovanna Moro (daughter of Giovanni) who, like Ravagnan's son, Carlo, visited the Willsons in San Antonio.

A welcome routine was dinner at Taverna San Trovaso, walking distance from their apartment near Campo dell'Accadèmia. It would cap a day's work on the island and provide sustenance and fellowship with friends like Giovanna Moro, Louise Berndt, James Mathes, and Mary and Christopher Cooley. In those years, the couple always attended the Venice Biennale. Willson's comments about contemporary art grew increasingly shrill and negative over the years, but his judgments were based on firsthand experience of a wide range of work over a long period of time.

During these years, Willson developed and refined four major themes. The female figure, the landscape, the sphere, and the animal were devised and repeated with Raffaeli from 1985 to 1997. Selections from each category demonstrate how Willson's final period matured into a ravishing and impressive body of work. Like Matisse, he accommodated and adapted to old age and infirmity. Because he was not required to do the actual construction, Willson was able to participate as actively as he wished during the creation of each work, to oversee refinements, try out new ideas, and, eventually, embark on entirely new projects—his glass-and-steel sculptures, the crowning achievements of his career.

Willson's favored version of the human figure, the big-breasted female, has roots in his *Calithump* woodcuts of 1934 and in Mesoamerican art, specifically the Tlatilco culture. Willson's glass figures are quite close in size to seated pre-Columbian terra-cottas, partly due to the exigencies of the hot shop (larger work could not fit through the oven doorway) and partly in an attempt to approximate the devotional character of the Mesoamerican religious figures.

One of the last works done with Barbini, *The Color Model* (1988), is an ambitious and unusual work. Two clear cylinder-like breasts

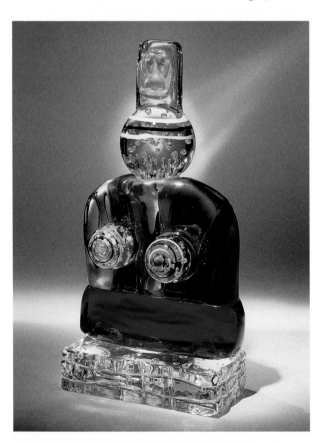

The Color Model, 1988, solid glass, 17 x 10 1/2 x 6 1/2, made with Alfredo Barbini, Venice.

contain concentric blue and white stripes. They adorn an abbreviated torso form above a clear stacked plinth covered with a red wraparound band resembling a *rebozo,* the Mexican peasant's cotton cloth. Red and blue stripes are visible within the clear torso, again resembling the woven structure of Mexican textiles. A pressed-glass face with broad flat nose is covered in gold leaf at the sculpture's top, perhaps more headdress than head. Below the schematized face, a large sphere connects the head and shoulders, possibly a second, featureless head.

Mirage (1992) revisits the idea of *Myth* and *Silver Virgin* (both 1970). Another torso (but all of one piece) in clear crystal, *Mirage,* has engraved curvilinear drawings that fill in the anatomical details of face, breasts, and pubic area. Intuitive-looking, the drawings were the result of painstaking engraving done at S.A.L.I.R. A faint blue tinge surrounds the profile. The eternal feminine is generalized in the extreme, but an essence of softened femininity makes this one of Willson's most magical works.

Ruins of Early Venus (c. 1985), a combination lower female torso and rocky landscape, can be traced to several early undated drawings and was made in several versions. The open-topped loin

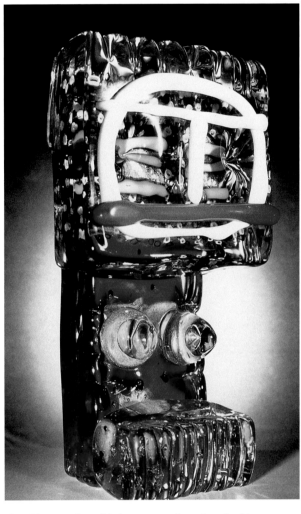

Cave Woman, 1985, solid glass, 17 x 9 x 6, made at Ars Murano, Venice. San Angelo Museum of Fine Arts, Texas, gift of the Duncan Foundation, 1997.004.06.

forms surround inner organs suggestive of ovaries or a womb (similar to an idea in *Creation* [1976]) above a blood-red center, common to all versions. Fecundity is the underlying theme of these works, with the clear quality of the glass acting as a water metaphor and underscoring the maritime origins of the goddess Venus. The work was perhaps influenced by the female figure glass sculptures of Jean Arp that Willson saw at Costantini's La Fucina degli Angeli Gallery. *Ruins of Early Venus* (1993) bears a golden relief stamp, a female torso with gold-leaf inclusions.

Cave Woman (1985) is among the last of Willson's sculptures with Maya-idol references. The blocky upright form, masklike face, and vivid red, white, blue, and gold coloring echo the terra-cotta forms common to Mesoamerican art. Executed by Raffaeli at Ars Murano, *Cave Woman* combines a variety of technical effects and is perhaps more showy than Barbini's or Signoretto's pieces ever were. However, the effect is vivid, colorful, and, despite its beauty, a bit frightening. The brutality and violence of ancient Mexico are always ameliorated or toned down in Willson's later art, subordinated to optical pleasure and far removed from the dark Cold War omens of *God and Goddess of War* (1957).

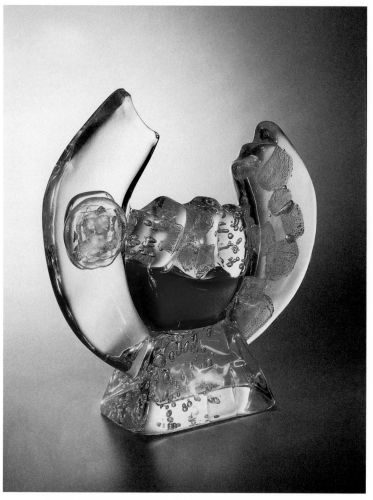

Ruins of Early Venus, 1993, solid glass, 16 x 16 x 6, made at Ars Murano, Venice.
Courtesy of Ravagnan Gallery, Venice.

Ruins of Venus, undated, colored chalks and gouache on gray paper, 24 x 36.
New Orleans Museum of Art, 89.138.49.

Study for *Ruins of Venus*, undated, graphite and colored pencil on
paper, 14³/₄ x 21. Collection of the Leonard S. and Juliette Rakow
Research Library, The Corning Museum of Glass, gift of Margaret
Pace Willson.

VIRGIN
Take me back to the night of Origin
and from your side let me be taken out
an opaque planet on fire with your light.
—Octavio Paz[9]

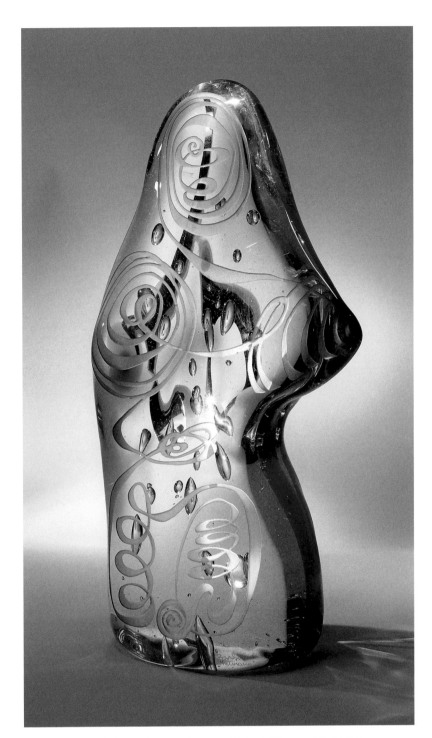

Mirage, 1992, solid glass, 16 1/2 x 8 x 4 1/2, signed Robert Willson and Barbini/Murano, Venice. Collection of The Corning Museum of Glass, gift of Margaret Pace Willson, 2001.3.28.

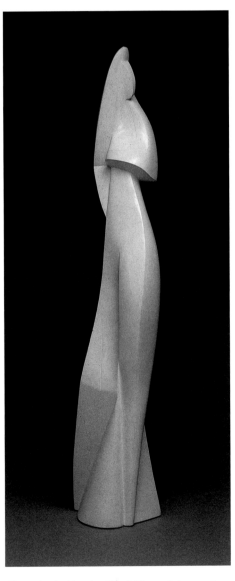

Alexander Archipenko, *The Bride,* 1936, terra-cotta, 34 1/4 x 6 11/16 x 4 3/4. Seattle Art Museum, Eugene Fuller Memorial Collection, 36.64. ©2001/Artists Rights Society and The Archipenko Foundation.

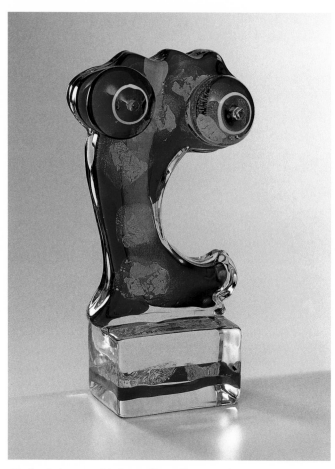

Marilyn Red, 1993, solid glass, 19½ x 14½ x 5, made at Ars Murano, Venice.

Marilyn Red (1993) begins a final streamlining of the female figure in Willson's oeuvre. One of a number of Marilyn versions, this effigy, inspired by Marilyn Monroe, links the aging artist again to modern masters like Jean Arp, Henry Moore, and Pablo Picasso. Without a head or any individually identifying features (besides big breasts), *Marilyn Red* is literally about placing woman on a pedestal—the tall clear base with red and gold lines. Joining the achievements of *Silver Virgin* and *Mirage, Marilyn Red* was not the most schematic or reductive of Willson's female figures. That honor goes to *Dreaming Girl* (1996), among his final figurative sculptures. It combines aspects of the earlier works, including the watery origins of *Ruins of Early Venus*, accentuated by the controlled red and blue bubbles in the lower square torso. The circles of the bubbles are echoed in the breasts. These organic shapes contrast with the square head and abrupt neck. A supreme example of the artist's desire for the fusion of image and object, *Dreaming Girl's* face is a recessed blue square surrounded by colored strands. To contemplate the distance traveled from Willson's first female nude drawings and woodcuts of 1934 to *Dreaming Girl* of 1996 is to chart the evolution of art in the twentieth century, from realism to modernist abstraction. The mythic subject matter—goddess, idol, altar—is reinforced by the material: transparent, accessible, yet inflected by elaborate, excruciatingly difficult process.

Like a novelist with recurrent characters or a poet with refrains, Willson repeated earlier themes in the final sculptures he created with Raffaeli, Cammozzo, and Vianello, but he also introduced new ones. These late works represent an advanced refinement that still privileges bravura technique and decorative beauty. After all the years when the ghost of pre-Columbian terra-cotta sculpture threatened unfavorable comparison to his glass translations, Willson's Ars Murano period yielded works that could not be imagined in any other medium. He had nearly transcended Maya art's power over him.

Study for *Marilyn Silver*, undated, graphite and colored pencil on paper, 24 x 19. Collection of the Leonard S. and Juliette Rakow Research Library, The Corning Museum of Glass, gift of Margaret Pace Willson.

The same process was occurring in the animal pieces. They were rooted in his childhood experiences in the west Texas hills and desertlike areas, then evolved through his exposure to ancient Mesoamerican art in which representations of animals were a means of mastering nature. Willson's late animal figures are also his most abstract. *Big Bad Bird* (1995) can only be a vulture, guardian and foreteller of death. With cloaklike wings and anthropomorphic bald head and beak, *Big Bad Bird* is more omen than ecological homage. Similarly, *Serpent Head* (1996) and *Pretty Serpent* (1997) revisit Chinese and Maya mythologies, respectively, linking the two civilizations long thought to be mysteriously connected by some anthropologists. With

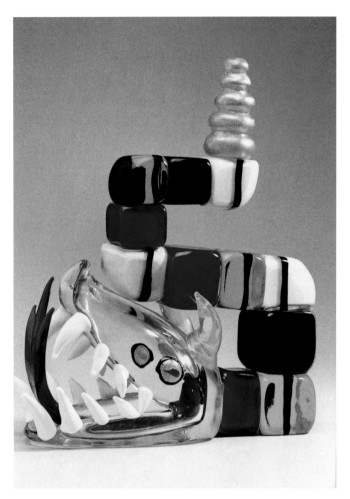

Pretty Serpent, 1997, solid glass with gold leaf, 19 1/2 x 21 1/2 x 5, made at Ars Murano, Venice.

Study for *Pretty Serpent*, undated, graphite and colored pencil on paper, 24 x 17 3/4. Collection of the Leonard S. and Juliette Rakow Research Library, The Corning Museum of Glass, gift of Margaret Pace Willson.

white teeth and vivid red lips, snout, and tongue, *Serpent Head* is a terrifying spectacle. *Pretty Serpent* employs the stacked-and-epoxied construction method used at Ars Murano. Topped by a golden rattle, this reptile is part Mexican myth, part Texas memory, religious in symbolic reference, dangerous in a practical sense. The intensity of separated colors and the upright, uncoiled position recall Octavio Paz's poem from the 1950s, "Serpent Carved on a Wall":

> The wall in the sun breathes, shivers, ripples,
> a live and tattooed fragment of the sky.
> A man drinks sun and is water, is earth.
> And over all that life the serpent
> carrying a head between its jaws:
> the gods drink blood, the gods eat man.[10]

Most abstract of all, *Two Frogs Resting* (1997) cleverly uses the rectangular slab form as a "landscape" backdrop for another symbol of transformation, the amphibian. Here the exuberant spontaneity of drawing is captured better than in any of Willson's other works. The frogs' two pairs of black eyes may also be read as tadpoles. The red circles and lines seen behind the black inclusions act as either schematic amphibious anatomy or vaguely vegetal resting places,

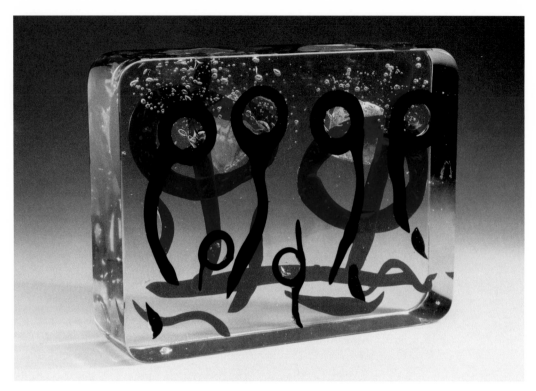

Two Frogs Resting, 1997, solid glass, 14 x 17 x 5, made at Ars Murano, Venice.

like lily pads. Willson's strengths and desires for solid glass sculpture, his quality of transparent water-based color, and a fresh sense of drawing all come together in a manner that would not have been possible with any of his earlier collaborators. Seen a final way, the upper bubbles suggest the entire image is set underwater, and in this sense (as in some of Ars Murano's

tourist-trade solid glass "aquariums"), *Two Frogs Resting* is more illusionistic than other Willson sculptures. The bold black outlines with red color behind them are a valedictory reminder of the basic ingredients of Maya vase painting.

The transition from his two-dimensional water-colors into three-dimensional glass is one of the culmi-nating achievements of Willson's final years in Venice. Always an influence in his glass, the watercolors exist autonomously as works of art. This was demonstrated thoroughly in a separate survey exhibition, *Trail of the Maverick: Watercolors and Drawings by Robert Willson, 1975–1998,* at the New Orleans Museum of Art in 1999.[11]

Two late-period watercolors reward close examina-tion. *The Ranch Needs Rain* (1986) has a horizontally stri-ated structure in shades of red with five Texas longhorn cattle seated at the picture's base. With a central sun (another Willson topos) flanked by blisteringly hot red clouds, the entire composition reflects the unique

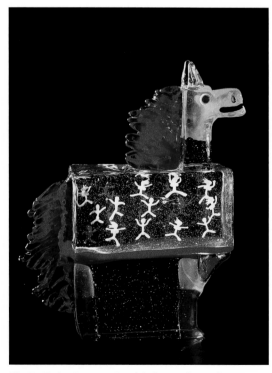

The Toy Trojan Pony, 1996, solid glass, 19 1/2 x 19 1/2 x 5, made at Ars Murano, Venice.

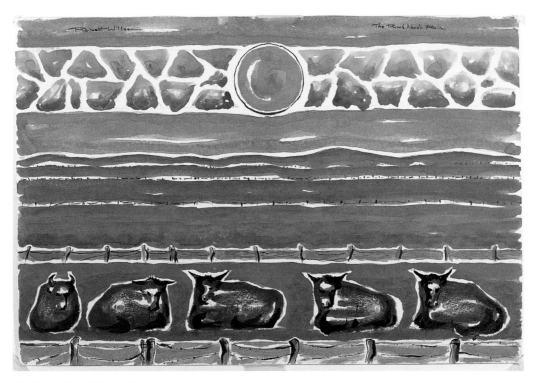

The Ranch Needs Rain, 1986, watercolor on paper, 31 x 43.

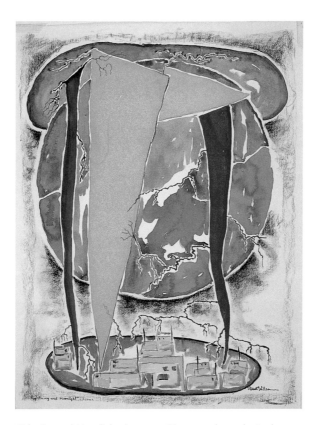

Lightning and Moonlight, Acoma, 1988, watercolor and mixed
media, 35 x 30.

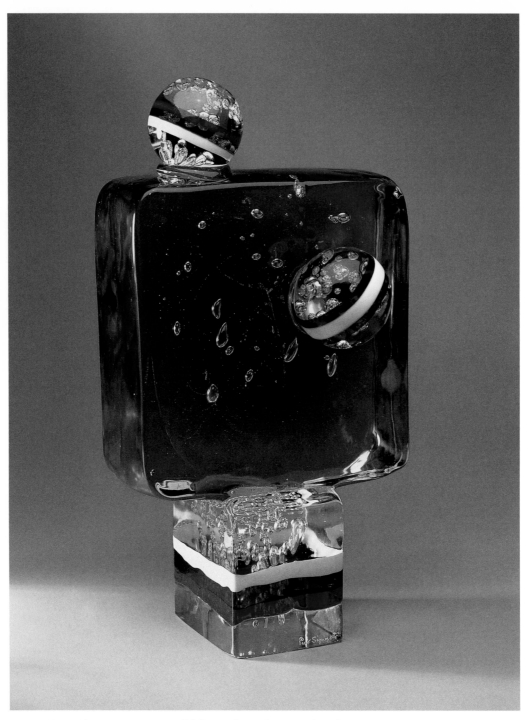

Stars in Sky (Window on Space), 1989, solid glass, 19 ½ x 10 ½ x 8, made with Giuseppe "Pino" Signoretto. Museum of Fine Arts, Houston, gift of Margaret Pace Willson, 2001.148.

regional properties of Texas. Comparable to Georgia O'Keeffe's abstractions of Western land-scapes is *Lightning and Moonlight, Acoma* (1988), with its bold triangular shafts of red, yellow, and blue lightning streaks before an enormous green globe resembling the Earth. In another Willson homage to Native American culture, the pueblo of Acoma, New Mexico, is at the base. Octavio Paz, Willson's contemporary and touchstone, also was inspired by the Southwest's severe meteorological phenomena in his early poem "Live Interval":

Lightning or fishes
in the night of the sea
and birds, lightning
in the forest night.

Our bones are lightning
in the night of the flesh.
O world, all is night,
life is the lightning.[12]

The flatness of the watercolor and Willson's abrupt frontal compositions find vitreous form in two landscapes of glass, *Stars in Sky* (1989) and *Concert on the Range* (1996). In the former, Willson's earliest technical innovation, the thick, stacked-metal mold used for pouring molten glass, appears as a window into the universe, a dark blue square with red, white, and blue planets applied. In the latter, much closer to a real watercolor, the "music of the spheres" or celestial phenomena may be the concert of the title. A large concentric spiral disk may be a moon against a deep blue sky. The barbed-wire fence is a sign both of delimiting space and of the impingements of human settlements in the West. One an image of infinite space, the other an image of confined space, *Stars in Sky* and *Concert on the Range* advance Willson's exploration of landscape to a higher level.

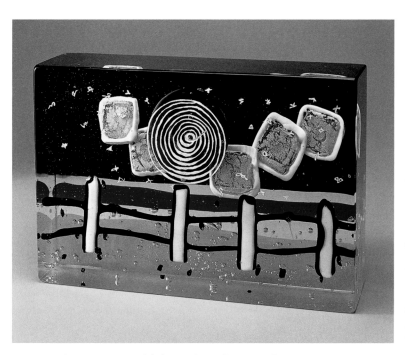

Concert on the Range, 1996, solid glass, 10 1/2 x 15 1/2 x 4, made at Ars Murano, Venice. Philbrook Museum of Art, Tulsa, Oklahoma, gift of Margaret Pace Willson, San Antonio, Texas, 2001.1.2.

Building on the carefully stacked oblong and rectangular proportions of *Stars in Sky, Desert Cactus* (1994) is Willson's addition to his evolution of abstract forms (cube, rectangular solid, sphere) as well as an extension of a motif popular in Venetian glass since at least the 1920s. Napoleone Martinuzzi's cactus sculptures, an allusion to a popular decorative motif, were affixed to an inner metal-strut frame in order to raise the height for a space in the Bergamo railroad station. In Willson's case, cactus imagery had frequently occurred in his watercolors. His studies with Harding Black, the San Antonio ceramics artist, exposed him to the latter's *Cactus* (1986). Black's bulging, corrugated celadon forms conceal an inner "trunk" and are devoid of needles. Willson's is far more hierarchic, less organic-looking, in that none of the elements are curved. Taking advantage of Ars Murano's increasingly bubbly clear glass, *Desert Cactus* acts as a mini-landscape with earth, tree, figure, horse, and sky all contained within one object.

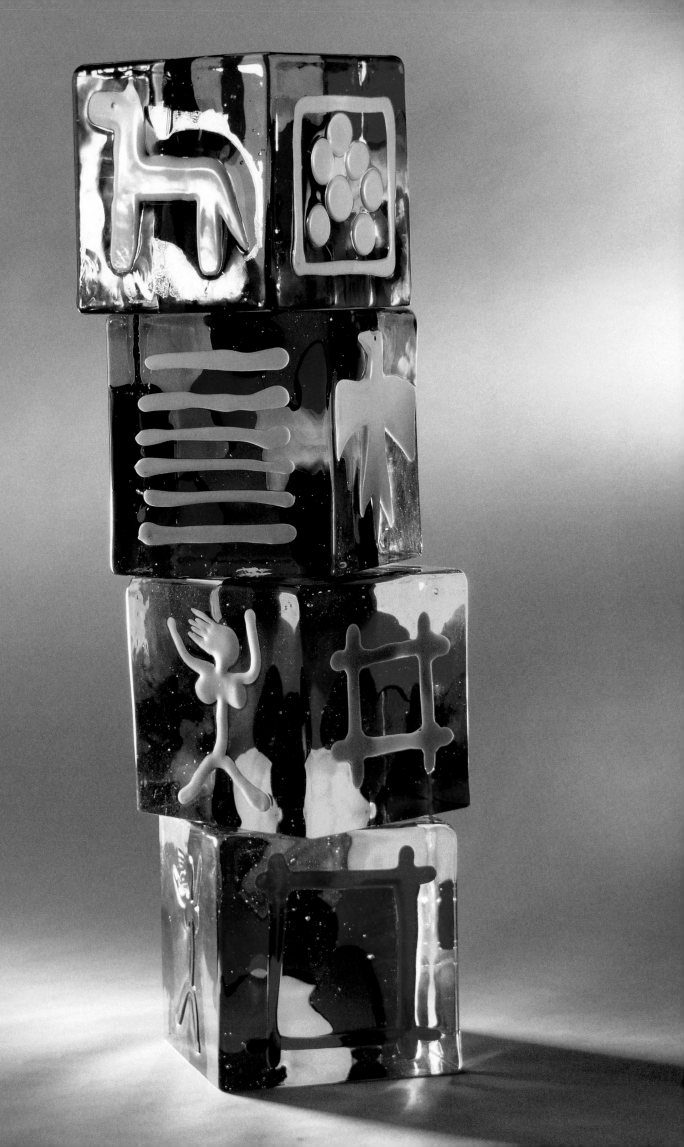

Harding Black, *Cactus*, 1986, earthenware with celadon glaze, 19 x 12. New Orleans Museum of Art, The Harding Black Collection, 95.296.

The rounded cubes, clear bubbly glass, and utterly simplified composition of *Note to Make a Tree* (1996) make up Willson's final statement about landscape. With abrupt lower "trunk," ice-block-like central "branches," and square red, black, and white "berries" on top, this work points in a fascinating potential direction. While the title evokes a sketchy quality, *Note to Make a Tree* implies a later, fuller elaboration that was not to occur.

Willson's landscapes such as *Desert Cactus* and *Note to Make a Tree* seemed to become more and more outer-directed, pointing toward space and sky. They connect to an important theme of the artist's—the sphere, which, seen metaphorically, is among his most exalted and cosmic images. Begun with Barbini and Signoretto, the spheres continued with Raffaeli and his friends, becoming more complicated, colorful, and gradually larger.

Dale Chihuly's *Niijima Floats* (1992) may be larger—indeed, they are the largest objects ever held on a blowpipe—but they are hollow and inflated, whereas Willson's pieces are heavy solid glass with additions. Even here, where one would imagine a sense of the limitlessness of the universe, Willson draws attention to defining areas (*Fence around the World* [1993], *Stop Sign in Space* [1973]), reminding us of humanity's foolish efforts to colonize or despoil outer space.

Tribal Instruction, an undated colored drawing, proposed four spherical shapes that are similar to subsequently executed works. *Gold Strata* (1993) and *Geological History* (1993) use the sphere as a container form for versions of Earth. *Subtle Sky* (1988) has black intersecting lines across red, amber, and clear areas. Sculptures combining the sphere with other shapes (*On Target* [1992]; *Growth [Blossom]* [1990]) employ the shape more playfully, less as a global metaphor.

(left)
Builders' Cubes, 1996, solid glass, 8 x 8 x 8 each.

(bottom left)
Builders' Cube V, Collection of The Corning Museum of Glass, gift of Margaret Pace Willson, 2001.3.31.

Glass Series: Tribal Instruction, undated, graphite, watercolor, and mixed media on paper, 24 x 36. New Orleans Museum of Art, 89.138.53.

In his memoir, Willson said, "I would like to see the use of glass in larger standing sculptures and in relief walls made of assembled parts of heavy glass."[13] One of the advantages of longevity is the chance to fulfill long-held dreams that require time. Willson's patience must

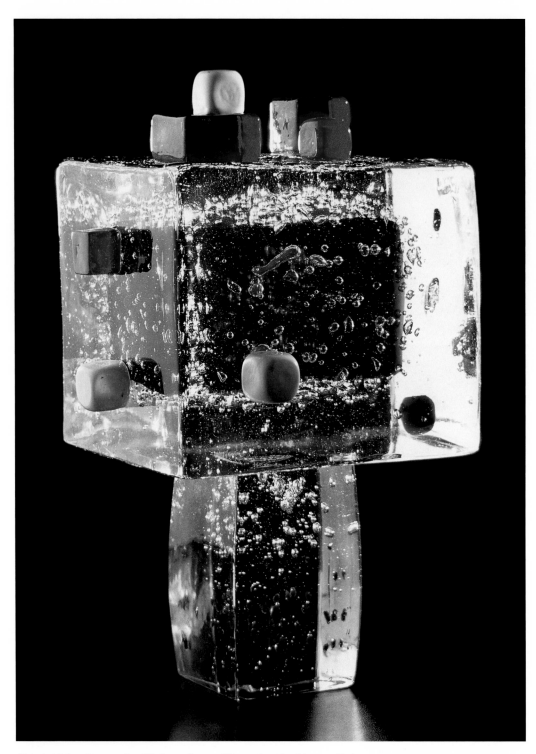

Note to Make a Tree, 1996, solid glass, 16 x 11 x 6 ½, made at Ars Murano, Venice.

have been enormous. Considering that he began working in Italy at the age of forty-seven, he may have rushed to make up for lost time. By 1986, when he was seventy-four, he devised and supervised construction of his first large-scale "relief wall," *Fiesta: Everybody Come Play*, acquired by the Texas Military Institute, a private secondary preparatory school in San Antonio. The eight separate panels are set into an 8-foot-high open steel frame. Three of the panels depict stylized male and female figures, while another three show Willson's characteristic

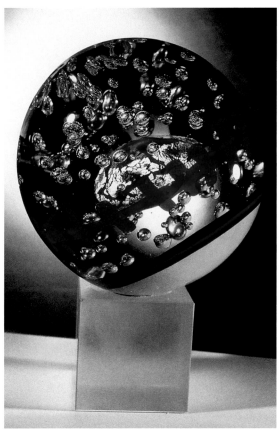

Fence around the World, 1993, solid glass, 12 1/2 x 8 x 8, made at Ars Murano, Venice. Trinity University, San Antonio.

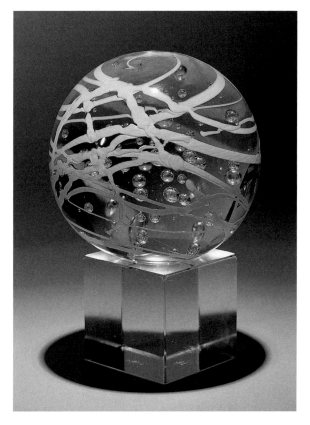

Small Sphere, c. 1995, solid glass, 7 1/4 x 5 diam., signed Robert Willson and Robert Hamon, made at Pilgrim Glass Co., West Virginia. Collection of The Corning Museum of Glass, gift of Margaret Pace Willson, 2001.3.39.

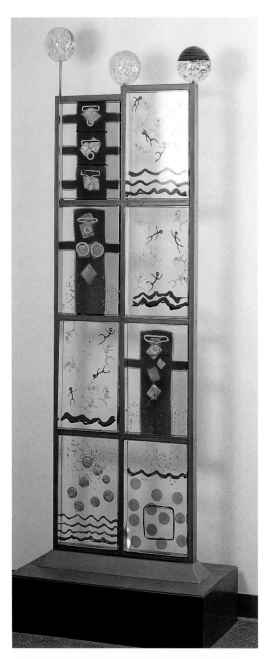

Fiesta: Everybody Come Play, 1986, solid glass
and steel, 96 x 48 x 48. Texas Military Institute,
San Antonio.

Study for *Fiesta: Everybody Come Play*, 1986,
colored pencil on photocopy, 11 x 8½. Collection
of the Leonard S. and Juliette Rakow Research
Library, The Corning Museum of Glass, gift of
Margaret Pace Willson.

pseudo-petroglyph stick figures in jumping and dancing poses. Three glass spheres adorn the panels' tops, like carnival or fiesta decorations. *Fiesta: Everybody Come Play* sets in motion a series of large-scale constructions that are among the artist's most important works.

Grapevine (1992) is a bizarre combination of glass balls, steel, and Plexiglas. *Tribal Trophy Rack* (1995) suspended colored glass spheres on a steel hanging system beneath flat glass panels. Far more successful and definitely in line with the artist's belief that glass had "possibilities for entirely new uses and directions,"[14] *Family Totem* (1993), *The New Doors of Life,* and *Door for All the Horses and the People* (both 1995) push glass forward into large-scale applications with wide-ranging implications for the future. These works also contain traces of the artist's most specific encodings in his symbolic language, drawn from annotated drawings and comments. *Family Totem,* completed at Ars Murano, takes the Northwest Coast Native American genealogical structure of the totem to display ten clear glass blocks of varying sizes. Extremely abbreviated images composed with gold and black lines and circles depict, according to the drawing, from top to bottom: planet, mankind, fire, beauty, growth, home, animal, movement, energy, and elements. A Willson cosmology that dates back to both the content and appearance of Maya hieroglyphs, *Family Totem* is a see-through work, elegant in its trans-

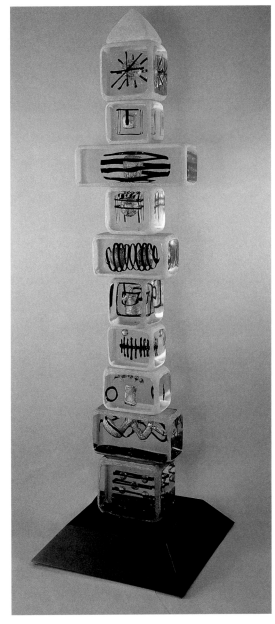

Family Totem, 1993, solid glass, 96 x 24 x 14, made at Ars Murano, Venice. Robert Gordon collection, Miami.

parency and lightness, serious in its profound listing of the artist's view of the underpinnings of tribal life.

Hank Murta Adams, *Map*, 1996, cast glass, steel, and patinated copper, 96 x 48 x 16. Courtesy of the artist and Elliott Brown Gallery, Seattle.

Door for All the Horses and the People is even more ambitious, a single see-through "door" with rectangular and square poured panels of glass set into steel frames. (Hank Murta Adams's wall-mounted *Map* [1996], made of cast glass and sharing Willson's frontal positioning and imagery, is an interesting parallel by a much younger artist.) Willson's *Door for All the Horses and the People* is a reverie on the artist's carefree childhood, when he roamed the Oklahoma Indian reservation on horseback with his Choctaw friend, Bob Dukes. Horses and people share cherished wide-open spaces

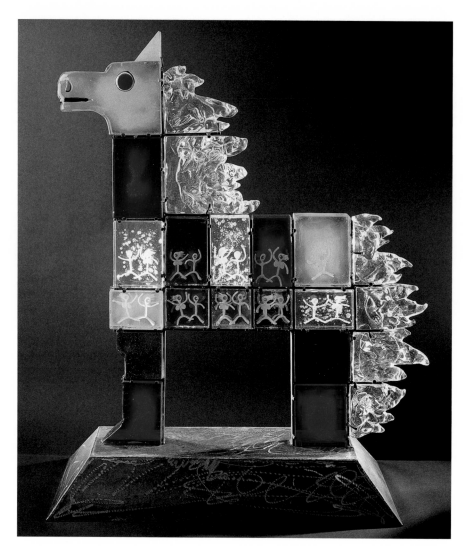

The Real Trojan Horse, 1996, solid glass with steel supports and plinth, 60 x 60 x 36, made at Ars Murano, Venice. Courtesy of Spotted Horse Gallery, Aspen, Colorado.

Study for *The Real Trojan Horse*, 1996, graphite and Crayola on paper, $52\frac{1}{4}$ x 44. Collection of the Leonard S. and Juliette Rakow Research Library, The Corning Museum of Glass, gift of Margaret Pace Willson.

throughout the seventeen panels, all crowned with two "good luck" horseshoes. Large red dots enclosed by black square outlines suggest the hot Texas sun.

The series climaxes with *The New Doors of Life*, Willson's final large-scale undertaking. Deep reds and golds cover fourteen panels in two sections angled slightly toward each other to imply opening double doors. White and red dots summon a variety of interpretations: the Maya counting system of dots and dashes, breasts, schematic figures, eyes, and dividing cells— the very origins of life. Rich in its use of gold, *The New Doors of Life* also conveys decorative and sacred levels of meaning. This piece is Willson's testament to life in all its crowded complexity; it is also the fulfillment of his desire to create large-scale freestanding glass sculpture. As he wrote at the end of *Texas, Venice and the Glass Sculpture Era—Notes:*

> In the future, art must have a sense of being close to man and must show a spirit of elegance, in the sense that elegance is the designation for the most complete and confident expression of the human creative spirit. It will be a beloved object that many generations can understand and enjoy to the honor of both the artist and the viewer.[15]

Door for All the Horses and the People and *The New Doors of Life* are sure to fulfill those roles.

Despite such adventurous undertakings, time was catching up with Robert Willson. After years of cordial and detailed correspondence with Marina Raffaeli about each year's plans (she once wrote Willson, "How many buffaloes this year? A herd?"), Willson mentioned to her in February 1999, "I have not been writing letters much because I have been a little sick."[16] When it became clear that illness would preclude a visit to Venice that year, the artist reluctantly

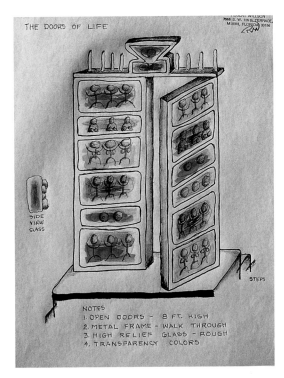

Study for *The Doors of Life*, 1972, mixed media on paper, 11 x 8½.

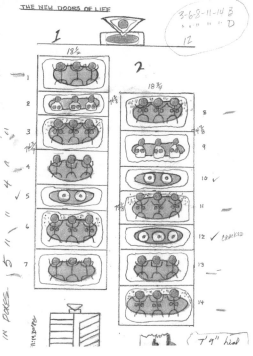

Study for *The New Doors of Life* (detail), 1996, graphite and colored pencil on paper, 11 x 8½. Collection of the Leonard S. and Juliette Rakow Research Library, The Corning Museum of Glass, gift of Margaret Pace Willson.

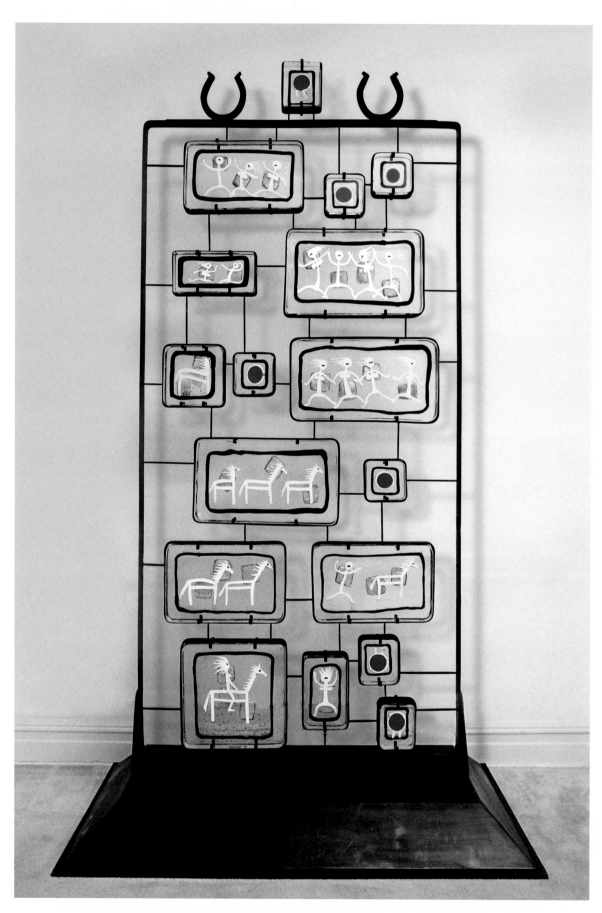

Door for All the Horses and the People, 1995, solid glass, gold leaf, and steel, 112 x 33 ½ x 65, made at Ars Murano, Venice.

agreed to an ingenious idea hatched by his son, Joe, and his assistant, Mary Anne Biggs:

> I will furnish you with a mobile video conferencing camera that could be connected to your computer. In that way, I can "see" you as you work through the internet. I can then direct the process by telling you when to "add more red glass" or to "make something thicker," for instance.[17]

With the aid of Biggs and a computer expert, Elio Raffaeli was eager to set the artist's plan in motion and immediately began exploring methods for implementing it. However, Marina Raffaeli responded cautiously:

> We can understand how you miss everything and everyone here because it's the same for us with you. You know that we really love to work with you and for you and would be very happy to have you and Margaret here, as always, next spring. However, the most important thing is your health.[18]

On New Year's Day 2000, Willson sent ten drawings for the crew to examine in advance of the video-Internet hookup that Joe (now a successful computer engineer with a doctorate from the University of Pennsylvania) was assisting with

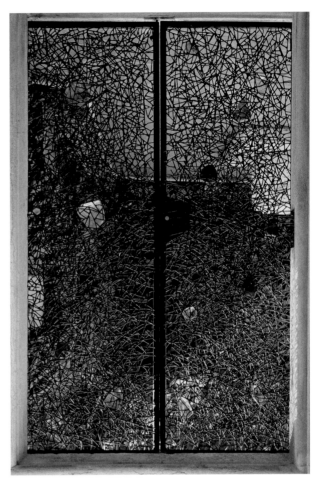

Claire Falkenstein, *Entrance Gates to the Palazzo*, 1961, iron and colored glass, 109 x 35, 109 x 30. Peggy Guggenheim Collezione, Venice (Solomon R. Guggenheim Foundation, New York).

arranging. He ended the letter "Keep in touch. We will have fun." It was his last letter to Ars Murano.[19] After a series of additional setbacks, Robert Willson died peacefully at home of congestive heart failure on June 1, 2000, at the age of eighty-eight. Marina Raffaeli wrote, "A great friend is missing. We remember Robert with immense love."[20]

Although Willson never returned to Venice after 1997 and was prevented by infirmity from pursuing the high-tech plan, he did leave behind a computer-altered version of *Image-Maker* (1978/2000). Filtered through the vivid electronic colors, the picture of the maker (perhaps, after all, a self-portrait) shone through clearly, indicative of how Willson not only adapted successfully to new technologies but remained true to his own creative vision. That unique twentieth-century vision is deserving of continued attention, scrutiny, and critical analysis in the twenty-first century.

Witness to the Mexican Revolution, veteran of World War II, expatriate American in Cold War Italy, and artist influential in reviving the artistic credibility of Murano glass, Robert Willson made art that is accessible, open-ended, and resonant with complex as well as simple meanings. He attempted something few others achieved: creating solid glass sculpture that qualified as art. His rich legacy will be the benchmark for those who come after. His

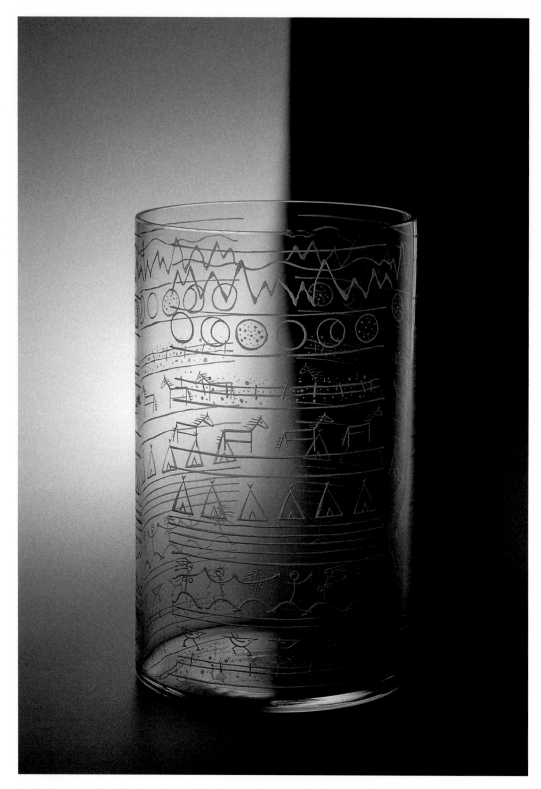

Untitled vase, 1996, solid glass with sandblasting, 14 x 6, made at Ars Murano and S.A.L.I.R., Venice.
Location unknown.

achievements as teacher, curator, and writer will supplement the artistic accomplishments of which he deserved to be so proud.

The world changed an enormous amount in Willson's lifetime. To the south of San Antonio, another Mexican revolution was occurring in 2000, the defeat of the Institutional

Image-Maker, 1978/2000, computer-altered image printed on laser paper, 8 x 10.

Revolutionary Party that had been in power since before his 1935 stay. To the north, in museums and galleries in New York, Chicago, Seattle, and other cities, glass sculpture is accepted and takes many different forms, attracting numerous fine artists. To the west of Texas, in Japan and Taiwan, solid glass sculpture is taking on greater importance, adapting ancient casting methods originally used for bronze. To the east, in Venice, Murano glass is being reassessed by curators, critics, artists, collectors, and dealers. When they gather, Willson will be remembered as the tall, modest Texas cowboy who was content when the Italians noticed.

William Morris, *Petroglyph Vessel*, 1985, blown glass, 20 x 17 x 4 1/2. Collection of Mr. and Mrs. Adam Aronson.

1. Roberto Cammozzo, interview with the author, Venice, March 8, 2001.
2. Elio Raffaeli, interview with the author, Venice, March 8, 2001.
3. Louise Berndt, interview with the author, Venice, March 8, 2001.
4. Luciano Ravagnan, interview with the author, Venice, March 14, 2001.
5. Ibid.
6. Ibid.
7. Raffaeli interview.
8. Margaret Pace Willson, interview with the author, San Antonio, February 9, 2001.
9. Octavio Paz, *Early Poems: 1935–1955* (New York: New Directions, 1973), p. 49.
10. Ibid., p. 49
11. Daniel Piersol and Paolo Rizzi, *Trail of the Maverick: Watercolors and Drawings by Robert Willson, 1975–1998* (New Orleans: New Orleans Museum of Art, 1999).
12. Paz, *Early Poems,* p. 13.
13. Robert Willson, *Texas, Venice and the Glass Sculpture Era—Notes* (San Antonio: Tejas Art Press, 1981), unpaginated.
14. Ibid.
15. Ibid.
16. Robert Willson, letter to Marina Raffaeli, February 22, 1999.
17. Robert Willson, letter to Marina Raffaeli, December 13, 1999.
18. Marina Raffaeli, letter to Robert Willson, December 14, 1999.
19. Robert Willson, letter to Marina Raffaeli, January 1, 2000.
20. Marina Raffaeli, letter to Mary Anne Biggs, June 2, 2000.

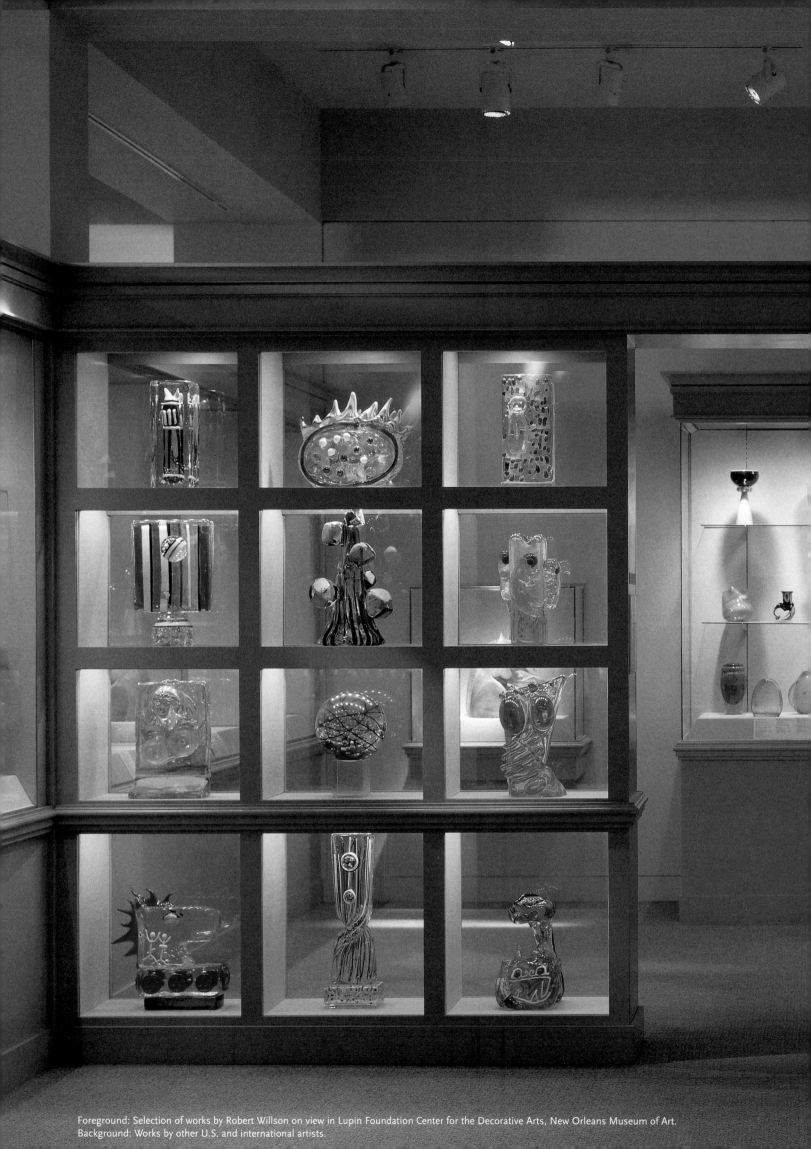

Foreground: Selection of works by Robert Willson on view in Lupin Foundation Center for the Decorative Arts, New Orleans Museum of Art.
Background: Works by other U.S. and international artists.

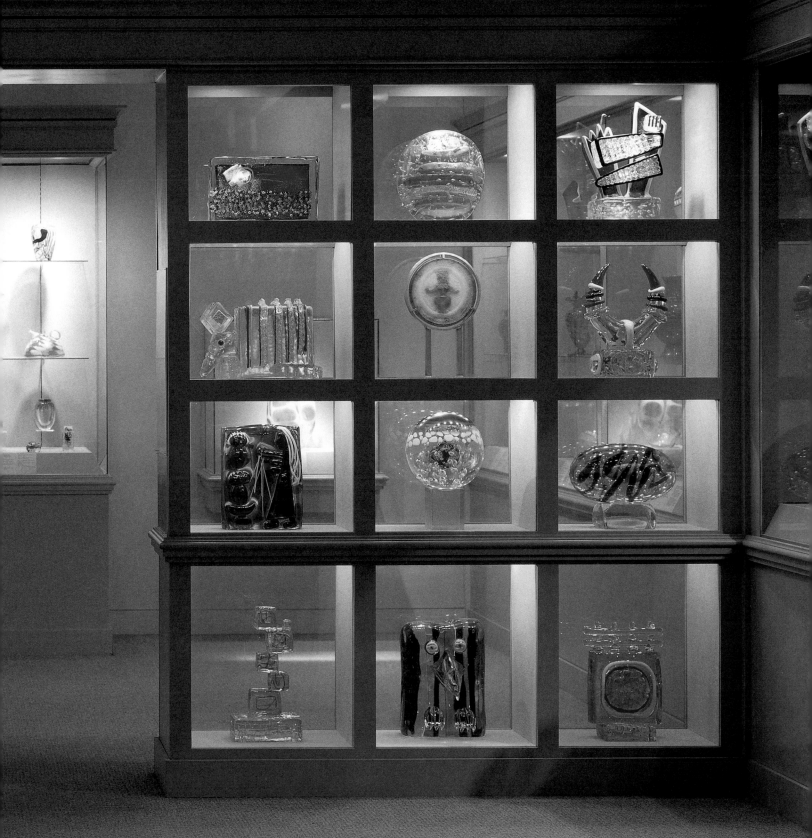

PLATES

Panther Bowl, 1956–58, blown glass with add-on medallions, 7 x 10³/₈ diam., made at Fratelli Toso, Venice.
New Orleans Museum of Art, gift of the artist, 89.138.1.

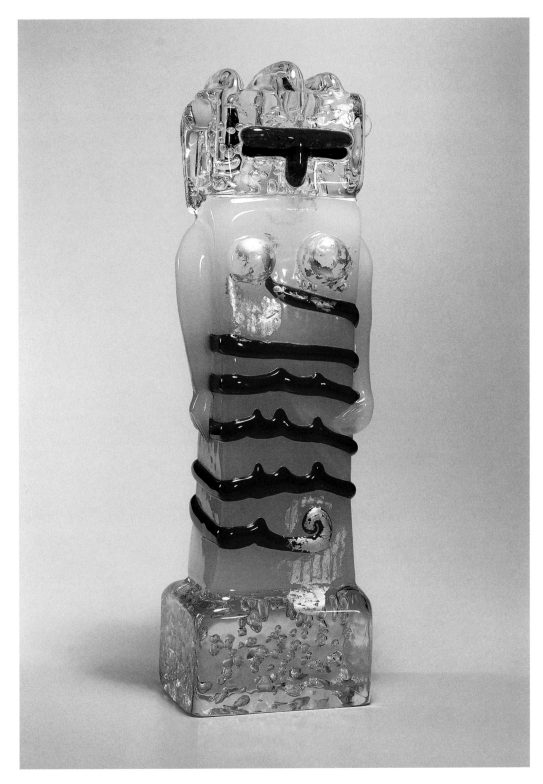

Ranch Doll, c. 1990, solid glass, 21 x 6 1/2 x 5, signed Robert Willson and Pino Signoretto, Venice.
Collection of The Corning Museum of Glass, gift of Margaret Pace Willson, 2001.3.34.

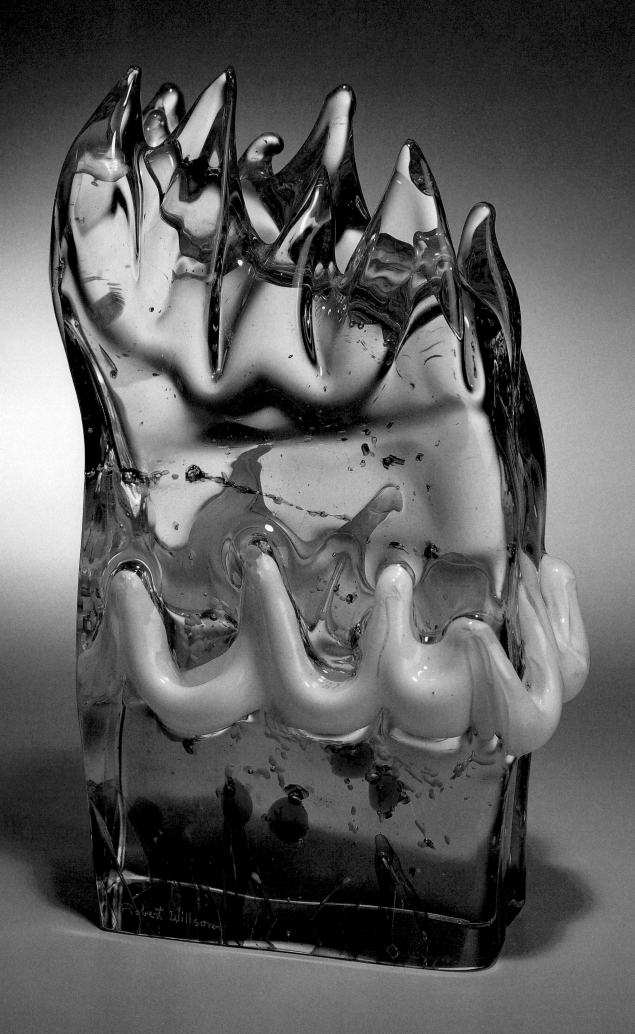

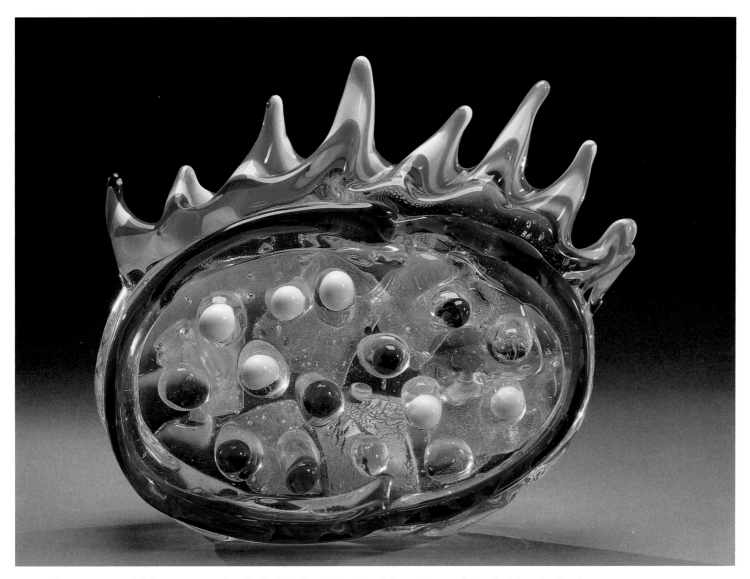

Foam and Wave, c. 1974, solid glass, 14 x 16, made with Alfredo Barbini, Venice. New Orleans Museum of Art, gift of the artist, 89.138.2.

Old Wave (Harbor Wave), undated, solid glass, 14 1/2 x 9 x 6, signed Robert Willson and Barbini/Murano. Collection of The Corning Museum of Glass, gift of Margaret Pace Willson, 2001.3.35.

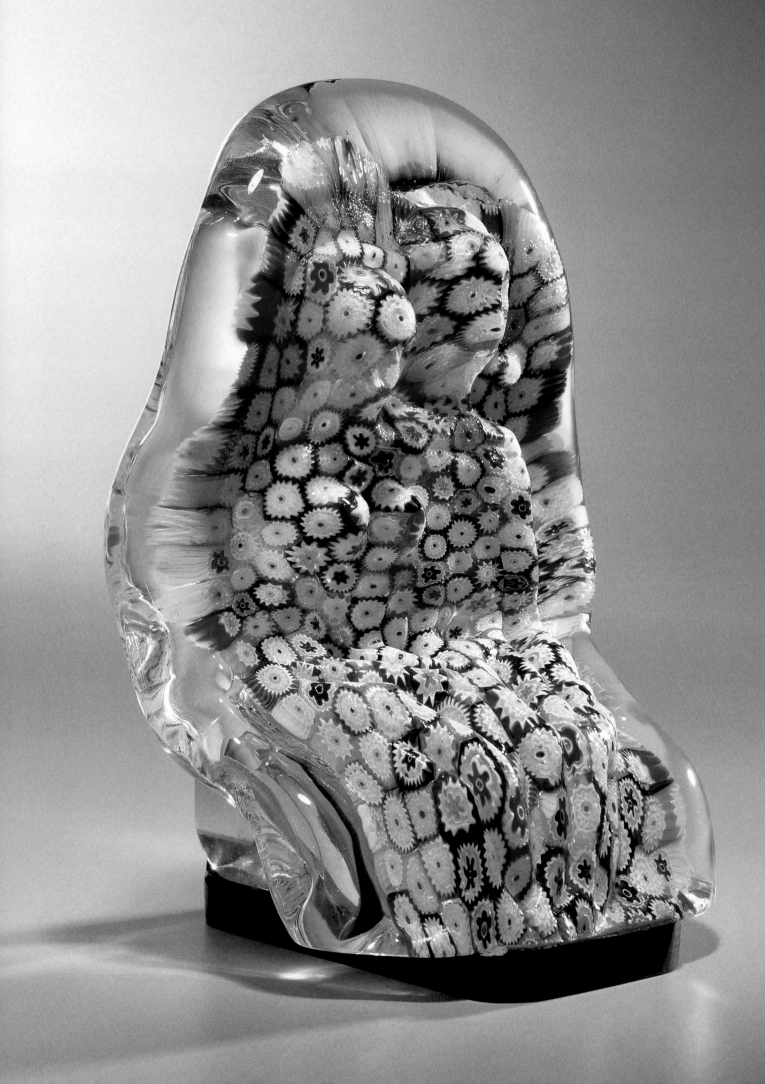

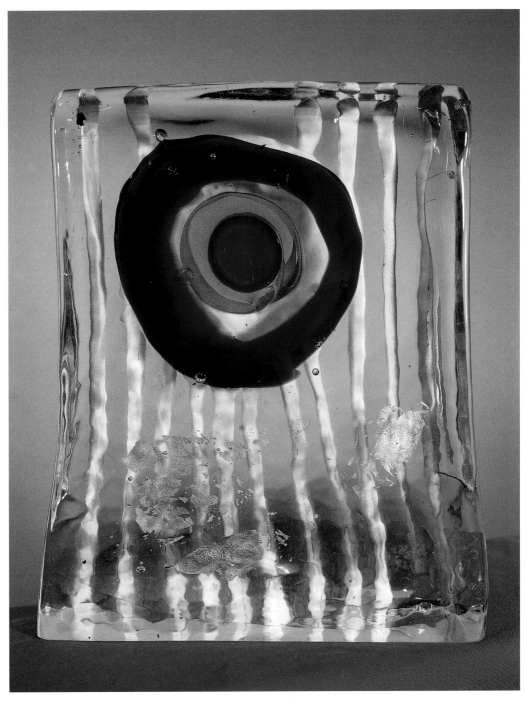

Magic Eye, 1976, solid glass, 14 ¹/₂ x 13 x 5. Trinity University, San Antonio.

King and Queen, 1974, solid glass, 12 x 9 ¹/₂ x 7. Collection of The Corning Museum of Glass, gift of Margaret Pace Willson, 2001.3.19.

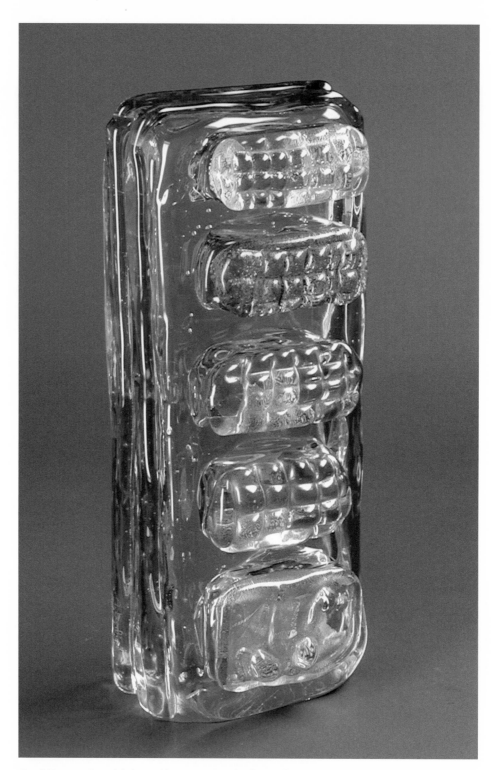

Ranch Totem, 1983, solid glass, 16 ¹/₂ x 7 x 5, signed Robert Willson and
A. Barbini/Murano. Los Angeles County Museum of Art, gift of the estate of
Robert Willson, 2001.

Stonehenge, c. 1978, stoneware and glazes with walnut base, 8 x 14 x 3. Location unknown.

Ancient Sumer, 1978, solid
glass, 8¹/₂ diam.

The Big Lightning, 1978, watercolor on paper, 30 x 35.

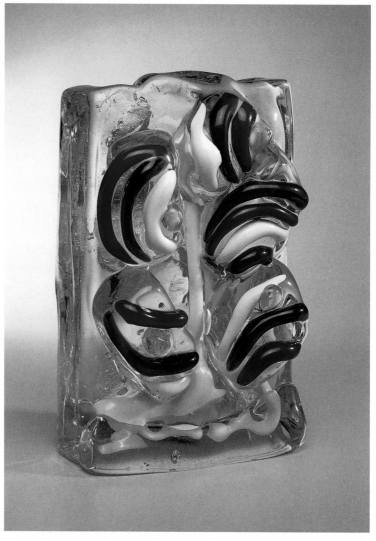

Love Letter, 1983,
solid glass,
16 1/2 x 11 x 3 1/2,
signed Robert Willson
and Barbini/Murano.
Collection of
The Corning Museum
of Glass, gift of
Margaret Pace
Willson, 2001.3.21.

Life Renewal, 1980, solid glass, 16 1/2 x 9 x 8. The Mint Museum of Craft +
Design, Charlotte, North Carolina, gift of Margaret Pace Willson, 2001.47.

Tree Altar, 1983, solid glass, 14 x 9 x 5, signed A. Barbini. Collection of The Corning
Museum of Glass, gift of Margaret Pace Willson, 2001.3.22.

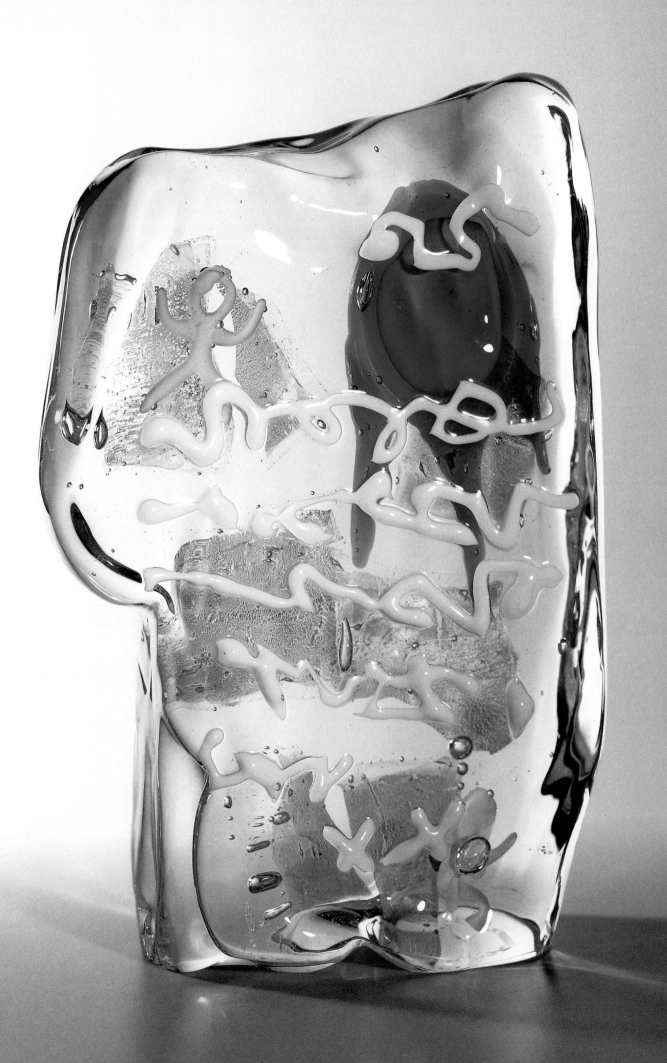

Untitled, c. 1990, mixed aqueous media on paper, 14 x 20.

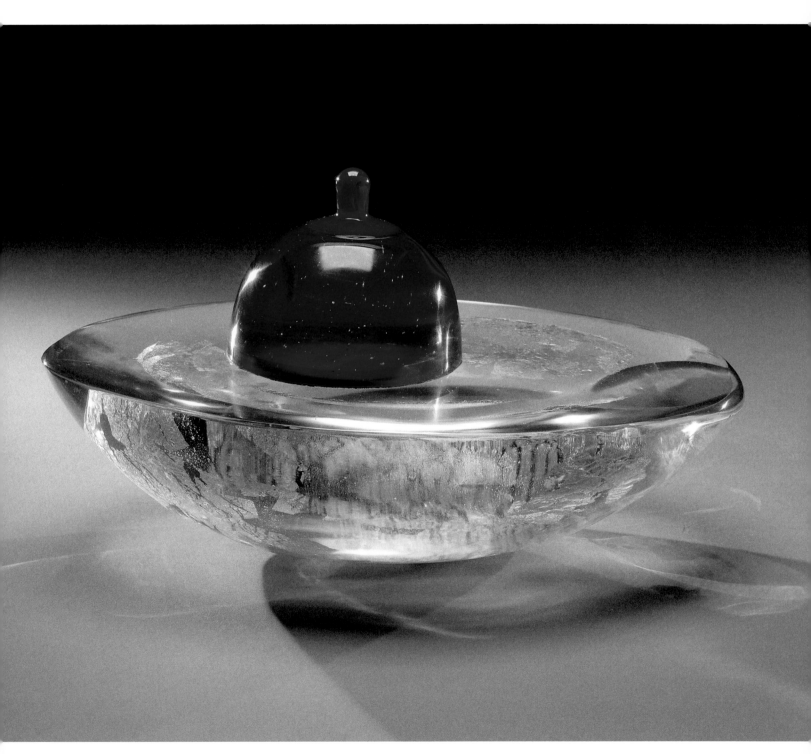

Venus on the Half Shell, 1976, solid glass, 7 ½ x 14 ½ x 6, made with Loredano Rosin, Venice. New Orleans Museum of Art, gift of the artist, 89.138.3.

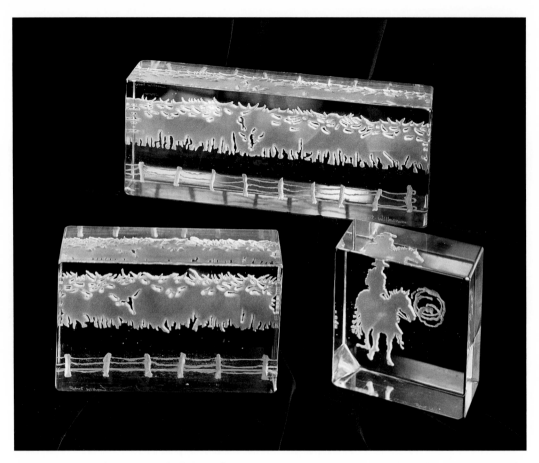

Night Herd, 1983, etched cast crystal (clockwise from top), 12 x 20 x 4, 8 x 8 x 4, 10 x 12 x 4, made at Ars Murano and S.A.L.I.R., Venice. Location unknown.

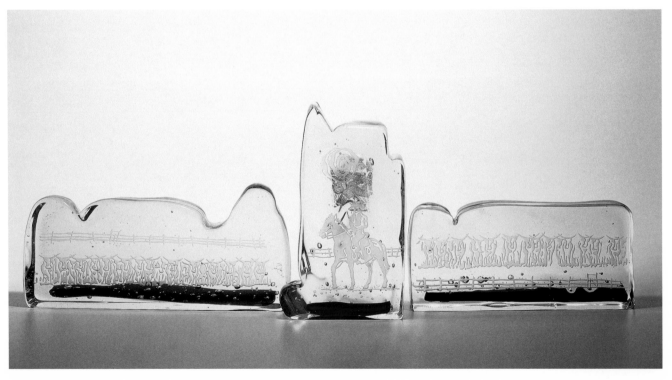

Night Watch (with Herd), 1985, solid glass with etching (from left), 8 x 18 x 3 1/2, 13 1/2 x 7 x 3 1/2, 7 x 15 x 3 1/2, made at Ars Murano and S.A.L.I.R., Venice. Collection of The Corning Museum of Glass, gift of Margaret Pace Willson, 2001.3.24.

Coyote, c. 1990, solid glass, 16 h., made with Pino Signoretto, Venice.

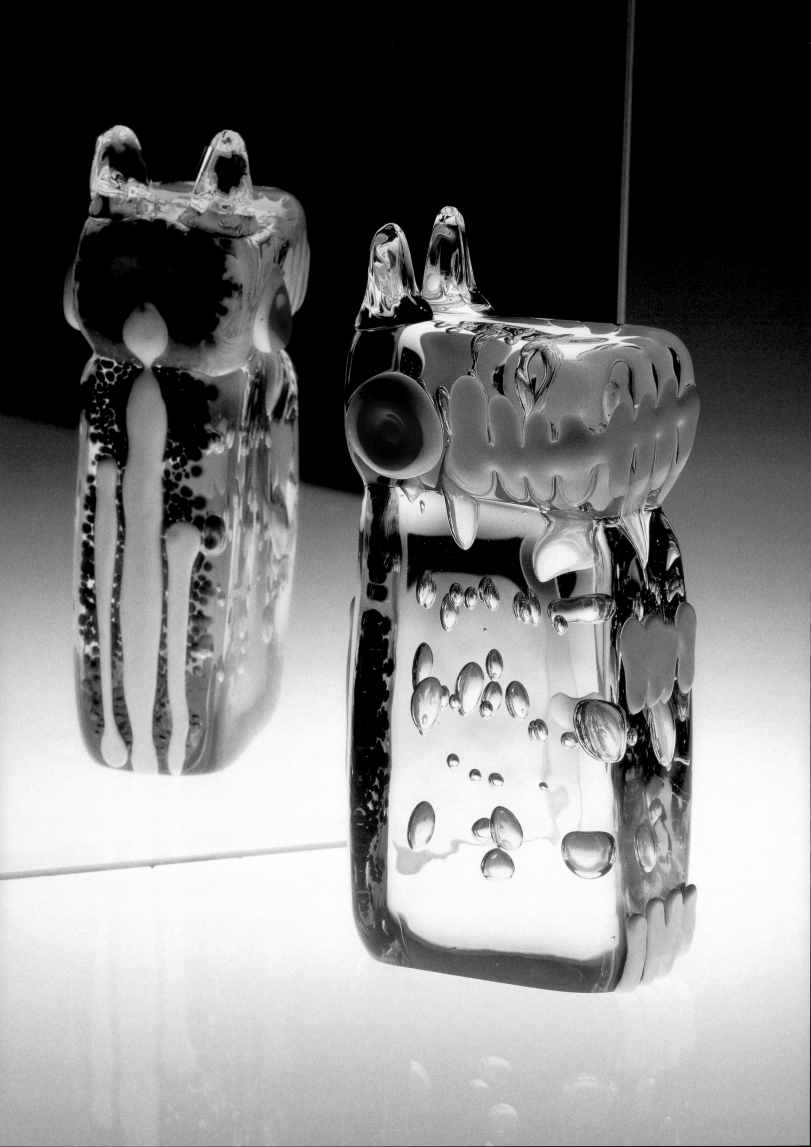

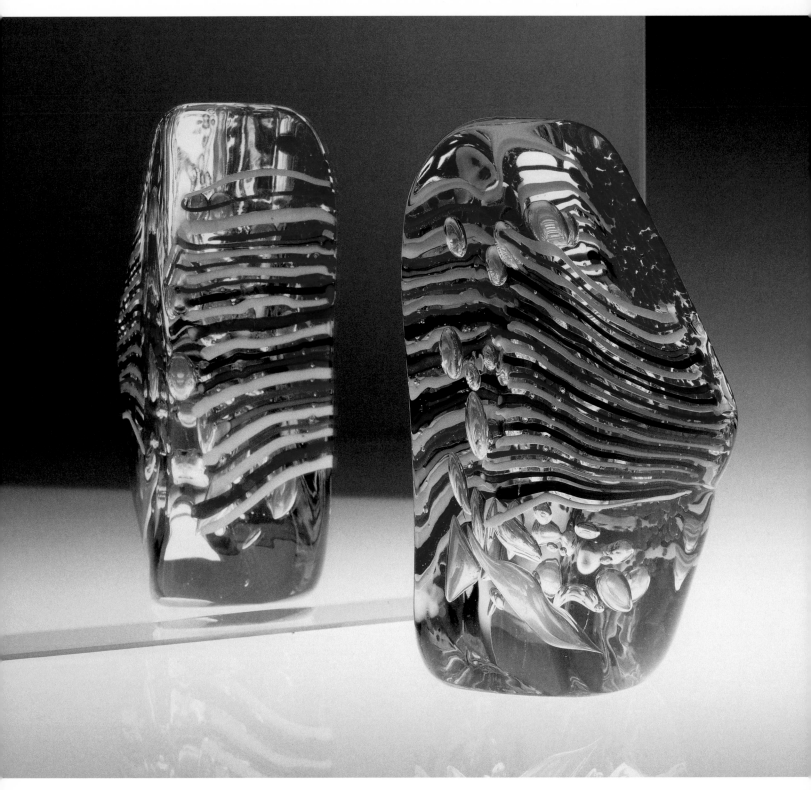

Red and White Chisel, 1992, solid glass, 19 h., made at Ars Murano, Venice.

Xilonen: Goddess of Young Corn, 1978, solid glass, 16 ¹/₂ x 12 x 6 ¹/₂, made with Alfredo Barbini. American Craft Museum, New York, gift of Margaret Pace Willson, 2001.18.

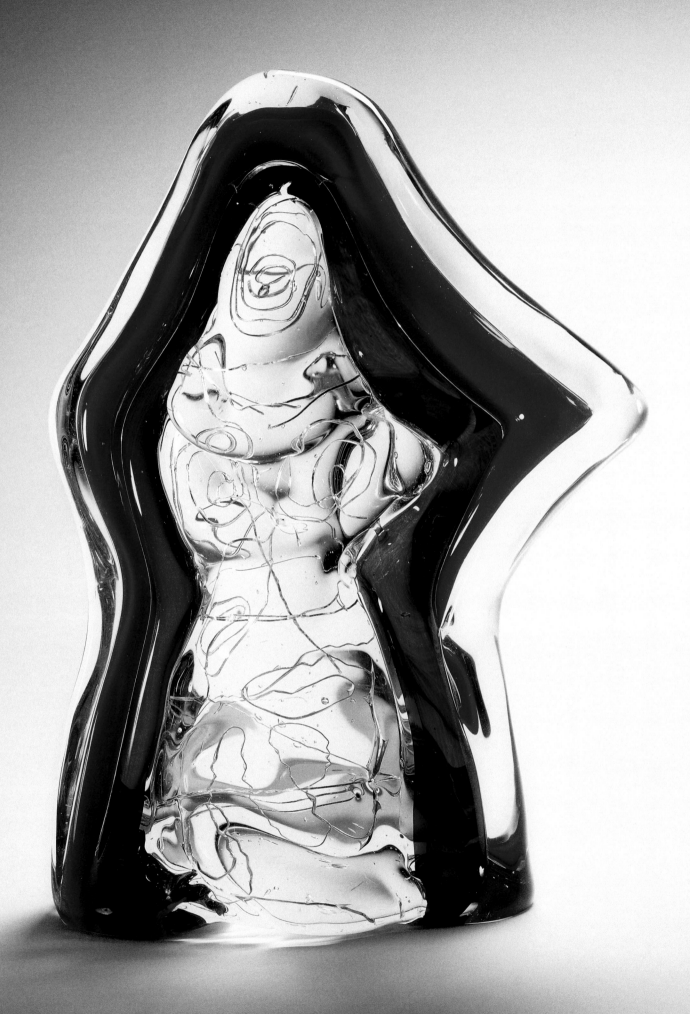

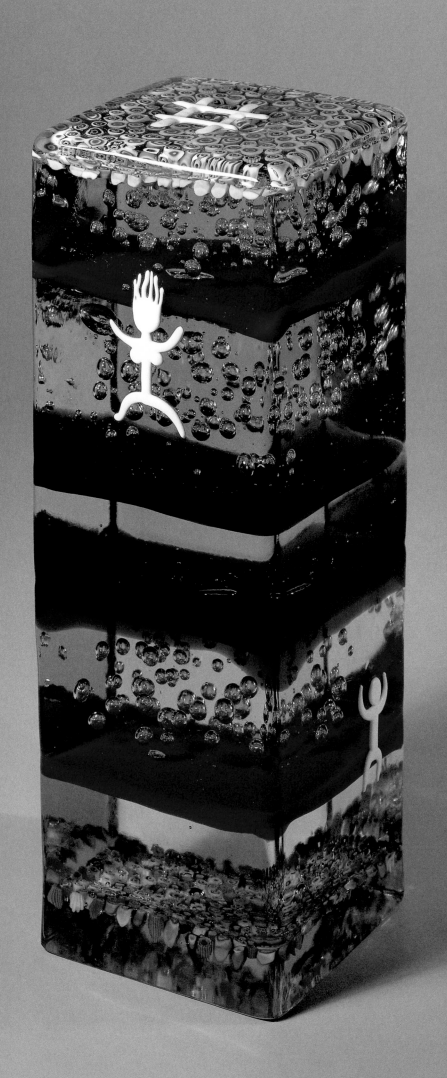

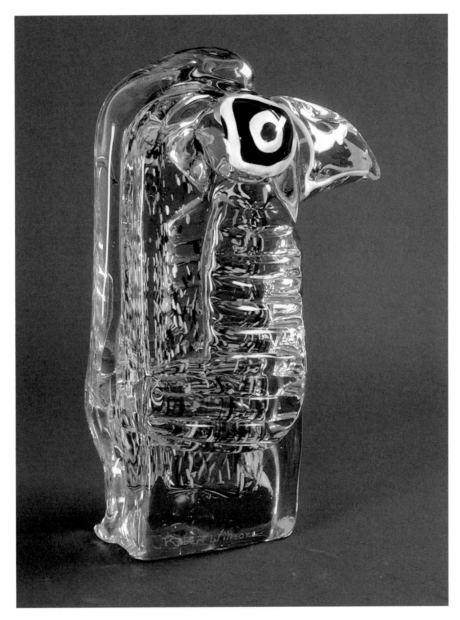

Eagle Dancer, 1980, molded glass, 17 x 11 x 7, signed Robert Willson and A. Barbini.
Collection of the Toledo Museum of Art, gift of Margaret Pace Willson.

Elevator, 1990, solid glass, 16 ½ x 6 x 6.
Charles A. Wustum Museum of Fine Arts
Permanent Collection, Racine, Wisconsin,
gift of Margaret Pace Willson.

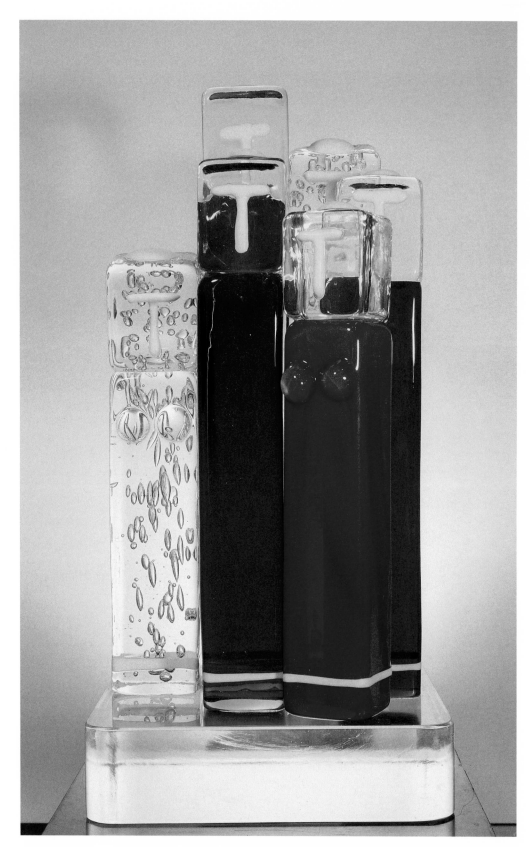

The Observers, 1992, solid glass, 20 x 14 x 8, made at Ars Murano, Venice.

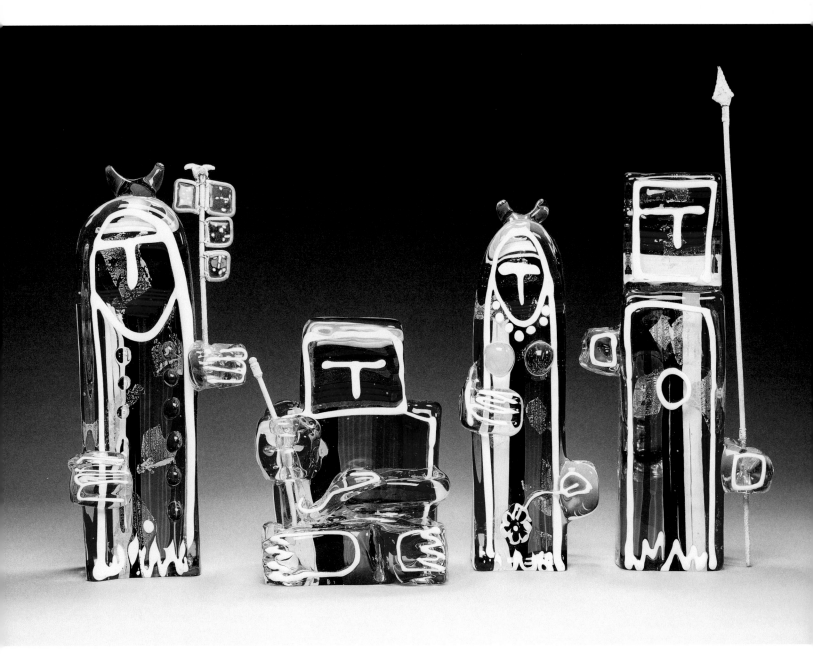

Tribal Group, 1979, glass with metallic paint (from left): 20 x 9 x 4 *(Chief)*; 12 1/8 x 9 x 6 *(Image-Maker)*; 18 1/8 x 7 x 5 *(Princess)*; 24 3/8 x 10 x 6 7/8 *(Hunter)*. San Antonio Museum of Art, purchased with funds provided by Mr. and Mrs. Albert C. Droste, 85.2a–d.

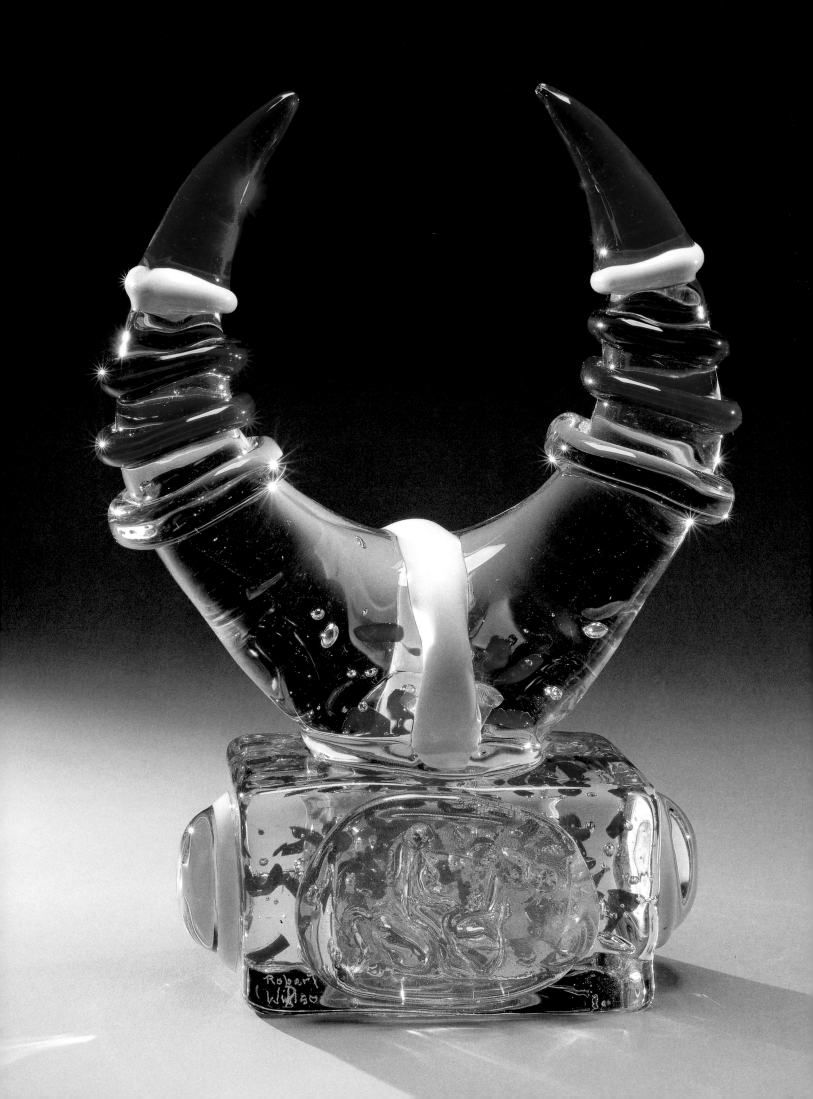

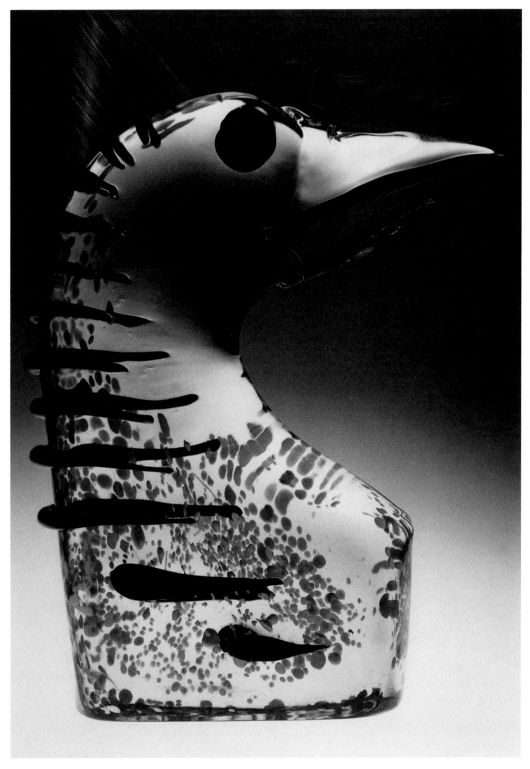

Great Bird, 1983, solid glass, 16 h., made with Pino Signoretto, Venice.

Texas Longhorn,
c. 1984, solid glass,
16 h., made with
Pino Signoretto,
Venice. New
Orleans Museum
of Art, gift of the
artist, 86.385.

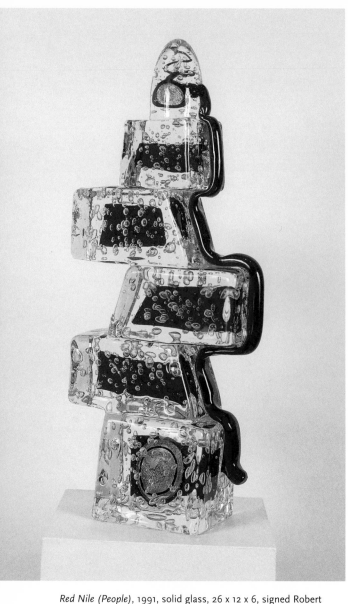

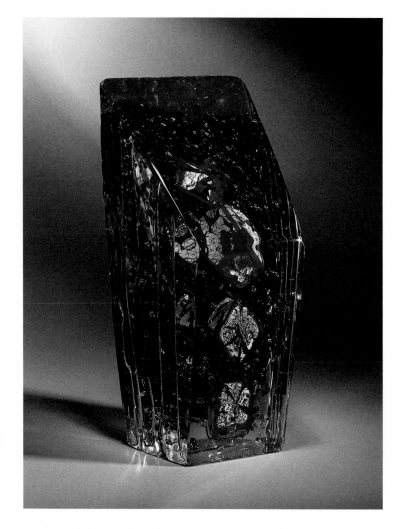

Tree Symbol, 1984, solid glass, 17 h., made with Alfredo Barbini, Venice. New Orleans Museum of Art, gift of the artist.

Red Nile (People), 1991, solid glass, 26 x 12 x 6, signed Robert Willson and E. Raffaelli. Collection of The Corning Museum of Glass, gift of Margaret Pace Willson, 2001.3.27.

Blue Chisel, 1990, solid glass, 17 ¹/₂ x 7 ¹/₂ x 7, signed Robert Willson and A. Barbini. Collection of The Corning Museum of Glass, gift of Margaret Pace Willson, 2001.3.26.

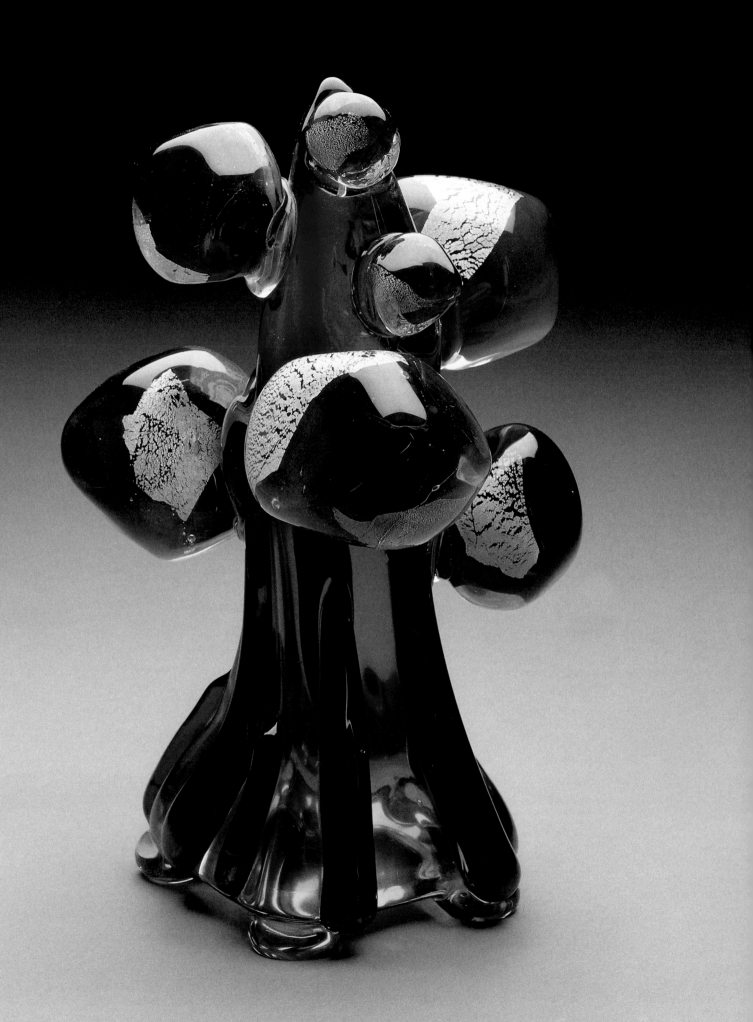

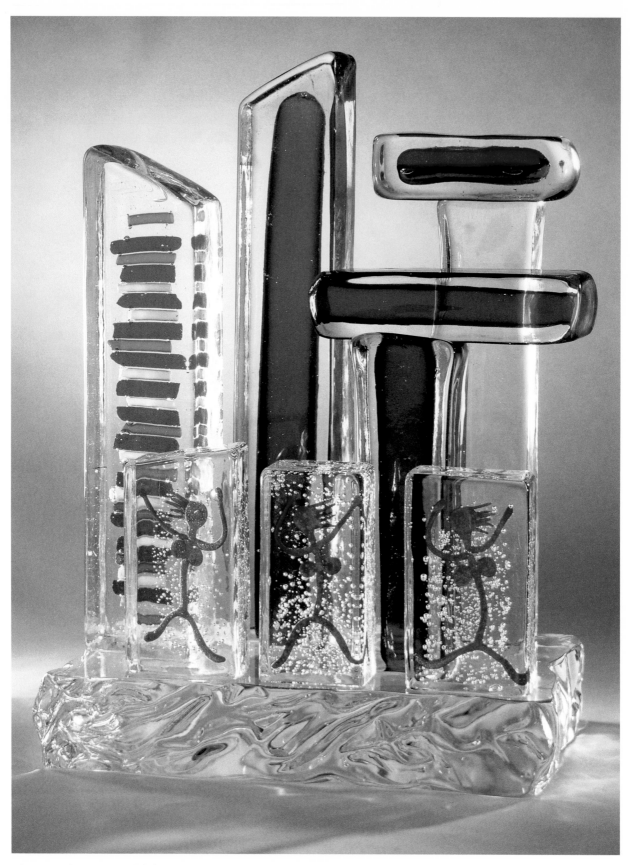

Rites at Stonehenge, 1996, solid glass, 18 x 13 x 9, made at Ars Murano, Venice.

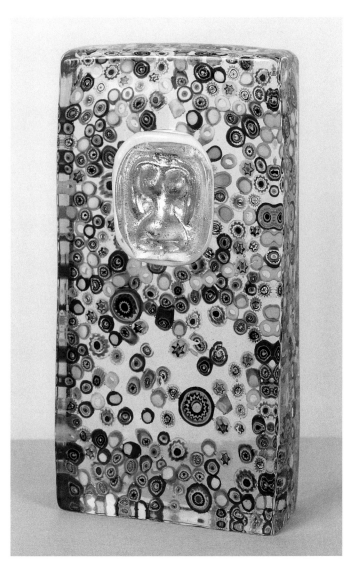

Millefiore Treasure, 1994, solid glass, 12 ½ x 6 ½ x 2 ½ , made at Ars Murano, Venice. Courtesy of Parchman-Stremmel Gallery, San Antonio.

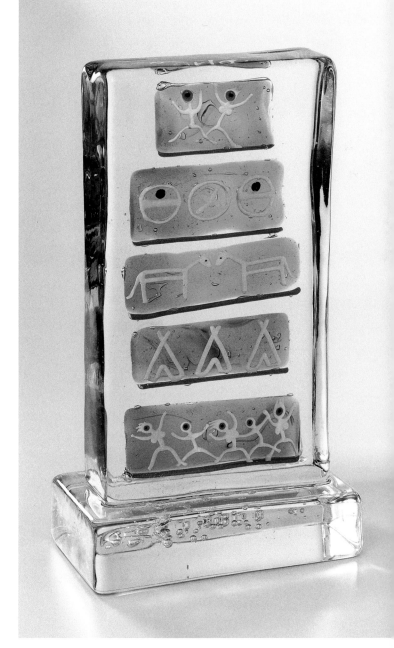

Family History, 1995, solid glass, 20 x 12 x 5, made at Ars Murano, Venice. Courtesy of Ravagnan Gallery, Venice.

Study for *Sculptor*, 11¹/₂ x 8, mixed media on paper.

Sculptor, 1983, solid glass,
18 x 12 x 4, made with Alfredo
Barbini, Venice.

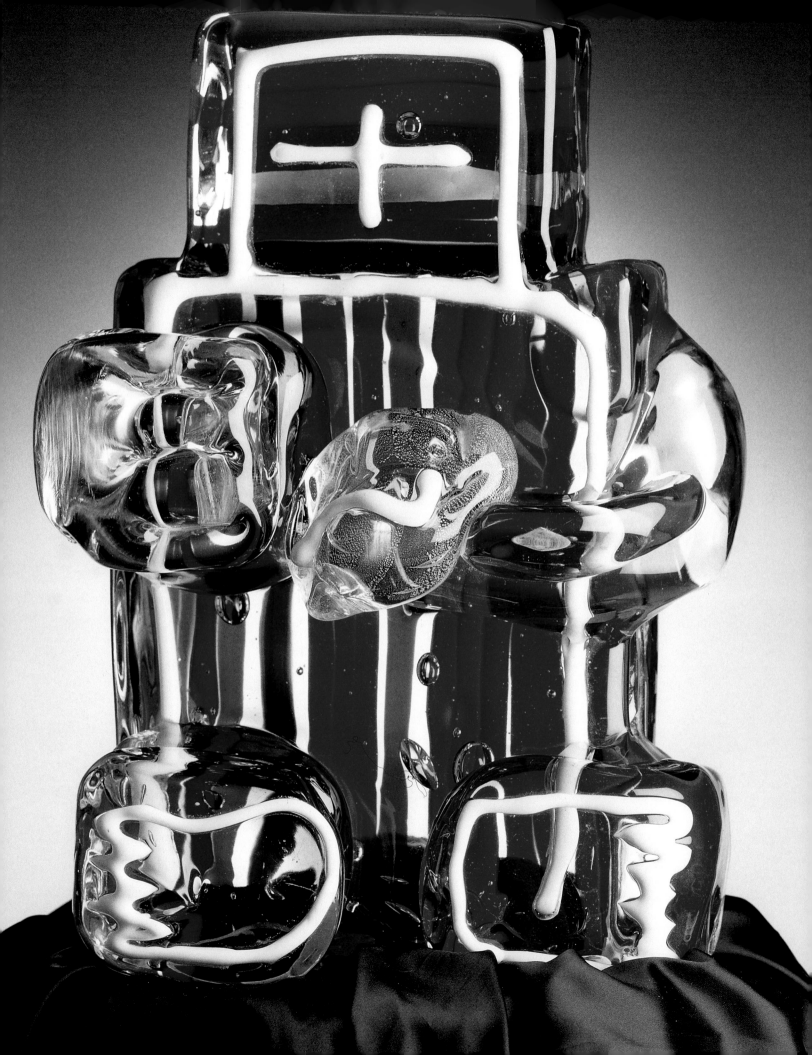

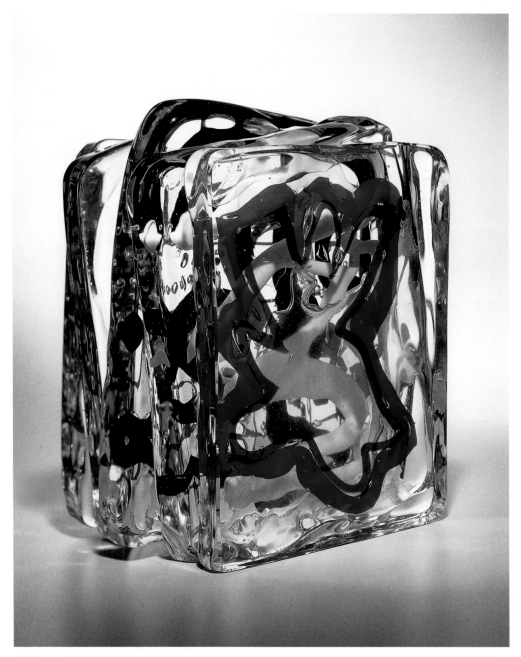

The Textures, 1996, solid glass, 13 x 13 x 7, made at Ars Murano, Venice. Collection of The Corning Museum of Glass, gift of Margaret Pace Willson, 2001.3.30.

Dreaming Girl, 1996, solid glass, 24 x 9 x 5, made at Ars Murano, Venice.

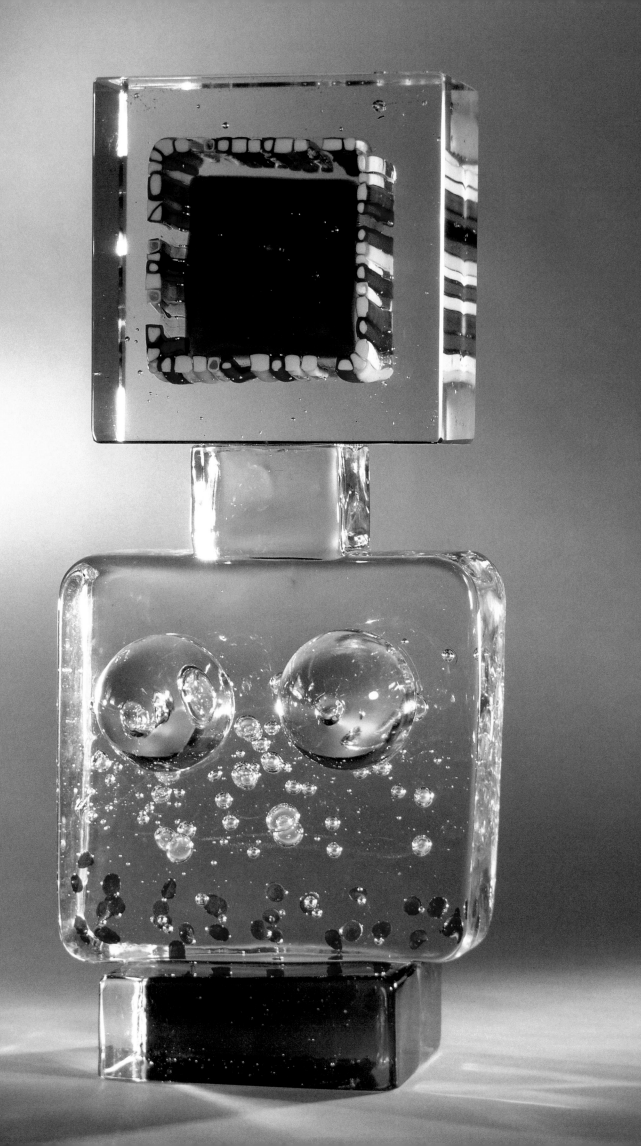

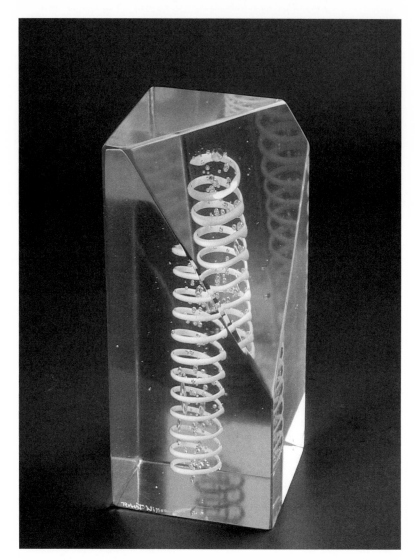

White Spiral, 1997, solid glass, 12 x 5 x 5.

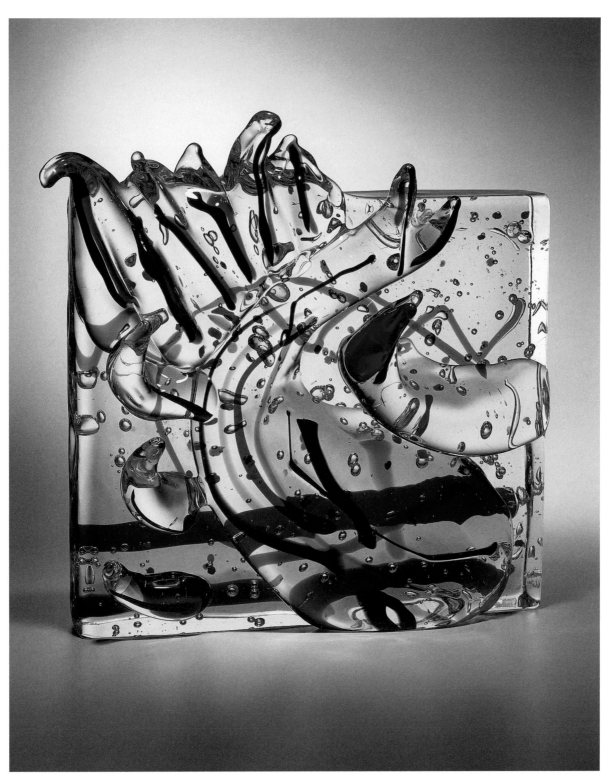

Ocean Music, 1997, solid glass, 17 x 17 x 5 ½, made at Ars Murano, Venice. Collection of The Corning Museum of Glass, gift of Margaret Pace Willson, 2001.3.32.

Beastie Dreams, 1997,
solid glass, 19 ¹/₂ x
19 ¹/₂ x 4, made at Ars
Murano, Venice.
American Craft
Museum, New York,
gift of Margaret Pace
Willson, 2001.17.

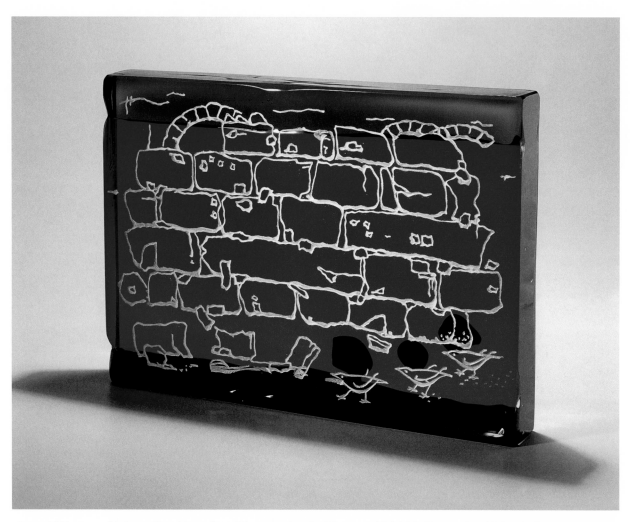

Roman Wall, 1997, solid glass with etching, 11 ¹/₄ x 16 ¹/₂ x 2, made at Ars Murano and S.A.L.I.R., Venice, signed Robert Willson.
Collection of The Corning Museum of Glass, gift of Margaret Pace Willson, 2001.3.33.

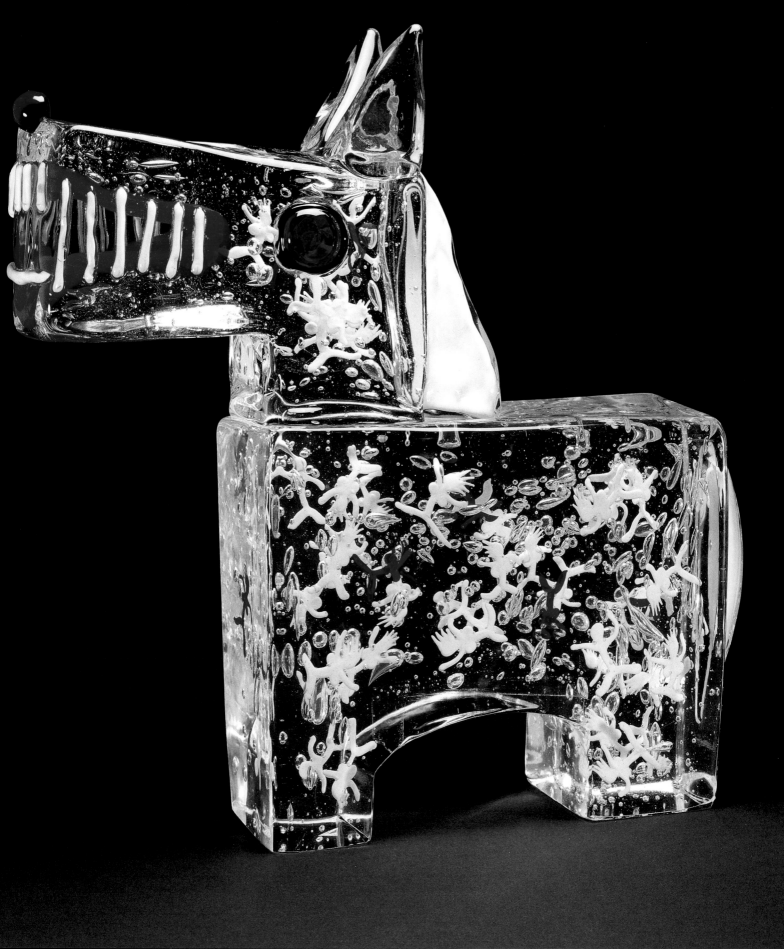

On Target, 1988, solid glass, 24 x 10 x 5, made at Ars Murano, Venice.

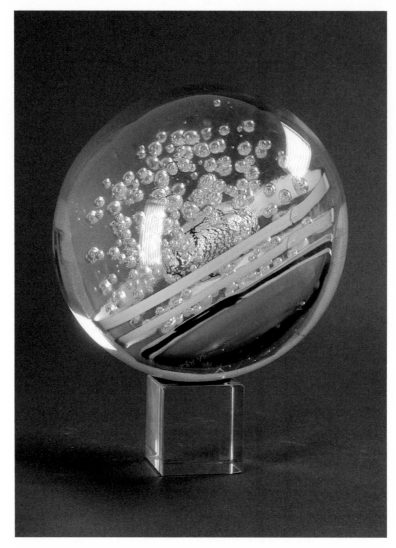

One of Those Stars, 1995, solid glass, 10 diam., made at Ars Murano, Venice.

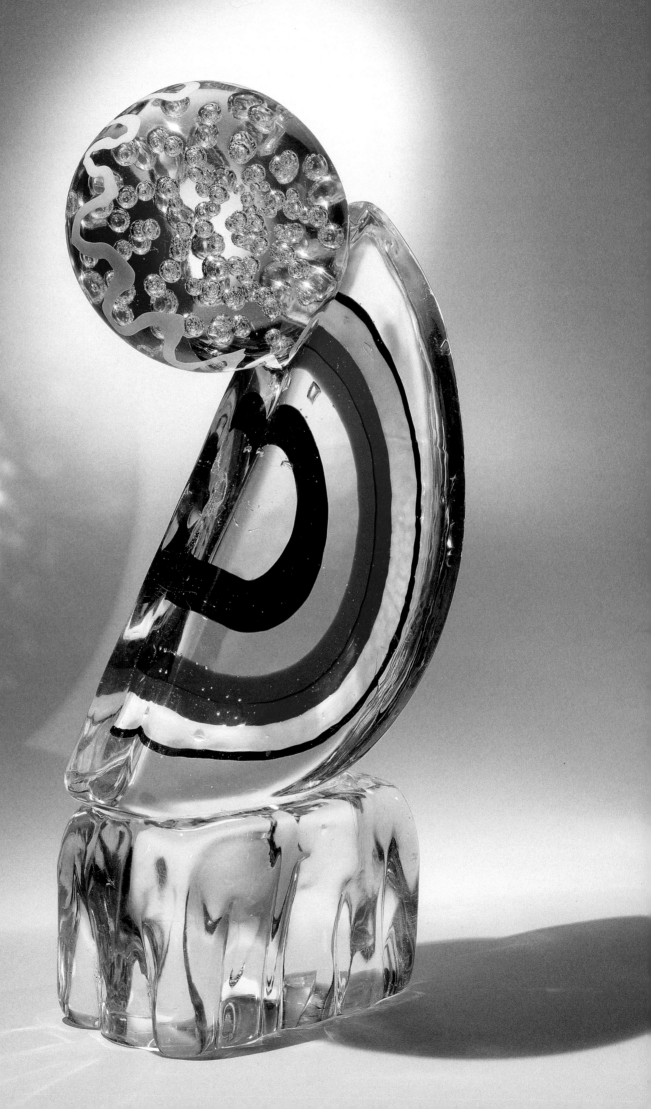

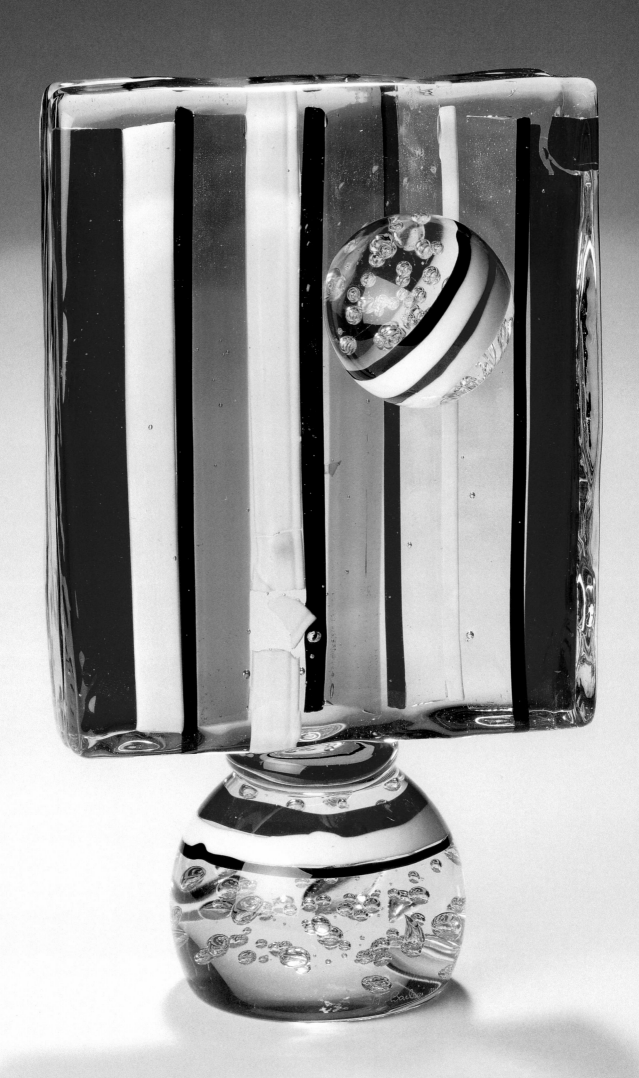

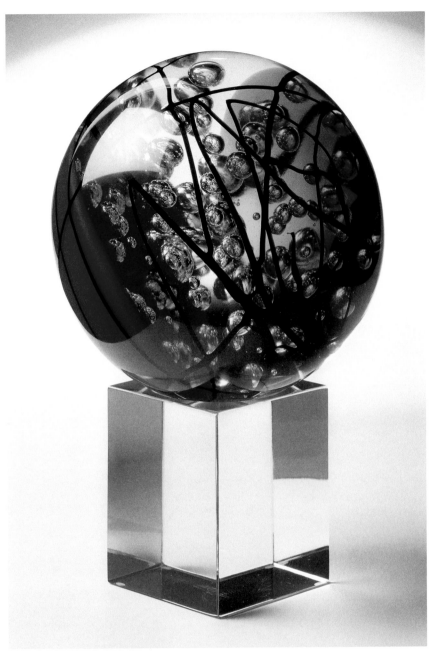

Subtle Sky, 1988, solid glass, 12 diam.

Rainbow, 1988, solid glass, 17³/₄ x 5, made with Alfredo Barbini, Venice. New Orleans Museum of Art, gift of the artist, 89.138.26.

Study, undated, mixed media on paper, 11 x 8¹/₂.

Study for *The History of the Earth,* undated, mixed media on paper, 12 x 20.

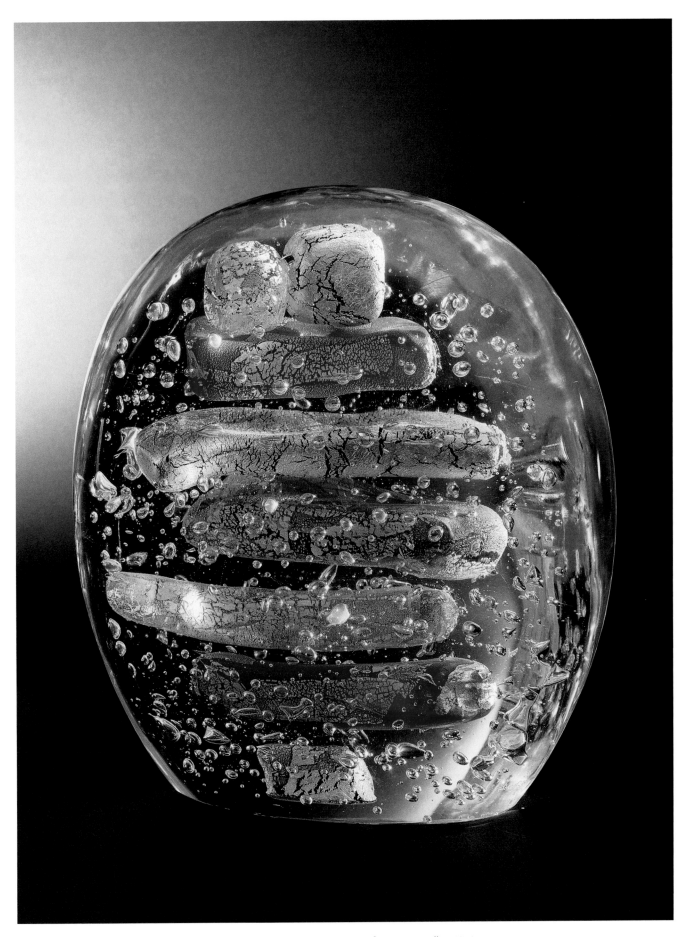

Gold Strata, 1993, solid glass, 18 x 12 x 4, made at Ars Murano, Venice. Courtesy of Ravagnan Gallery, Venice.

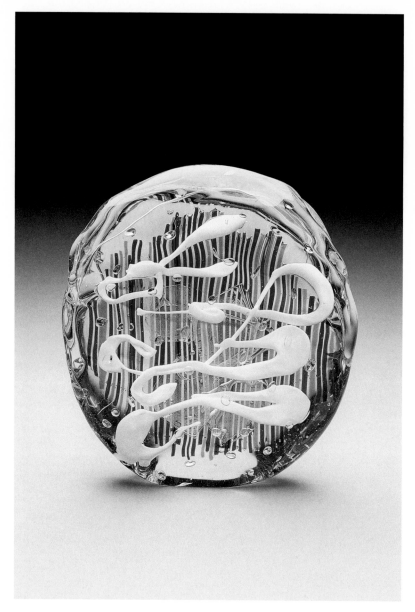

Coral Reef, 1989, solid glass, 13 x 12 x 4, made with Pino Signoretto, Venice.
Collection of University of Texas, San Antonio.

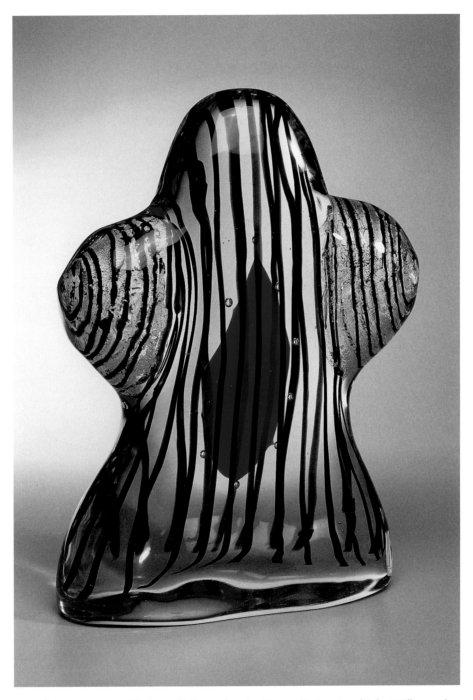

Lady of Character, 1992, solid glass, 17 1/2 h., made at Ars Murano, Venice, signed Robert Willson and E. Raffaeli. Collection of The Corning Museum of Glass, gift of Margaret Pace Willson, 2001.3.29.

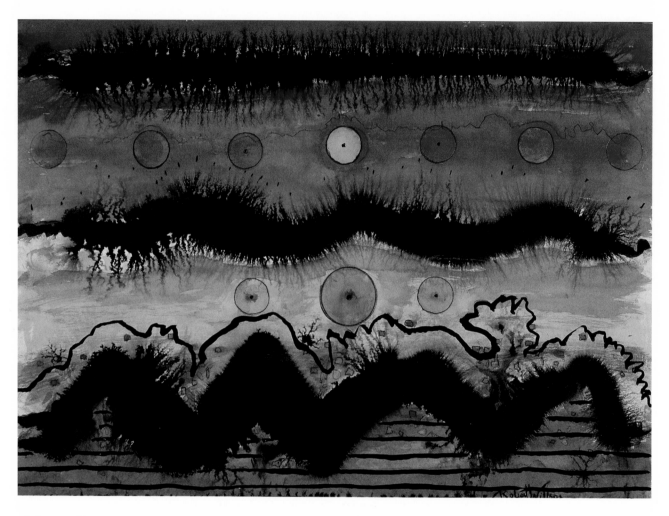

All the Beautiful Sunsets, Mexico, 1994, watercolor and mixed media on paper, 25 x 31.

Untitled vase, 1996, solid glass
with sandblasting, 14 x 6, made at
Ars Murano and S.A.L.I.R., Venice.
Location unknown.

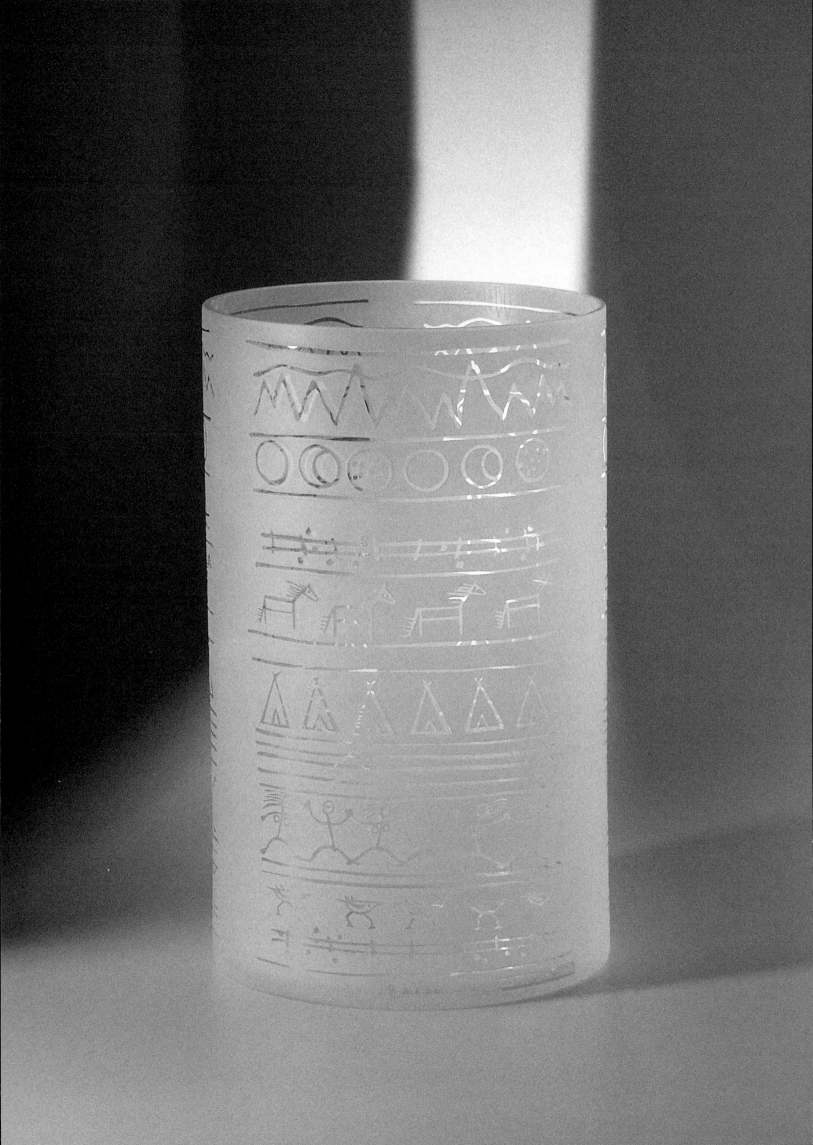

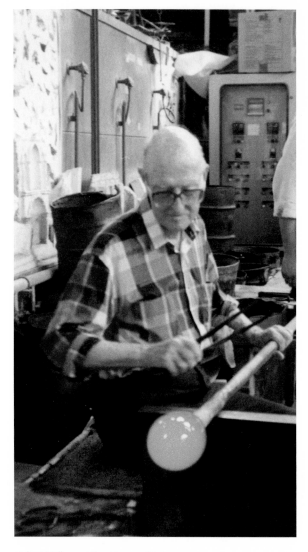

Robert Willson at Ars Murano, Venice, 1995.

CHRONOLOGY

Born May 28, 1912, Mertzon, Texas

Died June 1, 2000, San Antonio

EDUCATION

Southern Methodist University, Dallas, 1930–31

University of Texas, Austin, B.A., 1934

San Carlos Academy of Art, Mexico City, Mexico, 1935

University of Fine Arts, San Miguel de Allende, Mexico, M.F.A., 1941

TEACHING EXPERIENCE

Texas Wesleyan University, Fort Worth, 1940–41; 1945–46; 1947–48

Trinity University, San Antonio, 1946–47

Nob Hill Pottery, Mountainburg, Arkansas, 1948–50

University of Miami, Coral Gables, Florida, 1952–77

AWARDS AND HONORS

Scholarship, Southern Methodist University, 1930–31

Farmer International Foreign Exchange Fellowship, University of Texas, 1935

Merit Prize, San Francisco Museum of Modern Art Annual Exhibition, 1957

Member, Istituto Veneto per il Lavoro, Venice, 1968

Academician with Gold Medal, Italian Academy of Arts and Labor, Salsomaggiore Terme, Italy, 1980

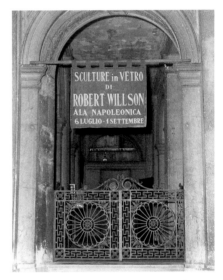

Banner for Correr Museum exhibition of Robert Willson's work, Venice, 1968.

SELECTED SOLO EXHIBITIONS

1964 *Robert Willson: Sculpture in Glass,* Bevilacqua la Masa Gallery, Venice

1966 *New Glass Sculpture by Robert Willson,* Harmon Gallery, Naples, Florida

1968 *Robert Willson: Sculture in Vetro,* Correr Museum, Venice

1970 *Robert Willson: Glass Sculpture,* Ringling Museum of Art, Sarasota, Florida; toured to Norton Gallery of Art, West Palm Beach, Florida; Corning Museum of Glass, Corning, New York; Vizcaya–Dade County Art Museum, Miami

1973 *Solid Glass Sculpture by Robert Willson,* Belgian Pavilion, Hemisfair, San Antonio Art League

1974 *Robert Willson: Glass and Watercolors,* Brickell Gallery, Miami

1976 Galerie 99, Bay Harbor Islands, Florida

 Robert Willson: Glass Sculptor, Harmon Gallery, Naples, Florida

1979 *Robert Willson: Sculpture in Glass,* University Art Museum, University of Texas, Austin

Installation view of *Robert Willson and Margaret Pace Willson,* Newcomb Gallery, Tulane University, New Orleans, 1985.

Works by Robert Willson at *982*, Venice, 1994. *Family Totem* (far left).

1981	*Robert Willson: Glass Sculpture,* Marion Koogler McNay Art Museum, San Antonio
1983	Foster Harmon Gallery, Sarasota, Florida
1984	*Sculture in Vetro: Robert Willson,* Ca' Pesaro Museum of Modern Art, Venice
	Ravagnan Gallery, Venice
1986	Art Institute for the Permian Basin, Odessa, Texas
1988	*The Glass Sculpture of Robert Willson,* San Antonio Museum of Art
1989	San Angelo Museum of Fine Arts, San Angelo, Texas
	Lyons Matrix Gallery, Austin
	Stein Gallery, Portland, Maine
	Robert Willson: Glass Sculptures/Sculture in vetro, Ravagnan Gallery, Venice
1990	*Sculpture in Glass: Works by Robert Willson,* New Orleans Museum of Art
1991	*Robert Willson: Works in Glass,* Martin Museum of Art, Baylor University, Waco, Texas
1992	Lyons Matrix Gallery, Austin
1993	New Mexico Museum of Art, Santa Fe
1996	*Transparencies: Glass Sculpture by Robert Willson,* Ellen Noel Art Museum of the Permian Basin, Odessa, Texas
	Venezia Aperto Vetro, Venice
1997	*Robert Willson: Glass Sculptor,* Turning Point Gallery, Miami
1999	*Trail of the Maverick: Watercolors and Drawings by Robert Willson, 1975–1998,* New Orleans Museum of Art; toured to Masur Museum, Monroe, Louisiana; Centenary College, Shreveport, Louisiana
2001	*Robert Willson: From the Permanent Collection,* San Angelo Museum of Fine Arts, Texas

SELECTED GROUP EXHIBITIONS

Poster for *Sculture in Vetro: Robert Willson*, Ca' Pesaro Museum of Modern Art, Venice, 1984.

1947 *Twelfth Ceramic National,* Syracuse Museum of Fine Arts, New York

1957 *Harry Hershey and Robert Willson,* Norton Gallery of Art, West Palm Beach, Florida

Painting and Sculpture Annual, San Francisco Museum of Modern Art

1966 *La Fucina degli Angeli Internazionale,* La Fucina degli Angeli, Venice; also 1967–88

1967 *Four Americans in Europe: Engel, Gorsline, Meigs, Willson,* Harmon Gallery, Naples, Florida

1971 *U.S. National Painting and Sculpture,* San Francisco Museum of Modern Art, Miami Art Center

1971 *Robert Willson and Walter Meigs,* Harmon Gallery, Naples, Florida

1972 *Biennale de Venezia*

Harmon Gallery, Naples, Florida

1973 *International Glass Sculpture,* Lowe Art Museum, University of Miami, Coral Gables

1976 Galerie 99, Bay Harbor Islands, Florida

1977 *14th Annual Major Florida Artists,* Polk Public Museum, Lakeland, Florida

Selections from the Glass Collection of the Lowe Art Museum, Lowe Art Museum, University of Miami, Coral Gables

1978 *15th Annual Major Florida Artists Show,* Harmon Gallery, Naples, Florida

1979 *20th-Century American Masters,* Harmon Gallery, Naples, Florida

1981 *20th-Century American Masters,* Harmon Gallery, Naples, Florida

1982 Museum of Modern Art, Mexico City

Texas Watercolors 33rd Annual Exhibition, Marion Koogler McNay Art Museum, San Antonio

1983 *National Glass Sculpture Invitational,* Matrix Gallery, Austin

1985 Tulane University and New Orleans Academy of Fine Art, New Orleans

1986 *Robert Willson and Florence Putterman,* Foster Harmon Gallery, Sarasota, Florida

1989 *Margaret e Robert Willson,* Santa Apollonia Art Center, Venice

1993 *Fine Art, Fine Craft,* Museum of New Mexico, Museum of Fine Arts, Santa Fe

1994 *Du Fantastique au visionaire,* Centro di Esposizione della Zitelle, Venice *Glass International*

982: Rassegna Internazionale Artisti del Vetro. Zitelle Centro Culturale di Espozione e Communicazione, Venice

San Antonio Museum of Art, 1988.

1995 Jeanine Cox Fine Art, Miami

Contemporary Crystal and Glass Sculpture from the Sixteen Countries of the European Union, Banque Generale du Luxembourg; toured to Liège, Belgium

Robert Willson and Margaret Pace Willson: Water and Glass, Rockport Center for the Arts, Texas

1996 *Margaret Pace Willson and Robert Willson,* Spotted Horse Gallery, Aspen, Colorado

1997 *Trial by Fire: Glass as a Sculptural Medium,* Newcomb Art Gallery, Tulane University, New Orleans

1999 *West Lake Fair,* Zhejiang Exhibition Hall, Wulin Square, Hangzhou, People's Republic of China.

SELECTED PUBLIC COLLECTIONS

American Craft Museum, New York

Auckland Art Gallery, Auckland, New Zealand

Charles A. Wustum Museum of Art, Racine, Wisconsin

Chrysler Museum of Art, Norfolk, Virginia

Corning Museum of Glass, Corning, New York

Correr Museum, Venice, Italy

Duke University, Durham, North Carolina

Jack S. Blanton Museum of Art, University of Texas, Austin

Lannan Foundation, Palm Beach, Florida

Los Angeles County Museum of Art

Lowe Art Museum, University of Miami, Coral Gables, Florida

Marion Koogler McNay Art Museum, San Antonio

Metropolitan Museum of Art, New York

The Mint Museum of Craft + Design, Charlotte, North Carolina

Museo del Vetro di Murano, Venice

Museum of Fine Arts, Houston

Museum of New Mexico, Santa Fe

New Orleans Museum of Art

Philbrook Museum of Art, Tulsa, Oklahoma

Renwick Gallery, Smithsonian American Art Museum, Washington, D.C.

Ringling Museum of Art, Sarasota, Florida

San Angelo Museum of Fine Arts, San Angelo, Texas

San Antonio Museum of Art

Texas Military Institute, San Antonio

Toledo Museum of Art

Trinity University, San Antonio

University of Texas–San Antonio

Victoria and Albert Museum, London

Witte Museum, San Antonio

Margaret Pace Willson and Robert Willson, Venice, 1989.

BIBLIOGRAPHY

The future will only be as good as the artists, and will not depend on what the critics say.

—R.W., *Texas, Venice and the Glass Sculpture Era— Notes,* 1981

WRITINGS BY THE ARTIST

Sketches Made in Mexico in 1935 by Bob Willson of Texas. Bound notebook.

Sun and Shade: Photos in Mexico 1935 by Bob Willson. Illustrated journal.

Sketches—Notes "For Paintings" 1940–1948: Robert Willson. Bound notebook, 1948.

"The Experimental Attitude in Art: A Declaration of Ideas," *Motive,* November 1948, pp. 17–19.

Glass for the Artist: Suggestions for the Experimental Use of Glass as a Material for the Fine Arts. Coral Gables, Fla.: University of Miami, 1958. Curriculum guide by Robert Willson and students.

3500 Years of Colombian Art: 1534 B.C.–1960 A.D. Coral Gables, Fla.: Joe and Emily Lowe Art Gallery, 1960.

"Creative Sculpture for Buildings." *The Florida Architect,* February 1962, pp. 6, 26.

"A Summary of the Ideas of the Exhibition." In *Renoir to Picasso 1914.* Coral Gables, Fla.: Joe and Emily Lowe Art Gallery, 1963.

"Distinction Out of Nothing, a Study of Architecture and Sculpture in Relation to Quality." *The Florida Architect,* April 1966, pp. 7–8.

Murano Diary 1966. Unpaginated notebook.

The Kress Collection. Coral Gables, Fla.: Joe and Emily Lowe Art Gallery, 1968.

Final Report Project No. 5-516-65, contract no. HEW .oEC-2-6-058304-1146. "A College-Level Art Curriculum in Glass." February 1968. Washington, D.C.: U.S. Department of Health, Education and Welfare, Office of Education, Bureau of Research, 1968.

The Character of Collecting Modern. Peoria, Ill.: Lakeview Center for the Arts and Sciences, 1969.

Fragments of Egypt. Peoria, Ill.: Lakeview Center for the Arts and Sciences, 1969.

Drawings in Search of Glass. Venice: Correr Museum, 1970.

"The Perfection of Glass . . . An Artist's View." In John J. Baratte et al., *International Glass Sculpture.* Coral Gables, Fla.: Lowe Art Museum, 1973, pp. 9–10.

Untitled artist's statement. *Robert Willson.* Miami: Brickell Gallery, 1974.

Venice Diary 1976. Unpaginated notebook.

Depth in Art Space: The Creative Artist's Handbook of Picture Depth, Space and The Perspectives, with Implications. Limited edition. San Antonio: Tejas Art Press, 1977.

Art in Clay: A World Survey of 27,000 Years of Ceramic Sculpture. San Antonio: Tejas Art Press, 1979.

"Solid Glass Sculpture." In Denise Schmandt-Besserat, *Robert Wilson: Sculpture in Glass.* Austin: University of Texas Art Museum, 1979.

Texas, Venice and the Glass Sculpture Era—Notes, 1981. San Antonio: Tejas Art Press, 1981.

"From a Texas Ranch." In Renato Borsato et al., *A Story in Glass: Robert Willson.* Venice: Edizioni in Castello, 1984, pp. 179–81.

"My 25 Years of Glass Sculpture in Venice-Murano." *Glass Art Society Journal 1985–86,* 1986, pp. 122–28, 133.

"Robert Willson." In *Robert Willson.* Odessa, Tex.: Art Institute for the Permian Basin, 1986.

"Words about Watercolor." In *New Watercolors by Robert Willson.* Naples, Fla: Harmon Gallery, 1989.

SELECTED BIBLIOGRAPHY

Aldridge, C. Clay. "A Note about Robert Willson." In *Glass by Robert Wilson.* Coral Gables, Fla.: University of Miami, n.d.

"Art League Exhibiting Sculpture in Glass." *San Antonio Light,* January 7, 1973.

"Art on the Walls." *Gambit Weekly,* May 11, 1999.

Baratte, John J. *University of Miami Art Department Faculty* (exhib. cat.). Coral Gables, Fla.: Lowe Art Museum, 1972.

_____. "Introduction," *University of Miami Art Department Faculty* (exhib. cat.). Coral Gables, Fla.: Lowe Art Museum, 1973.

Baratte, John J., Kenneth M. Wilson, Astone Gasparetto, and Robert Willson. *International Glass Sculpture.* Coral Gables, Fla.: Lowe Art Museum, 1973.

Barnes, Carol. "Willson Edits Poetry, with a Touch of 'Glass.'" *North San Antonio Times,* July 1, 1982, p. 3.

Battachi, Franco. "Dal Texas con amore." *Venezia 7,* September 28, 1984.

Beard, Bruce. "From Venice to Sarasota: Art in Glass." *St. Petersburg Times,* May 15, 1966, pp. 8–9.

Beard, Geoffrey. *International Modern Glass.* New York: Charles Scribner's Sons, 1976, p. 252.

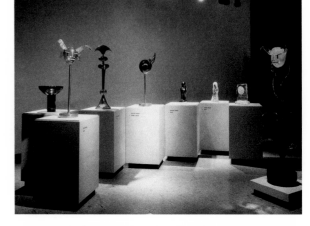

International Glass Sculpture, Lowe Art Museum, Coral Gables, Florida, 1973.

Benbow, Charles. "Willson Handles Visual Confusion." *St. Petersburg Times,* November 6, 1969, p. 6D.

Boccardi, Luciana. "Robert e Margaret Willson a Venezia: Insieme nell'arte e . . . nell'amore." *Il Gazzettino,* June 3, 1989, p. 3.

Borsato, Renato, Carlo Della Corte, Enzo Di Martino, Attilia Dorigato, Astone Gasparetto, Giovanni Mariacher, Guido Perocco, Paolo Rizzi, Giandomenico Romanelli, and Robert Willson. *A Story in Glass: Robert Willson.* Venice: Edizioni in Castello, 1984.

Brady, Barbara. "Artistry in Glass." *The Bradenton Times,* November 16, 1969, p. 1C.

Buda, Agostino. "La lune texana, gli indiani e il totem rivivono a Venezia nei vetri di Willson." *Messagiero Veneto,* September 26, 1984.

Chambers, Karen S. "Exhibition Review: Glass Exhibitions, New Orleans, May, 1985." *Glass Art Society Journal,* 1985–86, p. 133.

Corwin, Nancy A. *Trial by Fire: Glass as a Sculptural Medium.* New Orleans: Newcomb Art Gallery, Tulane University, 1997.

Cutler, Dick. "Texas Diary: Austin and San Antonio: March 1989." *New Work,* summer 1989, pp. 14–19.

Davis, Marian B. *First Survey of Contemporary American Crafts.* Austin: University Art Museum, University of Texas, 1967.

Della Corte, Carlo, Peggy Guggenheim, and Alberto Cavallari, with an afterword by Egidio Costantini. *La Fucina degli Angeli.* Venice: La Fucina degli Angeli, 1978.

Diehl, Suzanne. "A Man Who Sculptures Light? Who Is this Robert Willson?" *News and Reviews, McNay Art Institute,* January 1981.

Di Martino, Enzo. "Robert Willson: Le forme della luce." In *Robert Willson: Glass Sculptures.* Venice: Ravagnan Gallery, 1994.

Dinkins, Molly, and Dick DeJong. *A Rebirth of a Medium.* San Antonio: University of Texas at San Antonio Teaching Gallery, 1983.

Dixon, Allyson Reynolds. "Art of Glass." *San Angelo Standard-Times,* September 5, 1997, p. 1.

_____. "Special Sculptures 'Coming Home,'" *San Angelo Standard-Times,* September 12, 1997, p. 1.

Dobbs, Lillian. "Glassworks by Willson Mirror Artistic Vision." *The Miami News,* April 2, 1977, p. 1.

Dorigato, Attilia, and Dan Klein, eds. *Venezia aperto vetro/International New Glass.* Venice: Arsenale, 1996.

Ernould-Gandouet, Marielle. "Le verre, matériau nouveau pour la sculture." *Jardin des Arts,* no. 190 (September 1970), pp. 10, 14.

Fleischer, Roland E. "Some Recent Experiments in Glass Sculpture." *Art Journal,* no. 2 (winter 1965–66), pp. 164–68.

Fleischer, Roland. "Experiments in Glass Sculpture." In Roland Fleischer, Paul Franke, Paul Perrot, Astone Gasparetto, et al., *The Art of Robert Willson: Texas Artist.* Sarasota, Fla.: Foster Harmon Galleries of American Art, 1982.

La Fucina degli Angeli Internazionale (exhib. cats.). Venice, 1966–77.

Garza, Oscar. "San Antonio Museum of Art Marked Fragile as Diverse Exhibits of Glass Go on Display." *San Antonio Light,* March 13, 1988, p. J1.

Gasparetto, Astone. "Introduction to the Glass of Robert Willson." In *Robert Willson.* Venice: Bevilacqua la Masa Gallery, 1964.

"Glass Art Gallery: Robert Willson." *Glass Art* 3, no. 1 (February 1975), pp. 49–50.

The Glass Sculpture of Robert Willson. San Antonio: San Antonio Museum of Art, 1988.

"Glassy Art." *Austin American-Statesman,* February 4, 1979.

Goddard, Dan R. "Glass That Will Last Forever." *Sunday News-Express* (San Antonio), June 2, 1985, p. 13G.

Green, Roger. "Discovering the 'Exquisite Pleasures' of Glass Art." *Times-Picayune* (New Orleans), June 2, 1985, p. C6.

_____. "Glass Art Shines at Museum." *Times-Picayune* (New Orleans), May 6, 1990, F13.

Grover, Ray, and Lee Grover. *Contemporary Art Glass.* New York: Crown Publishers, 1975.

Hayes, Randall, Terence Keane, Dick De Jong, and Molly Dinkins. *Contemporary Glass.* Abilene, Tex.: Abilene Fine Arts Museum, 1987.

Hodgin, Leslie. "Artists Build World of Glass, Color." *Lariat,* October 30, 1991, p. 4.

Hollister, Paul. "The Pull of Venice." *Neues Glas/New Glass,* no. 1 (1990), pp. 4–9.

Kangas, Matthew. "Robert Willson: Image-maker." *GLASS: The UrbanGlass Art Quarterly,* no. 81 (Winter 2000), pp. 18–21.

_____. "Preservation, Renovation, Innovation: Glass in Public Art." *Public Art Review,* Spring 2001, p. 9.

Keefe, John W. "New Acquisitions in Glass." *Arts Quarterly, New Orleans Museum of Art* 9, no. 2 (April/June 1987), p. 7.

_____. "Sculpture in Glass: Works by Robert Willson." *Arts Quarterly, New Orleans Museum of Art* 12, no. 2 (April–June 1990), p. 1.

_____. *Sculpture in Glass: Works by Robert Willson.* New Orleans: New Orleans Museum of Art, 1990.

Klement, JoAnne. "Collage: American Artists Featured in Foster Harmon Exhibits Opening Today." *Sarasota Herald-Tribune,* January 30, 1983.

Klotz, Uta. "Venezia aperto vetro." *Neues Glas/New Glass* 3 (1996), pp. 12–19.

Lance, Mary. "Sculptor Creates Fanciful, Geometric Shapes from Glass." *San Antonio Light,* November 1, 1992, p. J6.

Lee, Amy Freeman. "Through the Glass Lightly." In *Robert Willson: Glass Sculpture.* San Antonio: San Antonio Art League, 1973.

Lee, Amy Freeman, and Glenn R. Bradshaw. *Thirty-third Annual Exhibition of the Texas Watercolor Society.* San Antonio: University of Texas–San Antonio, 1983.

Leeper, John Palmer. *The McNay and the Texas Artists.* San Antonio: McNay Art Museum, 1988.

"Major American Artists Represented at Harmon Gallery Opening Tonight." *Collier County News,* January 15, 1967, p. 6.

Mariacher, Giovanni. "Le sculture in vetro di Robert Willson." In *The Glass Sculpture of Robert Willson.* Venice: Correr Museum, 1968.

Martin, Jim. "Bringing His Artistry Home." *Northside Sun,* February 15, 1978, p. 3A.

McClelland, Eileen. "Colorful Couple Shows Work/International Artists Exhibit in Odessa." *The Odessa American,* September 14, 1986.

Milligan, Bryce. "Glass Has a Rebirth." *The Sunday News-Express,* October 16, 1983, p. 14B.

Myers, Joel Philip. "New American Glass." *Craft Horizons,* August, 1976, p. 40.

Oleson, J. R. "Glass Art Cools Cutting Edge." *Austin American-Statesman,* August 1, 1992, p. 11.

Parvin, Bob. "Glass Fantasies." *Texas Highways,* February, 1979, pp. 25–27.

Perrot, Paul N. "Robert Willson: Sculptor in Glass, an Appreciation." *Art Journal* 39, no. 1 (Fall 1969), pp. 46–47.

Petrella, Cristina Martinuzzi. "Vetri mistici." *Alto Adige,* July 7, 1994, p. 12.

Piersol, Daniel, and Paolo Rizzi. *Trail of the Maverick: Watercolors and Drawings by Robert Willson, 1975–1998.* New Orleans: New Orleans Museum of Art, 1999.

Pivato, Manuela. "Matrimonio d'arte a Venezia: La favola bella di Margaret e Robert Willson." *Il Gazzettino,* June 10, 1989.

Poor, Henry Varnum, and Richard H. Paas. *Twelfth Ceramic National.* Syracuse, N.Y.: Syracuse Museum of Fine Arts, 1947.

Reed, Harry. "Robert Willson: An Innovative Pioneer in Glass Sculpture." *ArtCraft,* April/May 1980, pp. 24–25.

_____. "Solid Glass: Robert Willson's Sculpture." *Glass Studio,* no. 41 (1982), pp. 28–30, 43–45.

Reno, Doris. "Nothing Quite Like It." *The Miami Herald Sunday Magazine,* November 1, 1964, p. 22.

_____. "Sculptor Gets Glass Grant." *The Miami Herald,* June 19, 1966.

_____. "Crystal and Glass Exhibition Gleams." *The Miami Herald,* September 1, 1968.

Rizzi, Paolo. "Un Americano a Venezia." *Il Gazzettino,* September 25, 1984, p. 11.

_____. "Willson doma il vetro." *Il Gazzettino,* September 28, 1984, p. 3.

_____. *Robert Willson Watercolors.* Venice: Edizioni Galleria Ravagnan, 1989.

Rizzi, Paolo, and Luciano Ravagnan. *Robert Willson: Sculture in vetro.* Venice: Edizioni Galleria Ravagnan, 1989.

Rizzi, Paolo, and Pino Signoretto. *Robert Willson: Sculture in vetro.* Venice: Galleria d'Arte Moderna Ravagnan, 1984.

Robert Willson. Miami: Brickell Gallery, 1974.

Robert Willson. Odessa, Tex.: Ellen Noel Art Museum of the Permian Basin, 1996.

Robert Willson: Glass Sculpture. San Antonio: McNay Art Institute, 1981.

"Robert Willson Lecture Fund Established." *GAS News: The Newsletter of the Glass Art Society* 12, no. 6 (November/December 2001), p. 1.

Rosenblum, Gail. "Complementary Careers in Art." *San Antonio Light,* February 2, 1986, pp. 18–19.

Schmandt-Besserat, Denise. *Robert Willson: Sculpture in Glass.* Austin: University of Texas Art Museum, 1979.

"Sculptor Wins Prize." *Veritas,* February 28, 1977.

Segato, Giorgio. "Vetro, luce e colore di Robert Willson." *Veneto Weekend,* September 10, 1984, p. 16.

Smith, Griffin. "Miamian Pioneers Rare Glass Sculpture." *Miami Herald,* May 25, 1969, p. 1L.

_____. "Glass Sculpture: Miamian's Pioneer Works Winning a Wide Audience." *The Miami Herald,* April 5, 1970, p. 1H.

_____. "A Solid Look at Major Florida Painters." *Miami Herald,* January 23, 1972.

_____. "Where the Action Is: International Exhibit at Lowe Is the 'Armory Show' of Glass Sculpture." *Miami Herald,* April 15, 1973, p. 9F.

_____. "Willson's Glass an Exhilarating Art Experience." *Miami Herald,* April 7, 1974, p. 8H.

Stearns, Thomas. "The Façades of Venice: Recollections of My Residency in Venice." In William Warmus, *The Venetians: Modern Glass 1919–1990.* New York: Muriel Karasik Gallery, 1989, p. 4.

Sturhahn, Joan. "The Paintings of Robert Willson." In *Robert Willson.* Miami: Brickell Gallery, 1974.

[Tagliapietra, Silvano.] "Le sculture in vetro di Robert Willson." *La Voce di Murano* 4, no. 26 (August 1968), p. 1.

Thirty-three Miami Artists. Miami: Miami Art Center and Museum of Modern Art, 1971.

Thompson, Paul E. *University of Miami Art Department Faculty* (exhib. cat.). Coral Gables, Fla.: Lowe Art Museum, 1975.

"UM Professor Finds Glass an Exciting Medium." *The Miami Herald,* May 27, 1956.

University of Miami Art Department Faculty (exhib. cat.). Coral Gables, Fla.: Lowe Art Museum, 1976.

Urrutia, Judy. "Robert Willson: An Artist in Glass." *San Antonio Light,* January 8, 1981, pp. 12–13.

Villani, John. "The Fine Line between Art and Craft." *Pasatiempo,* January 22–28, 1993, p. 21.

Warmus, William. *The Venetians: Modern Glass 1919–1990.* New York: Muriel Karasik Gallery, 1989, p. 9.

Watson, Jessica Lewis. "Willson Exhibit Continues at Baylor," *Discover Waco,* January 1992.

_____. "The Glass Master." *Texas Alcalde,* July/August 1993, p. 24.

"Willson a Ca' Pesaro." *Tutto,* June–September 1984, p. 6.

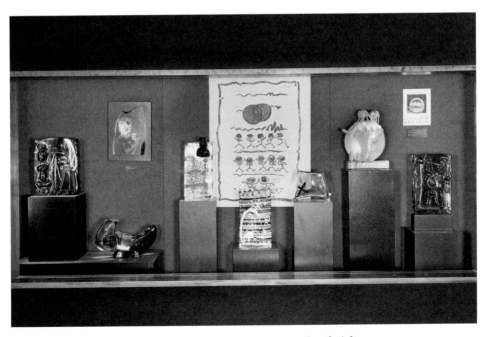

The Corning Museum of Glass, Corning, New York, 1968. *Etruscan Altar* (far left).

Sunset over Handley, 1949, watercolor on paper, 4 x 5.

Robert Willson: Image-Maker was set in Adobe Garamond and Scala Sans and printed in Canada at Hemlock Printers, Ltd., Burnaby, B.C.

PHOTO CREDITS

Every effort has been made to identify the photographer of each photograph.

In addition to the photographers and institutions credited below by page number, many individuals worked hard to bring together the beautiful reproductions in this book. They include Ansen Seale and Cary Whittenton, who worked with Robert Willson to take numerous photographs over time, and Judy Cooper and Owen Murphy of the New Orleans Museum of Art. Employees of institutions and galleries as well as private collectors smoothed the way for permissions, including Marsha Beitchman and Shawn Greene, American Craft Museum; Egidio Comelli, Fucina degli Angeli Gallery; Linda Cagney, Chrysler Museum of Art; Attilia Dorigato, Museo del Vetro di Murano; Sandra Divari and Claudia Reck, Peggy Guggenheim Collezione; Kate Elliott, Elliott Brown Gallery; Christy Fasano, Philbrook Museum of Art; Nicole Finzer, Art Institute of Chicago; Alexander Gray, The Archipenko Foundation; Richard Nicol and Marshall Hatch of the Marshall and Helen Hatch Collection; Melissa Klotz and Catherine Walworth, Seattle Art Museum; Rachel Mauldin, San Antonio Museum of Art; Olivia Hogue Mariño, estate of Alexander Hogue; Joyce Penn, Rockwell Museum of Western Art; Marina Raffaeli, Ars Murano; Luciano Ravagnan, Ravagnan Gallery; Holle Simmons, William Morris Studio; Jan Day, Virginia and Bagley Wright Collection; Artists Rights Society; Heidi Coleman, VAGA, New York.

All works courtesy of their owners unless otherwise noted.

Guillermo Angulo: 50 (bottom)

Artech, Seattle: 75 (top)

Egidio Comelli: 59, 60 (top and bottom)

Laura Constantine: 30 (top)

Judy Cooper: 13, 21 (bottom), 24 (top and bottom), 38 (top), 47 (left), 70, 71 (top), 73 (bottom), 74 (top and bottom), 75 (bottom), 77, 81 (bottom), 86, 87, 97 (bottom), 101 (top), 117, 123, 136, 158

Foto Attualità di Attilio Costantini: 61, 62 (bottom), 161 (top)

Foto Ferruzzi: 56 (top and bottom)

Eva Heyd: 131, 149

Interstudio: 64, 79 (top), 80 (top), 81 (top), 83, 84 (bottom)

Matthew Kangas: 89

Mirco Lion: 23, 151

Paul Macapia: 93 (left)

Richard Marquis: 71 (top right)

Owen Murphy: 18, 92 (bottom right), 97 (top)

Musei Civici Venezia, 71 (bottom right)

Richard Nicol: 32 (bottom), 40 (bottom)

Peggy Guggenheim Collezione: 109

San Francisco Museum of Modern Art: 49 (left)

Ansen Seale: 6, 10, 25, 72 (bottom), 79 (bottom), 82 (bottom), 90, 92 (bottom left), 93 (right), 94 (bottom), 95 (left and right), 96 (top and bottom), 98, 99, 100, 102, 103 (top and bottom), 104 (top and bottom), 106, 107 (right), 108, 115, 116, 118, 120, 124 (top and bottom), 125, 132, 133, 138 (top and bottom), 144, 145, 146, 148, 150, 152, 153 (top and bottom), 154, 156

Peggy Tenison: frontispiece

Rob Vinnedge: 105 (bottom), 111

Cary Whittenton: 129, 130

Nick Williams: 51

Margaret Pace Willson: 84 (top), 161 (bottom), 162

Robert Willson: 20 (bottom), 26, 29 (bottom), 30 (bottom), 31 (top and bottom), 32 (top), 34 (all), 35 (all), 36 (all), 39 (bottom), 41 (bottom), 46, 48, 49 (right), 50 (top), 54 (middle and bottom), 55 (bottom), 57 (top and bottom), 62 (top), 65, 66, 68, 72 (top), 73 (top), 76, 78, 107 (left), 163 (top and bottom)